The Year of the Dogs

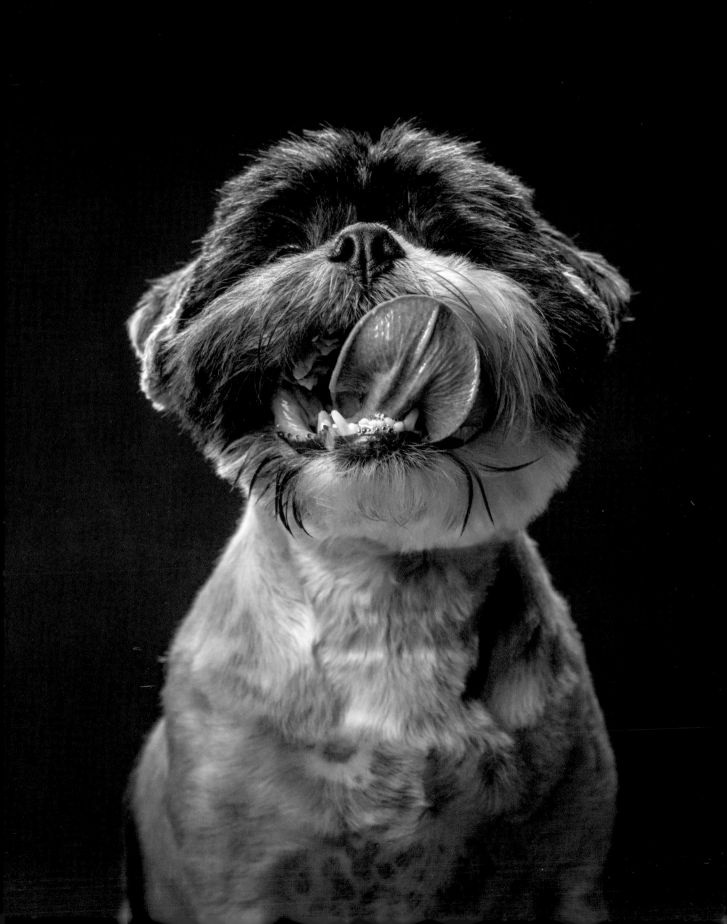

The Year of the Dogs

Vincent J. Musi

CHRONICLE BOOKS

SAN FRANCISCO

in association with

Blackwell&Ruth.

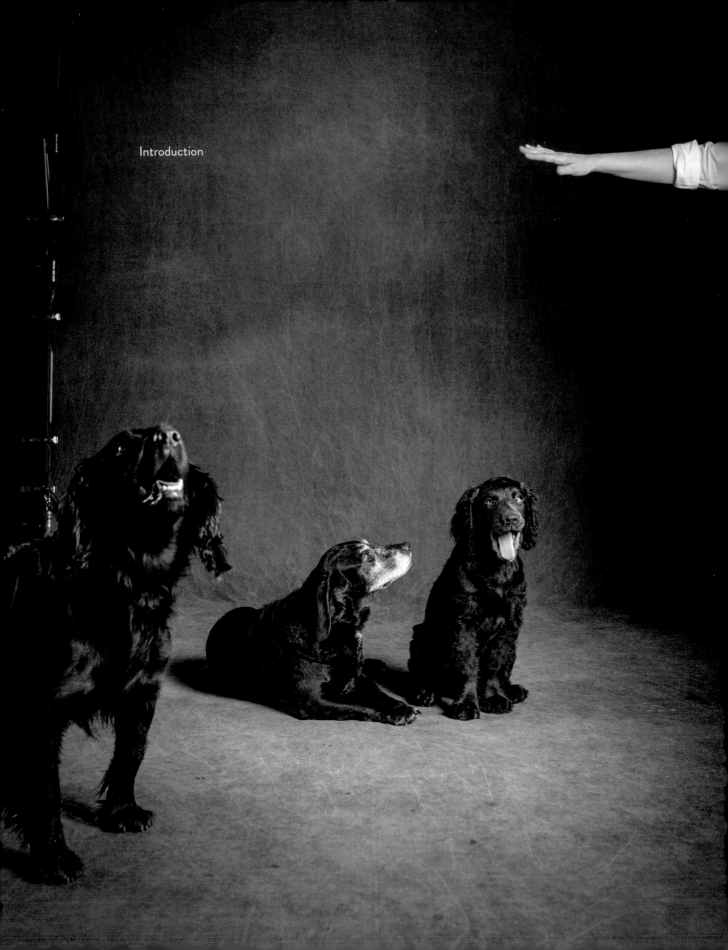

Introduction

The Year of the Dogs was never supposed to be about dogs.

In the spring of our son Hunter's sixteenth year, my wife, Callie, and I realized that he was quickly turning into a grown-up and would be leaving the nest before we knew it.

Wanting to spend as much time as possible with Hunter before the metamorphosis was complete, I decided to forgo all assignments that involved travel, which was pretty much all assignments. There are no *National Geographic* photographers who work from home that I know of; travel to the places you are photographing is pretty much a mandatory kind of thing.

So, I reinvented myself as a dog photographer and built a studio in the back of a pet-food store. I named it The Unleashed Studio and announced that I was looking for a few good dogs. I had absolutely no idea what I was doing. My colleagues felt bad for me and wondered if I was losing it. I started to wonder myself.

Callie knew I couldn't do this by myself. A great photographer, she put her own work on hold and began to help, becoming my overworked photo assistant, expert dog wrangler, and personal psychiatrist. Hunter pitched in as well with helpful critiques of the photographs and clever ideas like challenging me to write stories and post them to Instagram.

'Nobody cares about other people's dogs,' I said.

I was wrong about that.

We've received the kindest reaction from all over the world to these fabulous dogs.

People write to me when they laugh, when they cry, when they accidentally spit out their morning coffee over a joke or photograph. I read every comment, message, and email, and am humbled by the connection we have made.

And they are more than virtual friends. Many routinely travel hundreds or even thousands of miles with their dogs to be photographed in our studio. We are very grateful to them for sharing their dogs with us on Instagram, and now here with this book.

– VJM

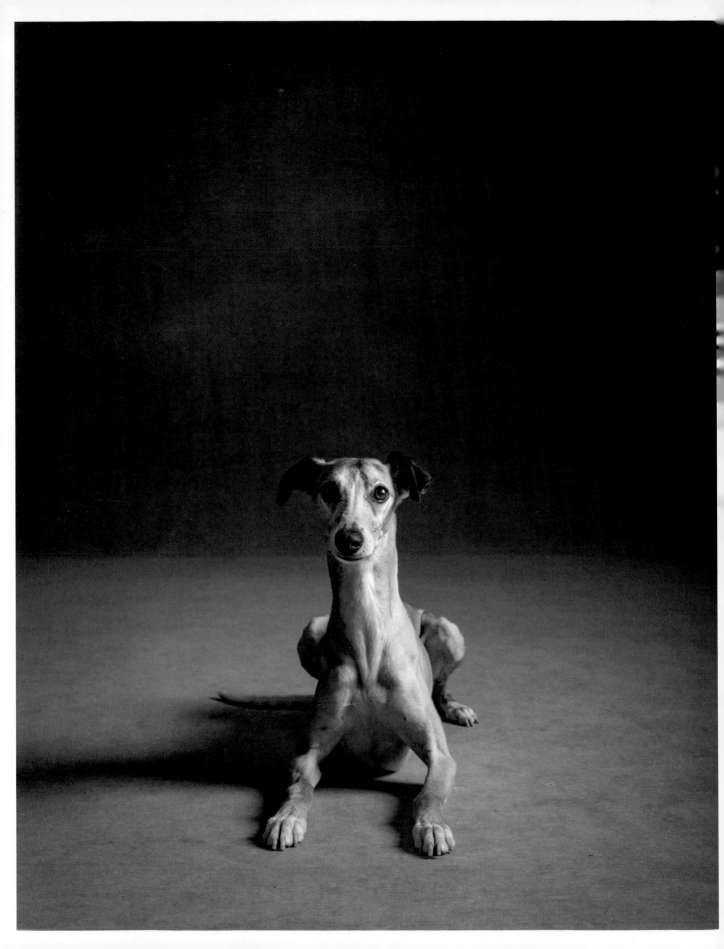

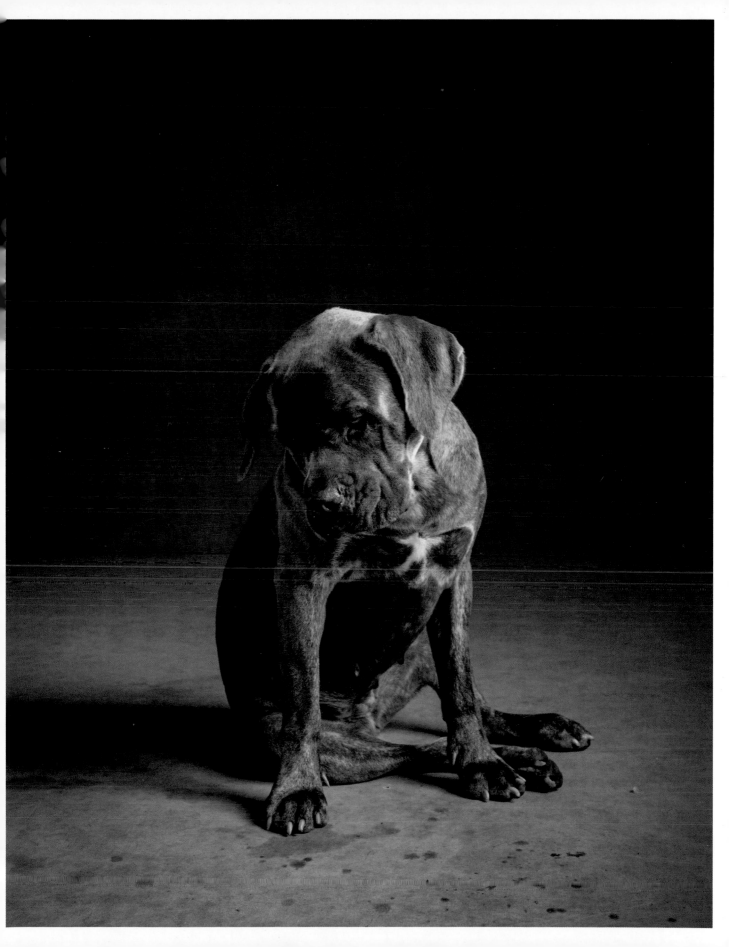

Murphy

In the interest of full disclosure, I do not have a dog. A friend challenged me recently: 'How can you be doing this *The Year of the Dogs* thing when you don't even have a dog?'

My retort is simple – I've photographed many animals: bears, elephants, tigers, lions, sheep, and pigs . . . Incredibly, some of them were even kept as pets, but I don't have any of those either.

Maybe I never got over the death of my childhood dog, or I've lived in too many weird apartment buildings. Whatever the reason, I am dogless. Yet dogs are no strangers at our home. Our front porch famously graced the cover of a coffee-table book about porch dogs, complete with a photograph of a dog that was not ours sitting on our porch.

I can say without hesitation that if I did have a dog, I would be lucky to have one as cool as Murphy. He's a family dog, good with his paws, and has just enough scruff to be considered authentic. He's a venerable first-generation labradoodle closing in on fourteen years of age. A loyal and friendly sort with a firm paw-shake, he needs no help opening or closing the front door of his home.

He's welcome on our porch any time.

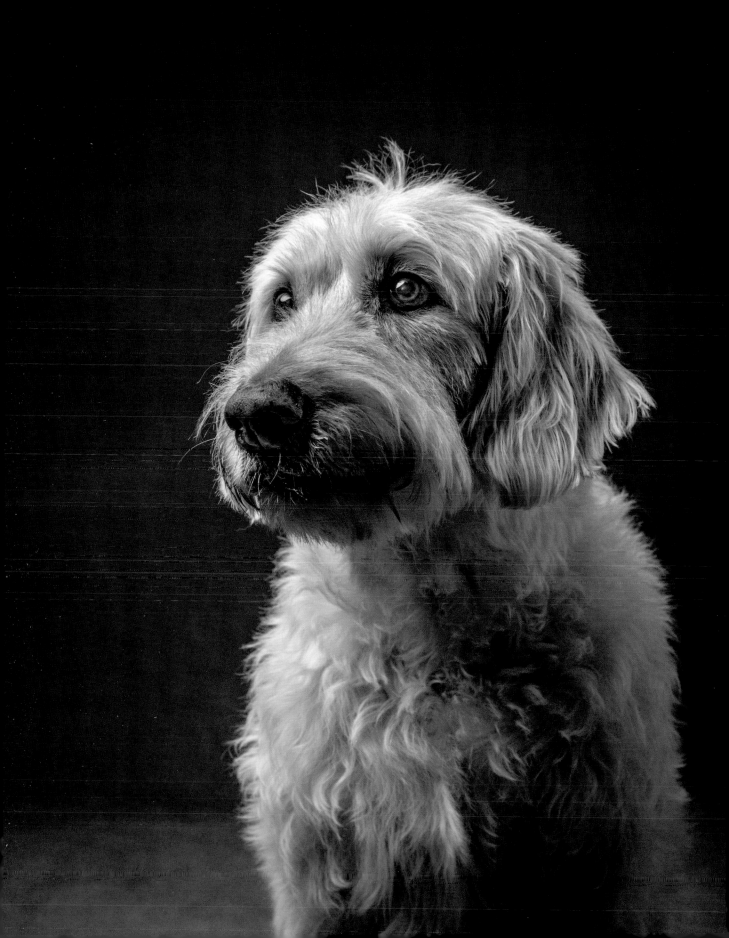

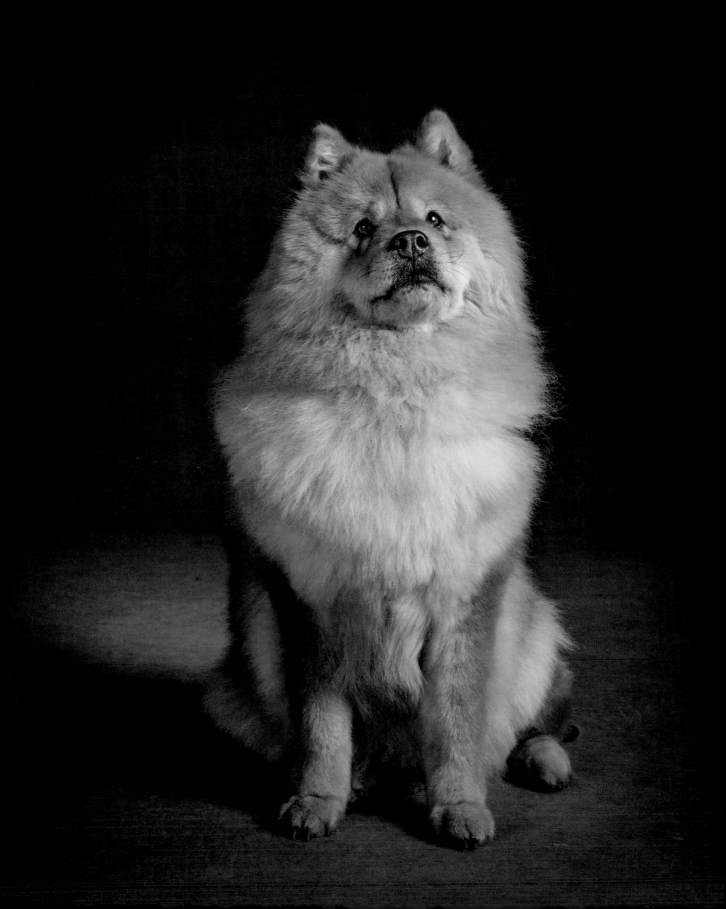

Daria

Daria was a flight risk. She'd traveled across multiple state lines to get to our studio, yet we didn't see it coming.

We work from a patch of concrete in a very active 43,000-square-foot open-plan warehouse that is divided into territories like the strategy board game *Risk*. I currently have an alliance with a company that renovates homes; they have amassed nearly a thousand thirty-eight-gallon water heaters on our sovereign border to the south. To the north is a formidable artillery of salvaged street bricks and stacks of recycled wood. We are at peace. Daria's entrance, planned weeks in advance, was greeted with the fanfare reserved for chow chows of her stature – similar to that of a head of state or other visiting dignitary. All seemed to be going perfectly as she reviewed the studio and personnel on hand, but then she discovered a squirrel hiding behind the water heaters.

Daria launched an immediate and thorough assault on the fugitive squirrel, which had, by then, successfully navigated a labyrinth of reclaimed flooring and hand-hewn beams to the open front door and was miles away.

In her mind though, Daria never let go of that squirrel. She viewed me and Callie as complicit in the escape and not to be trusted – regardless of how many individually wrapped slices of low-fat American cheese Callie might have had folded up in her pocket.

Leashes were used at times, photographs were taken occasionally, and the squirrel has not been seen since.

Mary Anne

Some time ago, I was honored with a very nice profile on my work with animals in a local magazine. Not so much the dogs, but lions, tigers, bears, and that sort of thing.

Daniel works at a local eatery where the magazine can be found. Prior to seeing my profile, he didn't know what I did for a living except order margaritas and Mama's special soup.

He was one of the few people who did not congratulate me on the article. It's his way, and I kind of like him for it. He simply said, 'What about photographing my dog, or is she not wild enough for you?' And so it was that, a few days later, Mary Anne showed up in the studio.

She's sturdy and athletic with a no-nonsense personality, much like Daniel, except she's not from Ecuador like he is.

Hailing from a shelter in Greenville, South Carolina, three-year-old Mary Anne is from 'off', as the locals might say here. An upstate dog with a negligible accent, she's the probable love child of a boxer and a Staffordshire bull terrier.

I'm sure Mary Anne would have congratulated me, had Daniel even shown her the magazine.

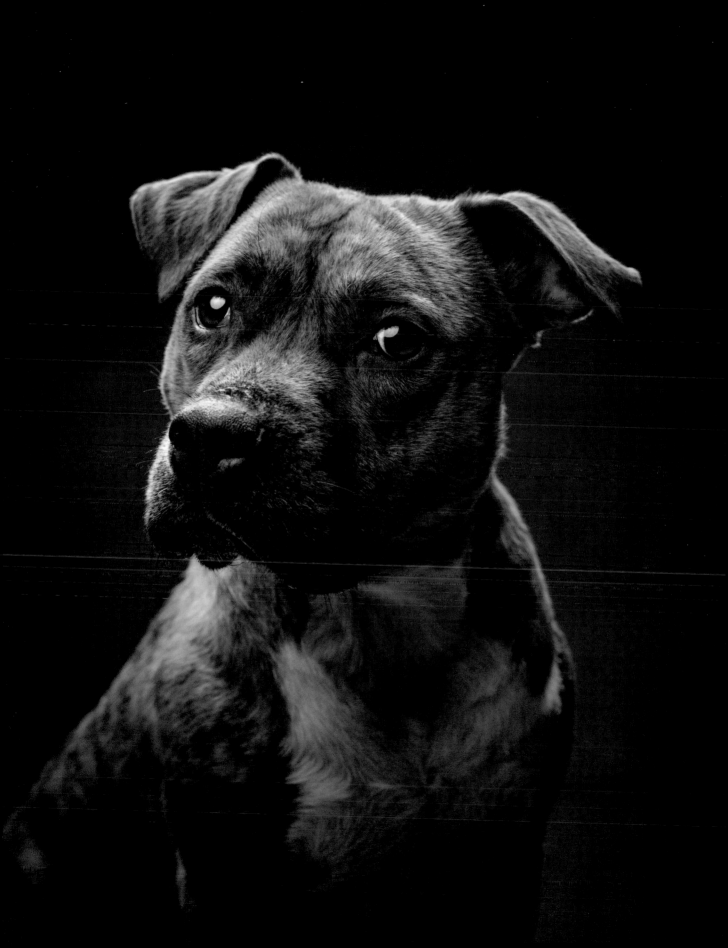

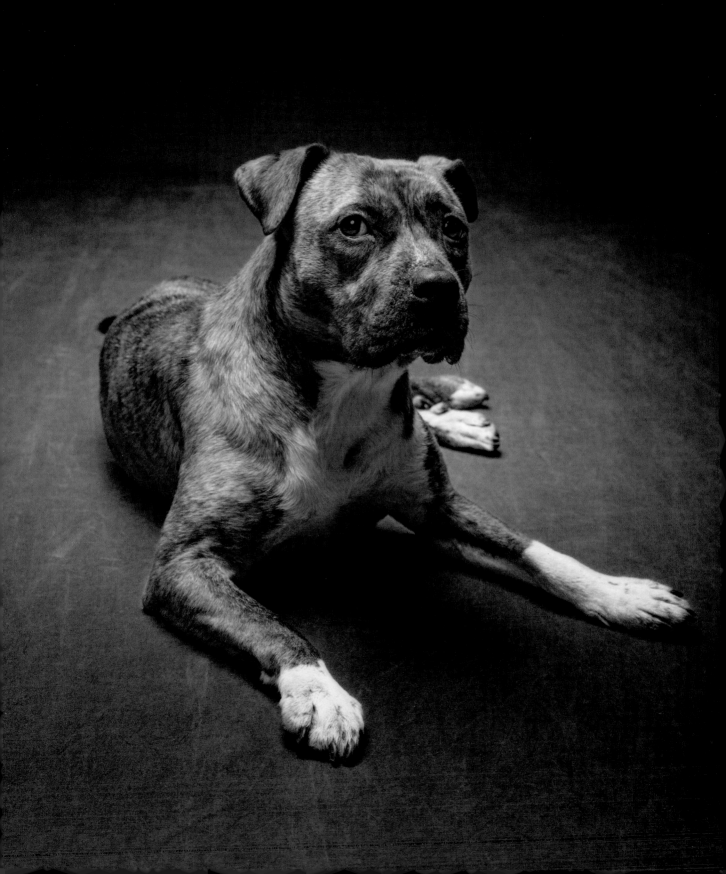

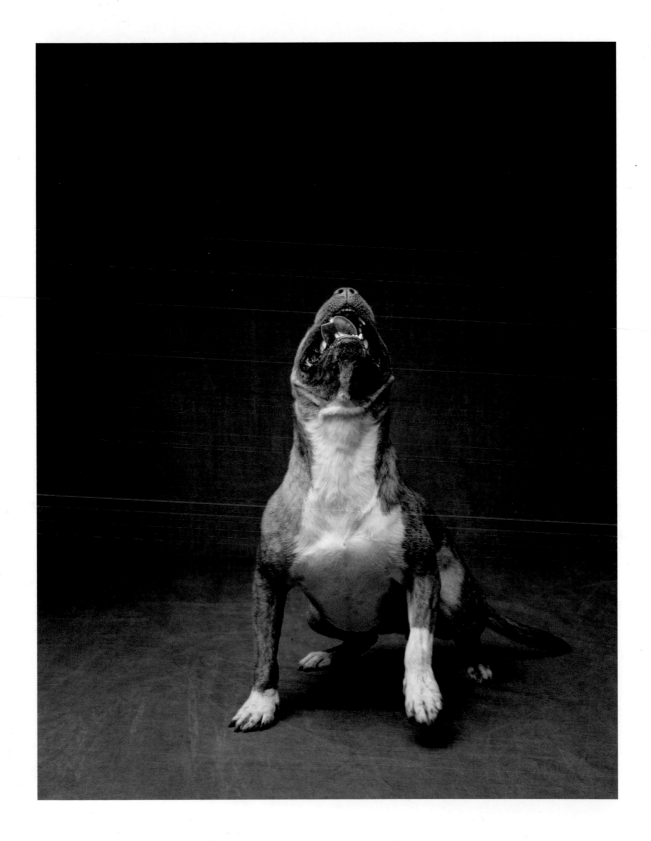

Luka

Luka is a very famous Great Dane, ranking somewhere up there with Lassie and Toto on the canine celebrity scale. Fame has not gone to Luka's head, although it's rumored she is endorsing a line of plus-sized dog collars and recording a duet with Tony Bennett.

She's a local landmark that can be seen from miles away on any given day, whether cloudy or clear. At three years old she is roughly the size of an American compact car, which is a larger vehicle than you might expect, and greatly admired once you get up close.

People love Luka and she loves them back.

Visitors and well-wishers often gather in small groups to lay hands on her in the same way that tourists rub the toe of a famous sculpture.

As oft happens, Luka came into her owner's life at a time when she was needed most; saving the life of one and brightening the lives of others, one person at a time.

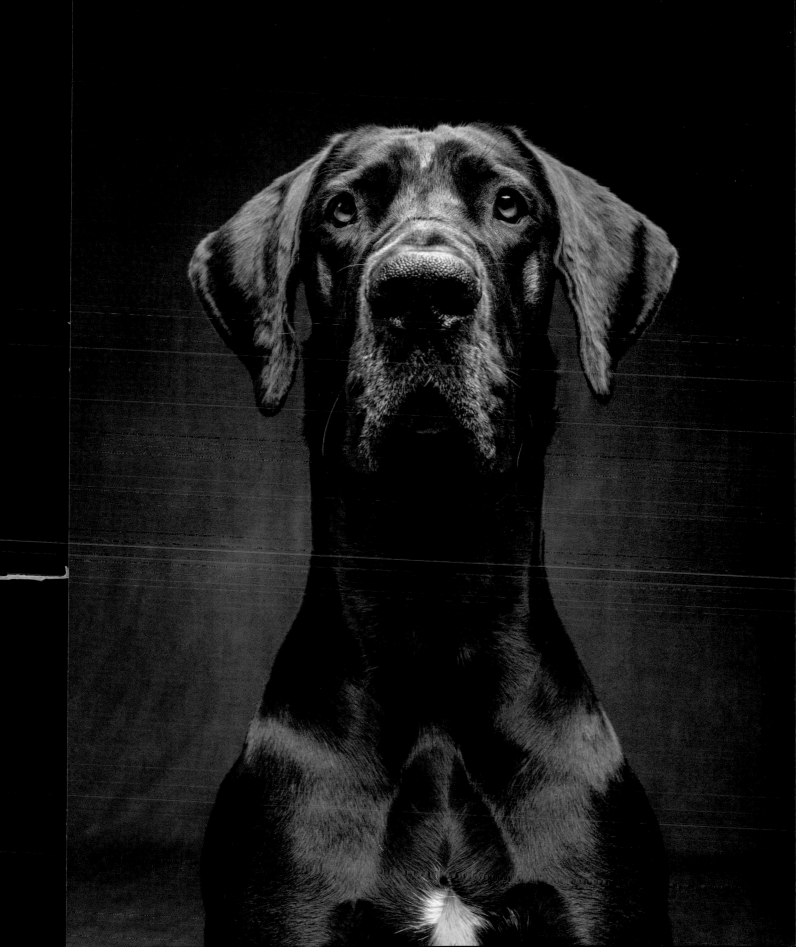

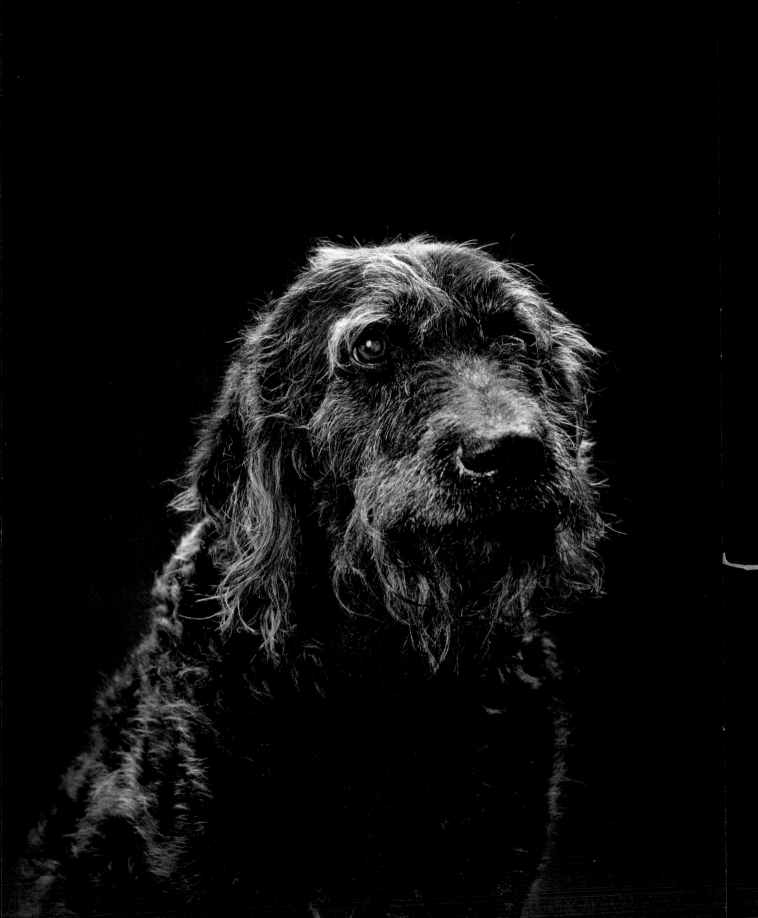

Cole

Cole, a thirteen-year-old labradoodle, is about as wild as it gets in our studio.

My colleagues at *National Geographic* frequently face extreme conditions to photograph wildlife. They travel to the ends of the Earth, live in tents, and often wait patiently for months to photograph an animal in the wild.

I understand.

Cole was seventeen minutes late. She pulled up to the studio in a Toyota Camry on a Wednesday afternoon. Because of her age, she doesn't drive anymore and had to wait on her ride.

She's got a bum eye and can't hear worth a damn out of either ear. This is a good thing for both of us, as I'm not always the most diplomatic person and I'd really hate to offend an old dog like Cole, no matter the reason for her tardiness.

Beyond that, her secrets remain with me as I'm bound by a strict photographer-dog confidentiality agreement.

Mojo

According to witnesses, Mojo and I got along very
well. He's a snapper of sorts – maybe not a fully
fledged biter, but a nice dog whose caution towards
men is understandable. This is particularly true
when said man is firing off cameras and flashes
with reckless abandon.

Mojo is fourteen, a Jack Russell-beagle-foxhound-
corgi blend. He came from a shelter more than a
day's walk from his home.

Friends and neighbors refer to this photograph
as the Mojo Lisa, which I hope will go a long way
towards smoothing things over with this old man.

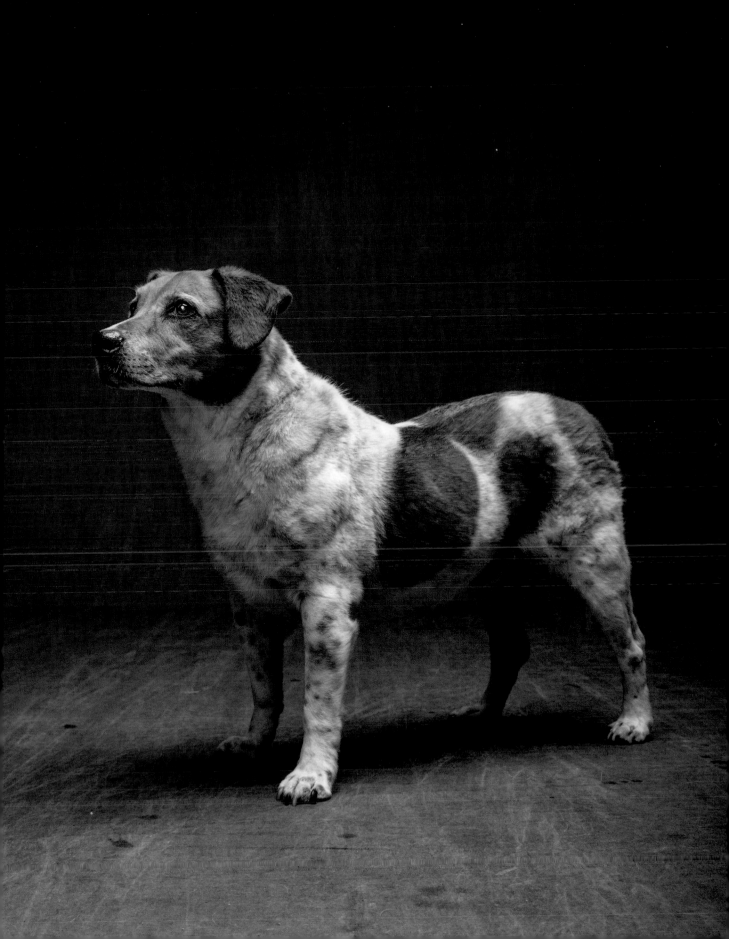

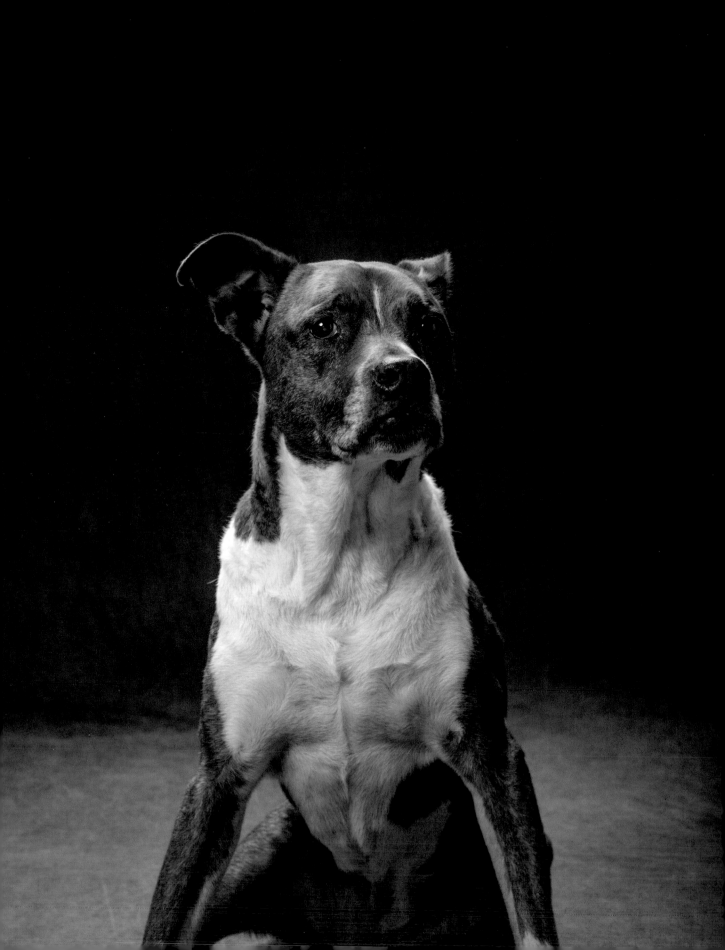

Brooklyn

Thirteen-year-old Brooklyn is a mix of pit bull and
other stories, some of which involve dog fighting.
Over many years, the emotional and physical scars
of her youth have healed. Today she is a survivor,
a lucky dog who beat the odds.

Never underestimate the underdog.

Bruiser

'This dog saved my life.'

I hear this claim often enough not to question it,
and I know enough to believe it.

Such is the case with Bruiser – who answers to 'Bru' –
a little dog I was largely interested in until I found out
he was a Chihuahua.

Don't judge me. My professional opinion is scientific,
based on an on-again off-again relationship with
'The Chihuahuas', a notorious gang of two retired into
the witness protection program in Florida. They have
always had it in for me, my ankles, and my hearing.
They work in tandem until they break you down.
Good cop, bad cop.

Bru is an engaging lad in a very strong relationship
with one human, and has spent the last few years
working as her personal life coach. He's considered
to be a greatest-of-all-time kind of dog, and has
done more good in that regard than his three-pound
frame should allow for.

Maybe this will get me back in good standing with
The Chihuahuas.

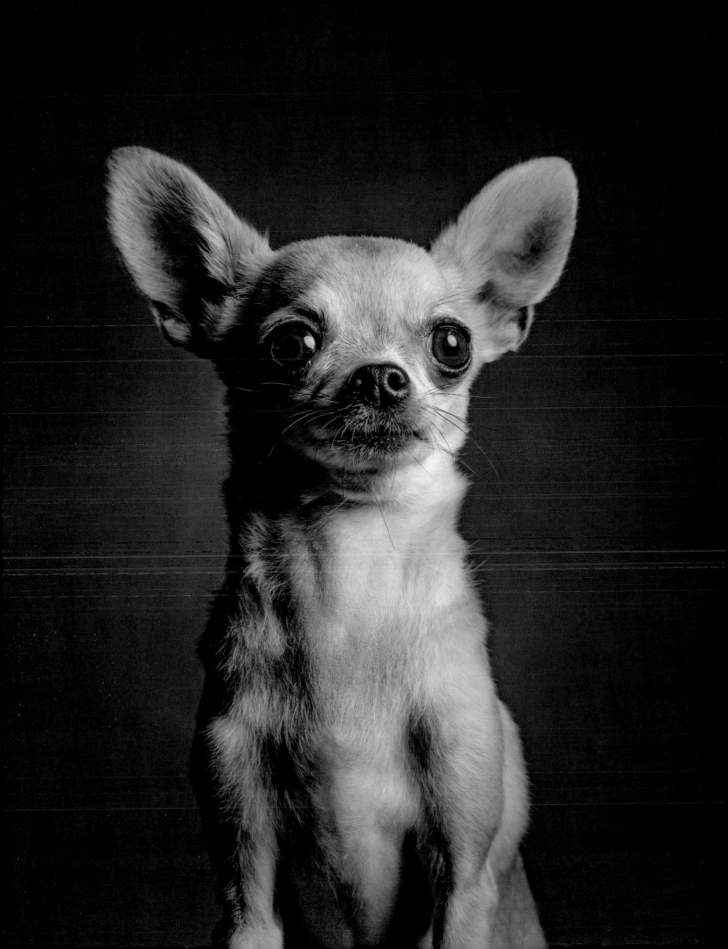

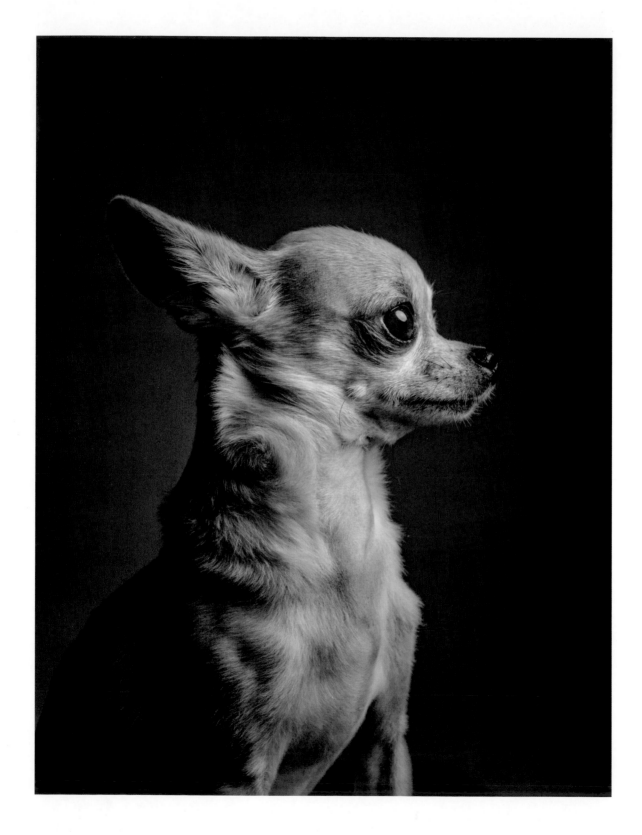

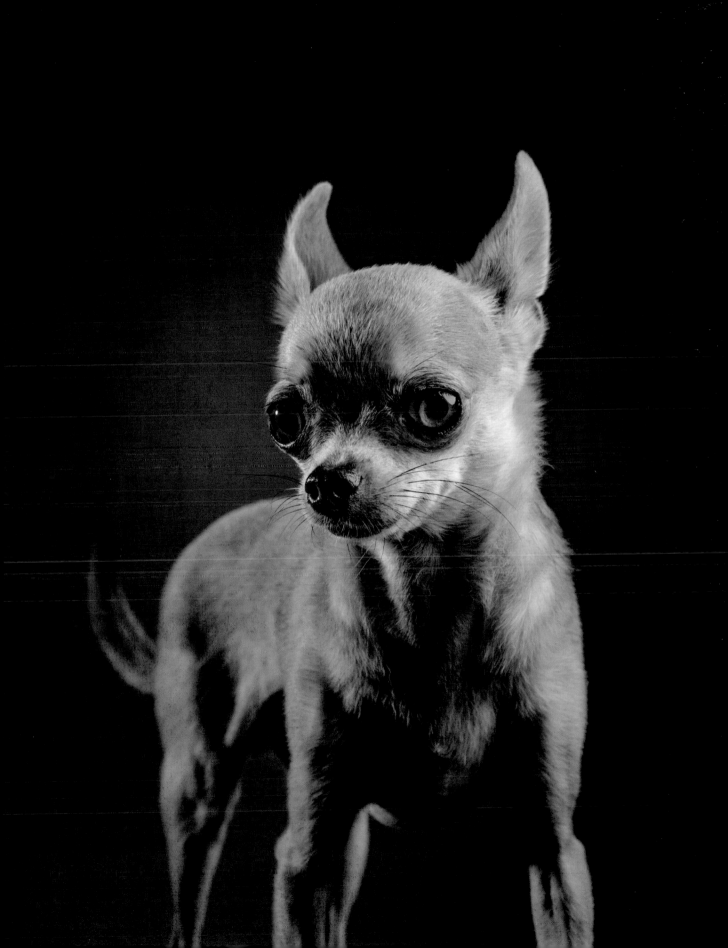

Daisy

I've known Daisy for a long time – most of her twelve years. She's never been much of a dog person, if you can say that about a dog. Daisy has always preferred the company of people and cats, having raised a couple of each over the years.

She would never brag, but in her prime Daisy might have been the best hunting dog there ever was – and they don't say that a lot around here unless it's true.

In her youth she was fast and wild. Once, she established that the quickest way from the top of the stairs to the bottom of the stairs was to skip over the stairs entirely and just leap.

The stunt ended only slightly better than Evel Knievel's jump over the fountains at Caesars Palace in 1967. In my youth, I once failed in a similar attempt to jump my fastback bicycle, a yellow Schwinn Stingray, over the old blue USPS mailbox at the end of our street. My bones have since healed, but my banana seat was never the same.

Daisy and I are both older and wiser now, and although I have a considerable edge in hearing, it might be a draw on vision. We can both see well enough to know we don't. Neither of us does stunt work anymore.

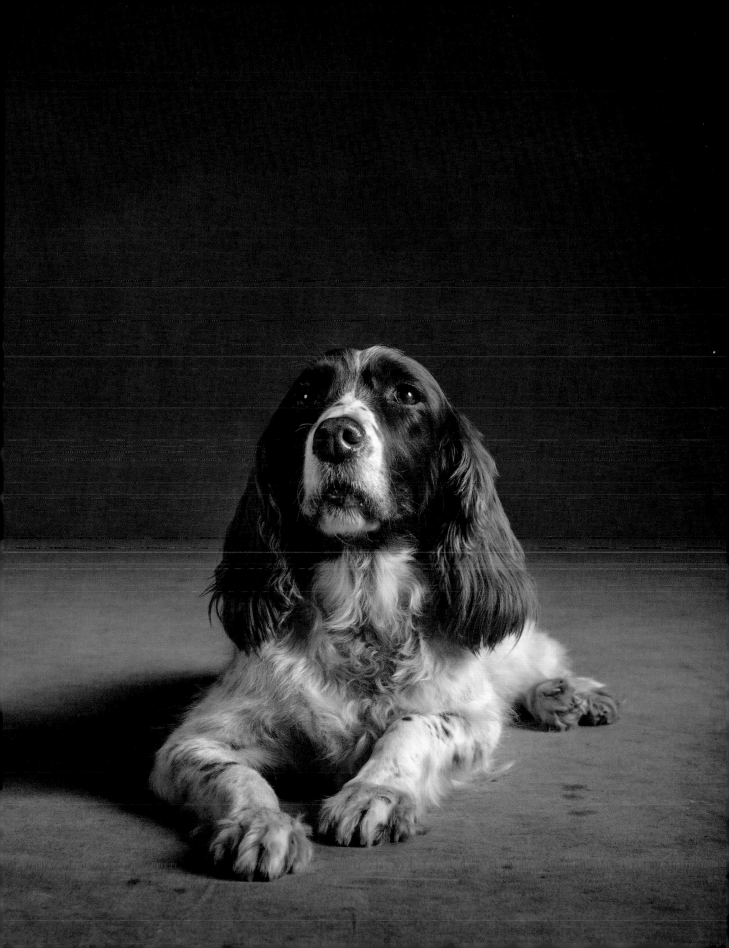

Monty

There's something about doodles and me. I'm not very good with rejection – thin-skinned, you might say – particularly when it comes from a doodle, whether they be 'golden' or 'labra' or any of the other varietals.

Monty is known as 'The General' in his household, where he commands a small brigade of humans and another dog or two (on a good day).

At just a little more than nine years old, Monty was having no part of what I was selling. The number of photographs he permitted me to make can be counted on one hand. It is quite humbling to have an otherwise amiable dog physically turn his nose up at you and your dreams of fame as a dog photographer.

What you see here is what I got, and that's all I was getting. We have since reached a peaceful accord, but the relationship remains tenuous.

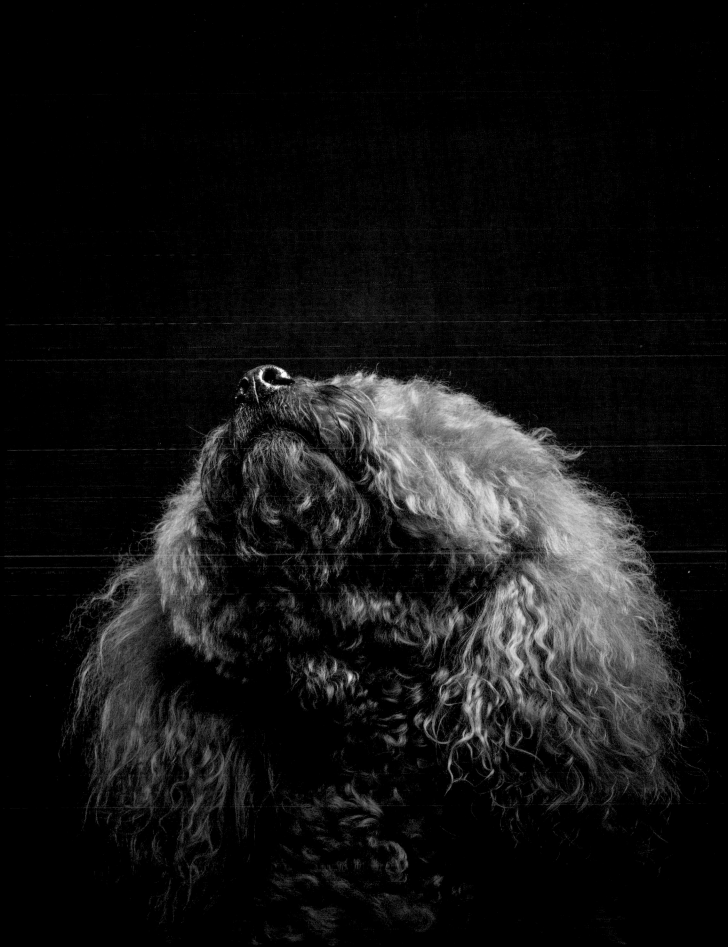

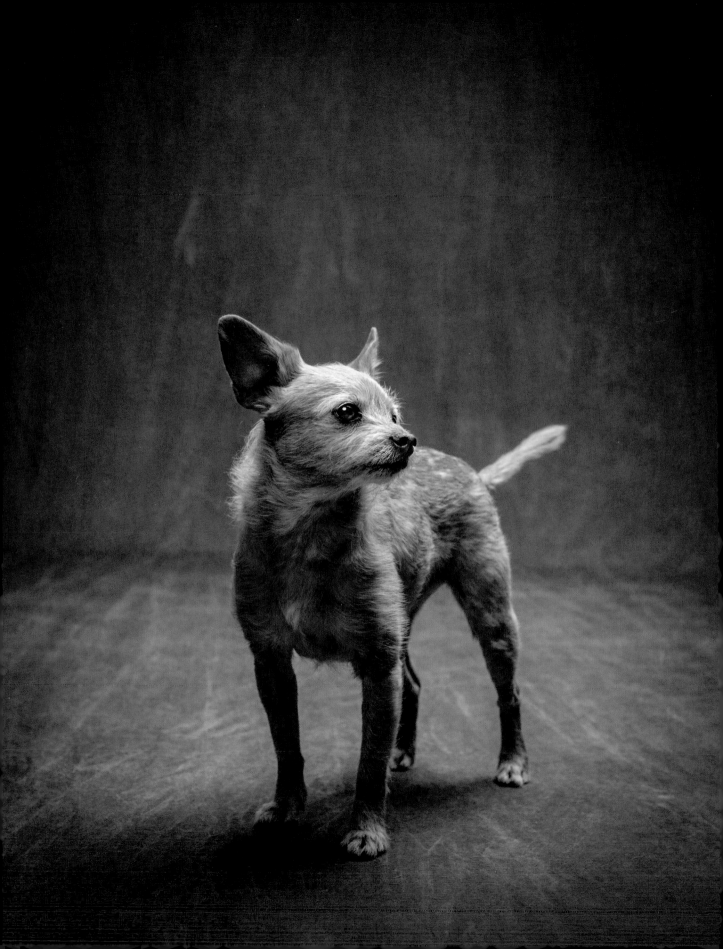

Sally

Size matters. At well over a foot tall, Sally is just
about the biggest dog I've ever met. I imagine she
thought her life was about to go from bad to worse
when she was yanked from a fast-food dumpster
and hauled off to an animal shelter.

At three months and three pounds, she flirted with
the right lady at the right time. Sally pushed her tiny
legs through her wire cage just as her eventual 'mama'
was passing by on the way to pick up a friend's dog.

Aristotle, who must have owned a mixed breed or two
back in his day, opined that the whole is greater than
the sum of its parts. Sally is a 'Sally', or, if you want
to get technical, a mélange of Chihuahua, poodle,
Tibetan terrier, bichon frise, and Brussels griffon.

I'm pretty sure that pedigree would preclude her
from competing in the Westminster Kennel Club
Dog Show.

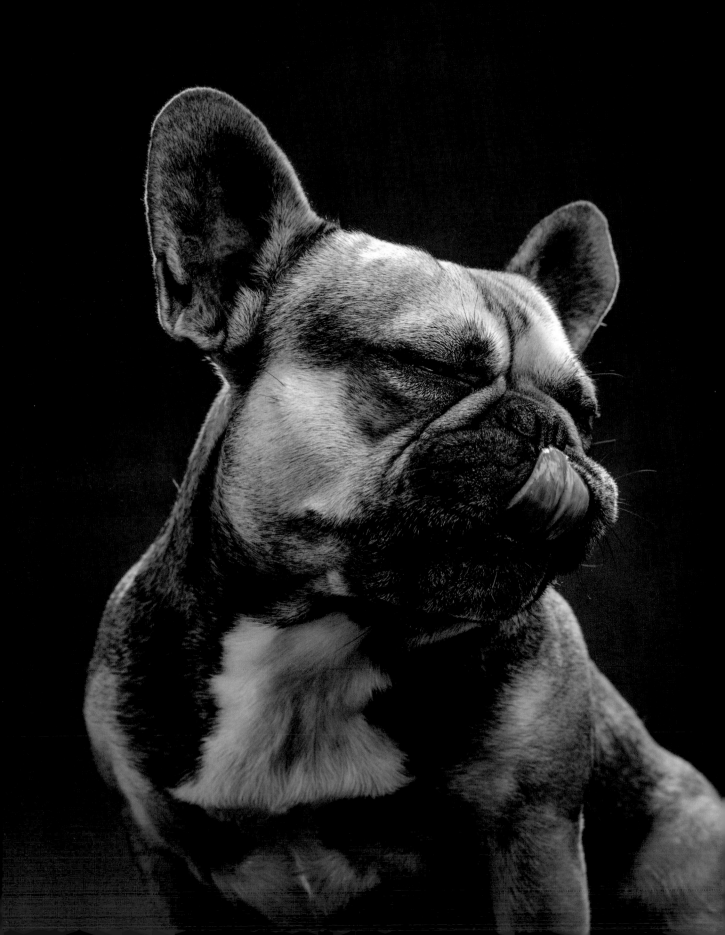

Larry

Yes, there's something about Larry.

The phrase *je ne sais quoi* is overused, but it's necessary in this case. I don't know exactly what it is about Larry, a two-year-old French bulldog loaded with attitude and good posture. Friendly as can be, but in a take-over-the-world kind of way.

You're either with him or you're not. I choose the former.

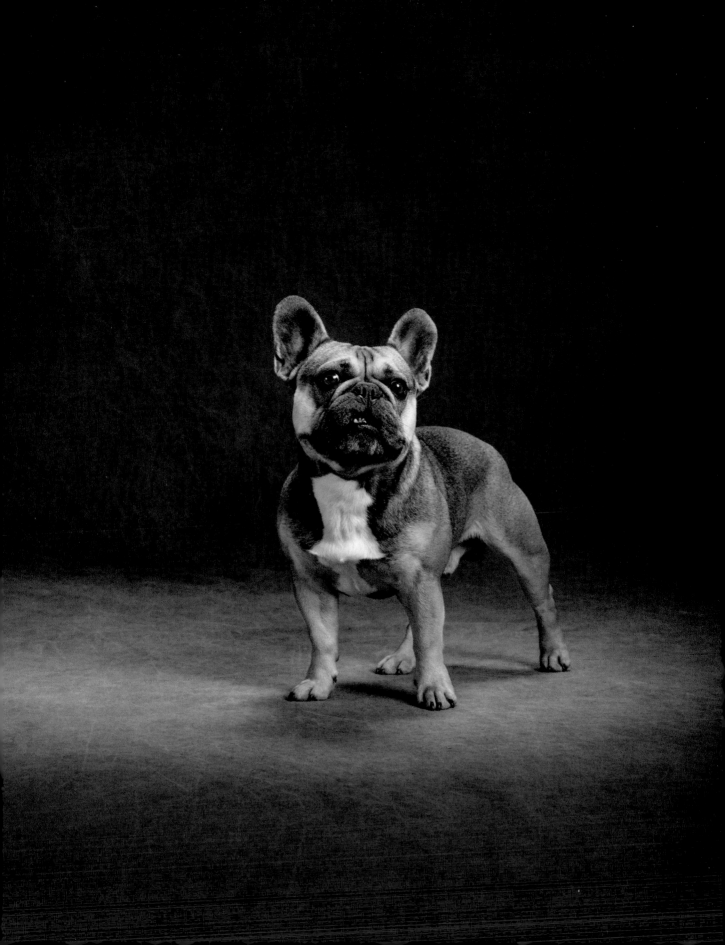

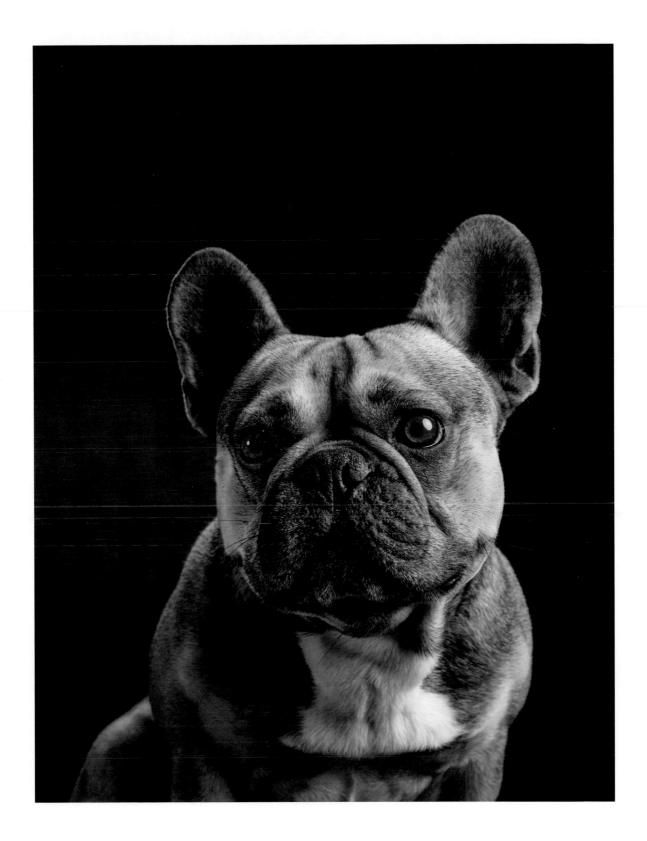

Tough Guy

This dog is smiling because he's a loser.

Anyone familiar with *The Simpsons* will also know the family's adopted dog, Santa's Little Helper, a former racer who got his big break on the show when he was abandoned at the track for finishing dead last.

Tough Guy, in his career as a racing greyhound, also lost far more races than he won – and to put it that way is far more polite than accurate. He was terrible.

While he might dispute this claim, well-intended documents were casually researched, revealing he won just twice in a career cut short by his shortcomings. His performance is embarrassingly detailed as 'faded, never-headed, tired badly under pressure, lost ground, out-finished, trouble throughout'.

Crafty and clever are two words you won't see used in these records, but what if Tough Guy was throwing his races all along?

I raised the question with Tuff, as he is known informally, and he responded diplomatically, with sincere apologies to all those who bet on him and lost.

In his new career as a family pet he enjoys a life of leisure, where he is rarely competitive but never finishes last.

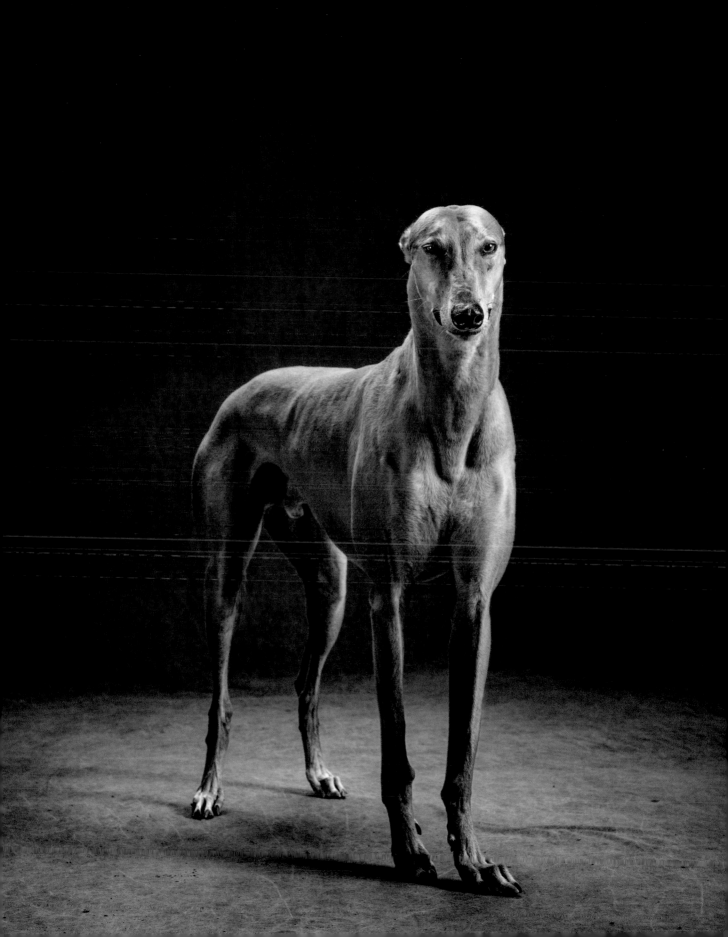

Dove, Bullet, and Bliss

My father always told me that bad things came in threes, yet there are many examples of good, if not great, 'threes' in history – the Three Stooges, the Three Amigos, the Tenors, Musketeers, Bears, Blind Mice, and even the Three Little Pigs.

All had nothing on Dove, Bullet, and Bliss: three lovely and talented Boykin spaniels.

As a rule, I try never to photograph more than one of anything in a picture; it's safer that way for all those involved. Yet, it was my brilliant idea to follow a successful session of individual portraits with this trio. Callie also thought it was a good idea. The patient and supportive owner of these pups concurred. Everybody thought this was a good idea except for the dogs.

I am often asked how we get the dogs to remain calm for these photographs. I am usually vague and secretive in my responses, because much of what I can share is restricted by nondisclosure agreements and other legal nonsense – it's proprietary information or everyone would be in the lucrative business of photographing dogs.

That said, a few DIY tips for trying this at home.

First, begin with a strong elevator pitch. You must sell the dogs on the idea and never show weakness or self-doubt. Convince them that this will be *great*. Second, be flexible and humble. This is really not a good time to cry or spout self-pity about how you used to travel the world as a *National Geographic* photographer. Also, shouting 'I DON'T NEED THIS' does not work as a motivational tool on any level.

Third, know when you're beat. When the dogs and your own wife turn on you, it's time to put the camera down.

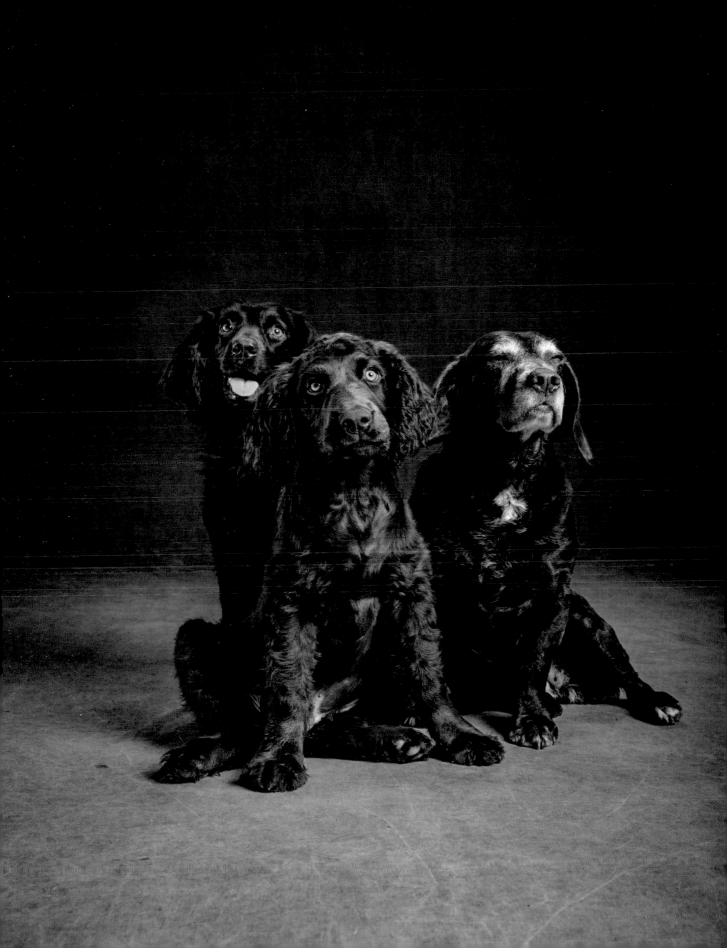

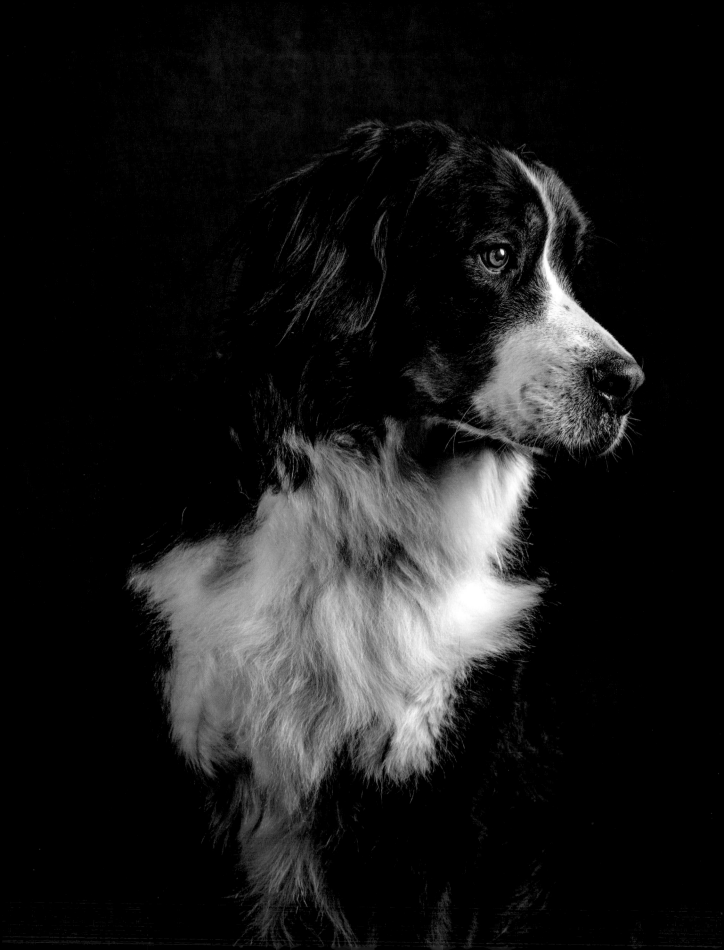

Tyler

Tyler is a handsome dog.

Good-looking, in a rugged, old-school leading-man sort of way with a chin straight out of Turner Classic Movies.

Do dogs even have chins anymore? I think not.

Compare Tyler to today's movie stars and he's right up there with any of the four Chris's of Hollywood: Evans, Hemsworth, Pine, or Pratt. Vulnerable yet masculine with a limited range of facial hair. All are as comfortable in a designer tuxedo as they are in a Gap pocketed tee. You would never see Tyler shove a paparazzo or get involved in a scandal with another dog's wife.

Tyler's a five-year-old Bernese mountain dog who speaks perfect English and is not stuck-up in the least. At home, he's a simple dog who makes sure that food isn't left unattended in the kitchen, sharing most of what he recovers with a deaf dog named Beezie and a blind cat named Whiskey.

At least that's what the supermarket tabloids say.

Macy

Macy, my next-door neighbor's dog, passed away recently. The sadness around here is one you'll be familiar with if your next-door neighbor had a dog like Macy. She was every bit of her thirteen years.

Sure, she might have been a little hard on squirrels in her youth, but over time she learned the value of a peaceful coalition. I've often wondered if it was the squirrels that aided her occasional escape over the enemy lines of the invisible dog fence.

Macy was a great family dog. She had an important hand in the raising of four children, the oldest of which conspired with us to make this portrait as a gift for his mom.

Despite a recent surgery, Macy worked through a routine of some of her better-known poses, most of which involved looking cute and begging for food. Family dogs are like that.

She will be missed.

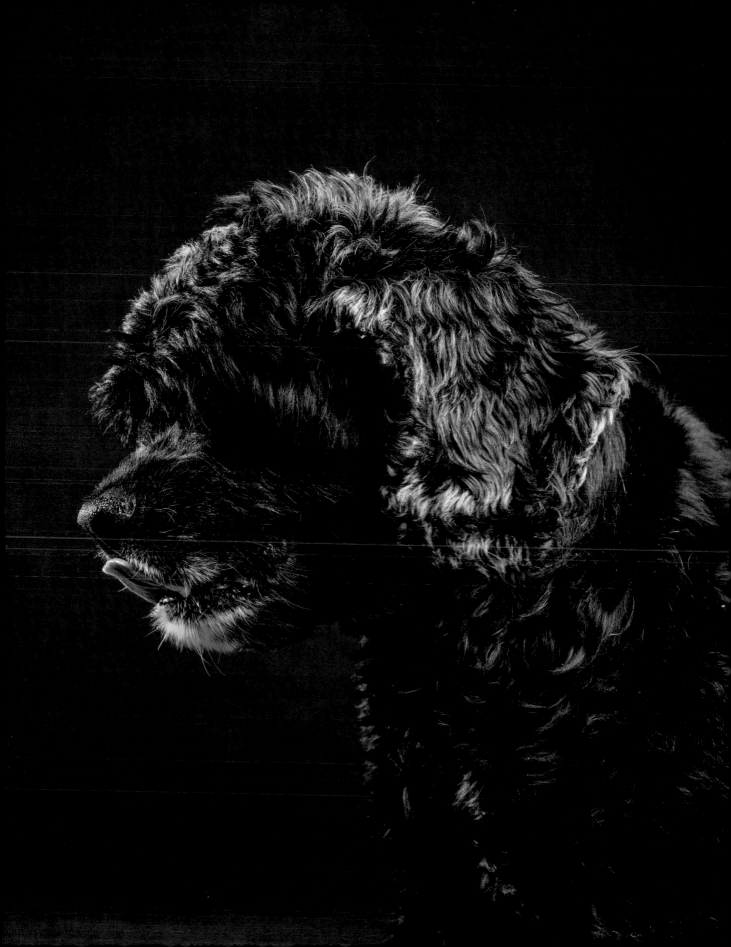

Henney and Pippa

Long before an old canvas became the backdrop
for my project, I photographed Henney out in a
field where she was far more comfortable doing the
things she was born and bred to do, like running
and retrieving.

She and her younger sister Pippa are German
shorthaired pointers, a breed that I learned is often
referred to by the initials GSP.

GSP sounds more like a trim upgrade or options
package on an imported sports car than a breed of
dog. I should think the GSP edition would come with
a faster engine, performance suspension, a flawless
navigational system, and a two-tone paint job.

These specifications are also true of these dogs, as
they are fast, durable trackers with great fashion sense
and style. Both are accomplished outdoor dogs with
good indoor skills. They have no fear of fluorescent
lights or children, both of which have been my
downfall at different times.

Henney was four years old when we made these
photographs. Pippa, the latest model GSP, was just
five months old.

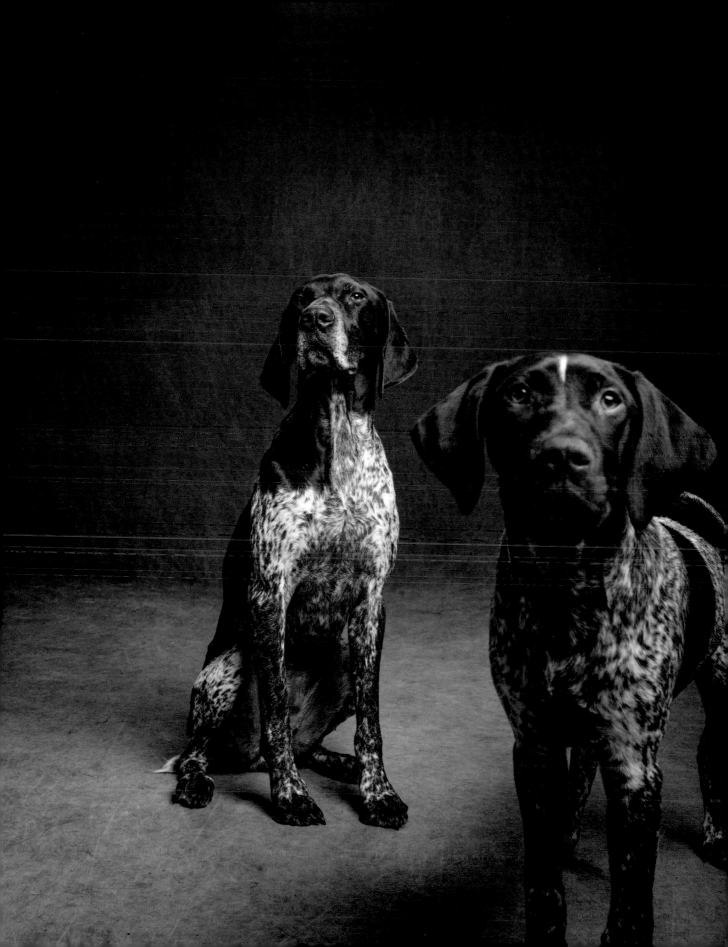

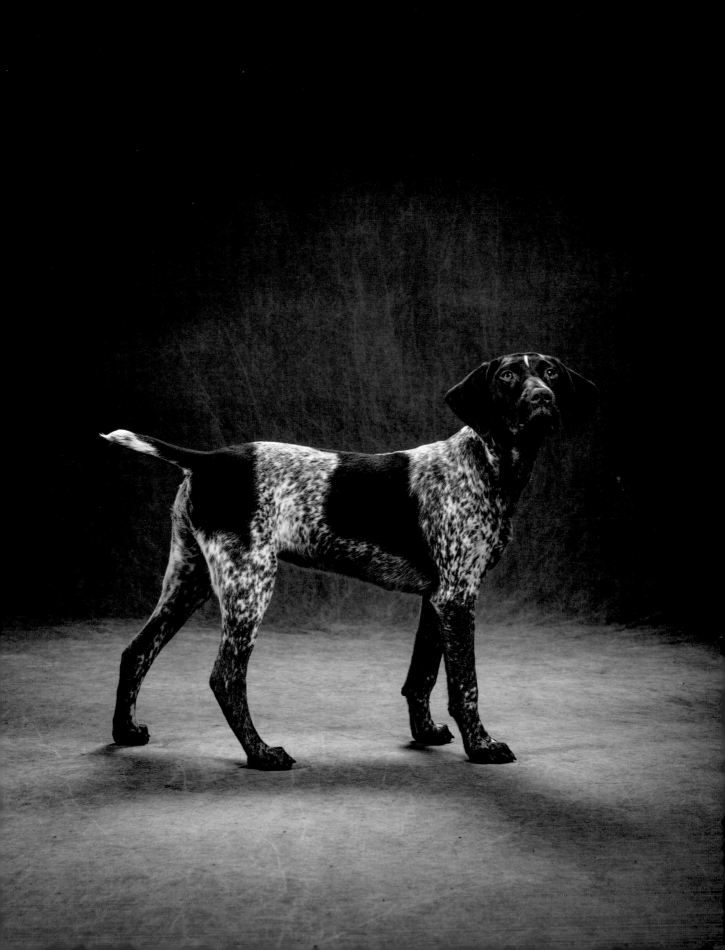

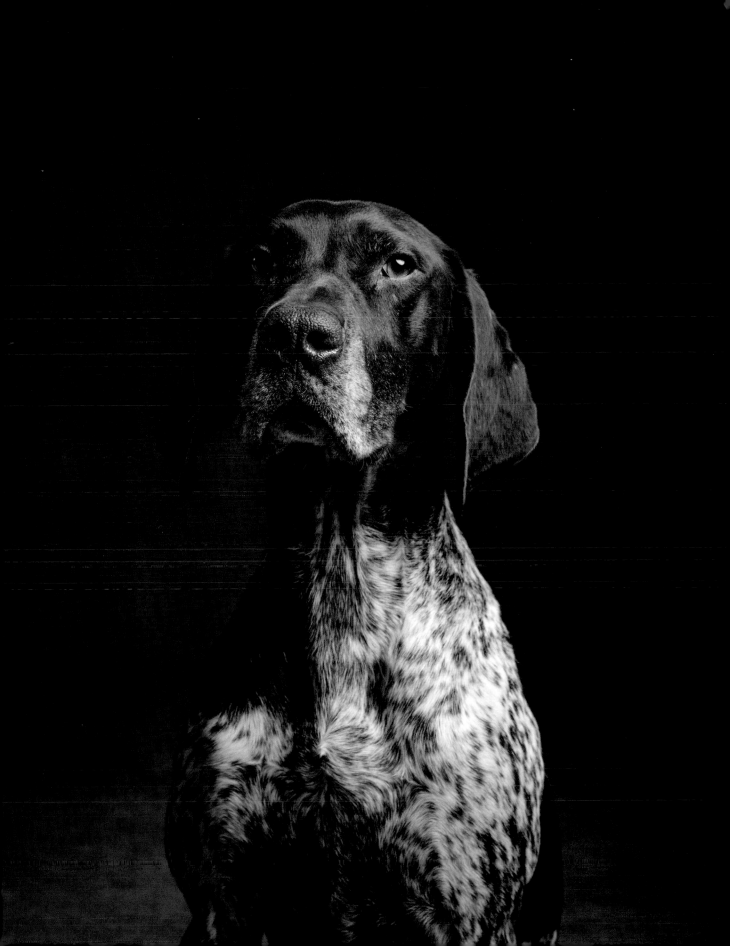

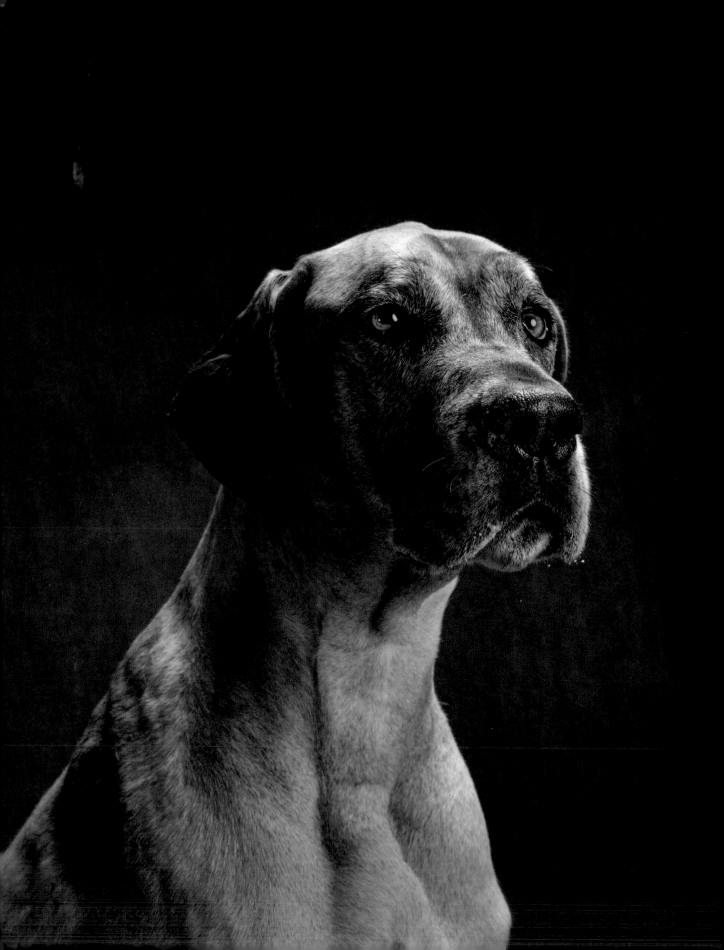

Anubis

Anubis is a massive rescued Great Dane who might easily outweigh your average high-school senior. She is a gentle, loving, and shy creature who can be afraid of her own shadow, particularly when said shadow is cast by a large piece of photographic lighting equipment.

Those of you familiar with the alternate dimension known as 'The Upside Down' from the science fiction television series *Stranger Things* will understand what it might be like for a dog to enter our studio.

I could easily be mistaken as the predatory Demogorgon, a grunting humanoid covered in dog hair who sprawls on the floor with a large camera discharging a lightning storm through an array of studio flashes.

It requires a huge leap of faith on a dog's part to trust us – a leap that can be directly measured by their level of food motivation or interest in chasing a squeaking, neon-colored tennis ball around a cavernous warehouse.

It doesn't always go smoothly. This is where Callie, my first assistant, loyal wife, and chief dog whisperer, takes control of the situation while I curl up in a ball, issuing statements about the end of my career to anyone who will listen.

These are just a few of the obstacles that even the most affable dog and well-adjusted photographer must overcome together to make it in *The Year of the Dogs*.

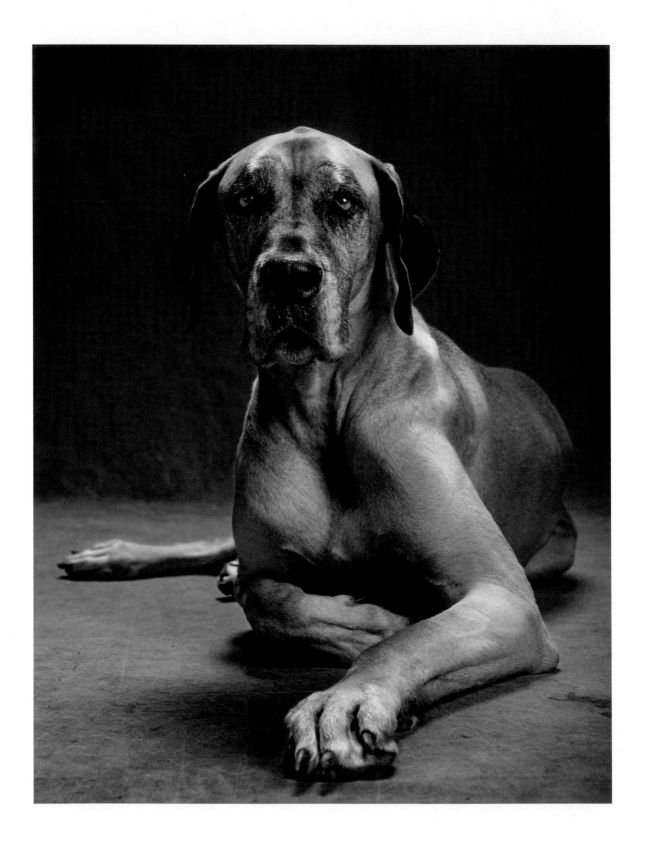

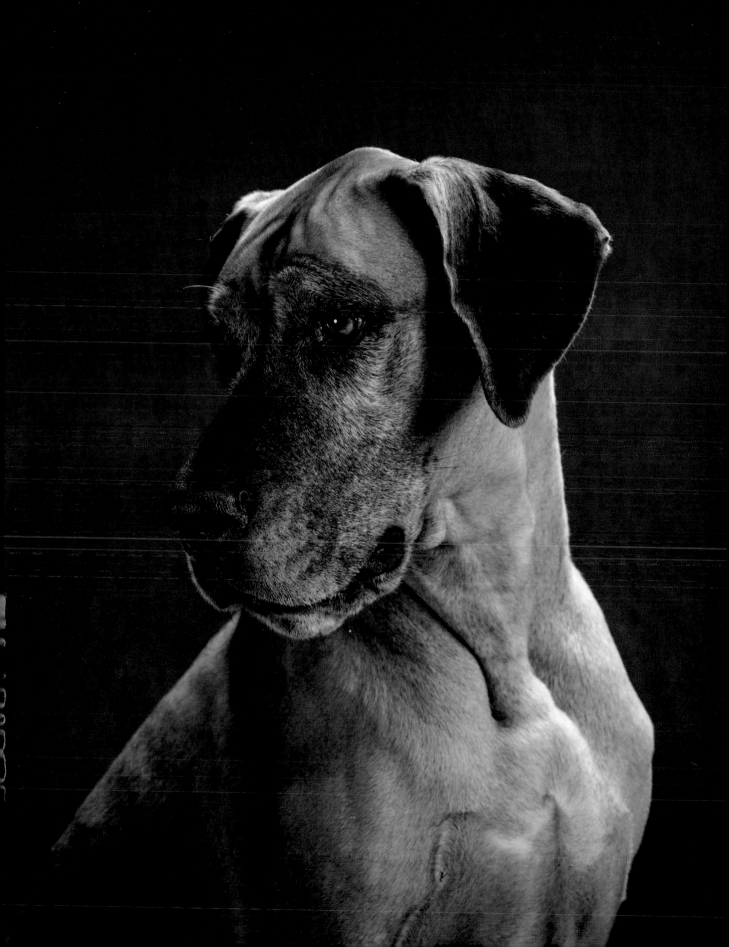

Vegas

The hardest thing is to get a dog to just stand there
and look at me. They all want to do dog things, like
sit, lie down, play, run, and jump.

I get it.

What I'm after is that moment, that pause – a
connection that can say so much about the soul
and spirit of an animal.

We had spent the better part of two hours with
Vegas, a very spirited fourteen-year-old greyhound.
This was the moment where she was alone on my
backdrop and looked around to see her owner for just
a second. Just a little reassurance that he would be
okay while she posed for us.

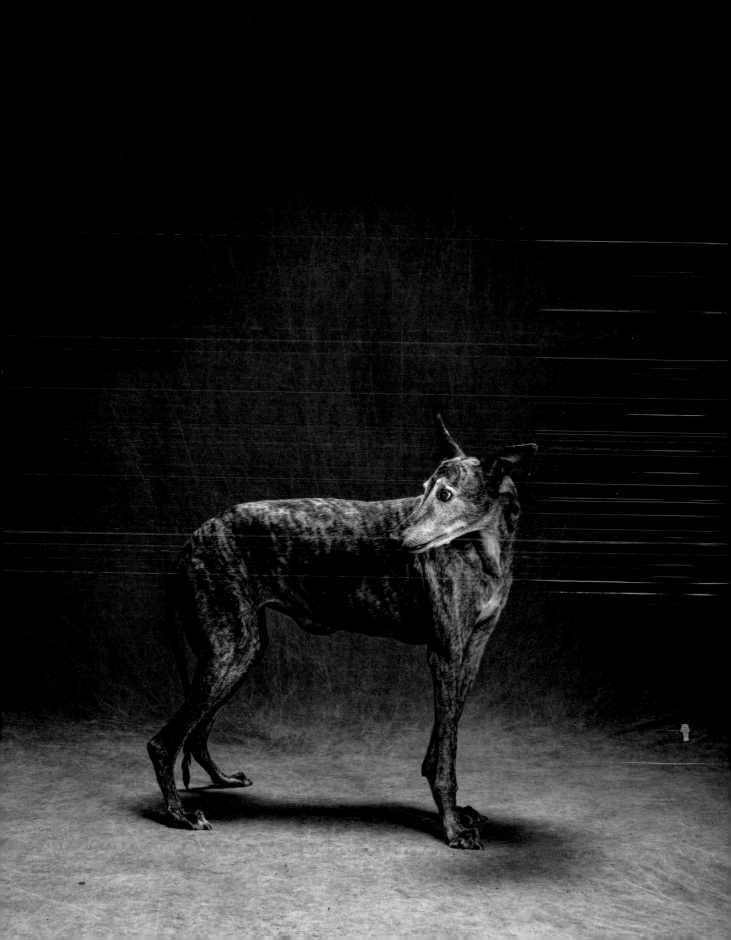

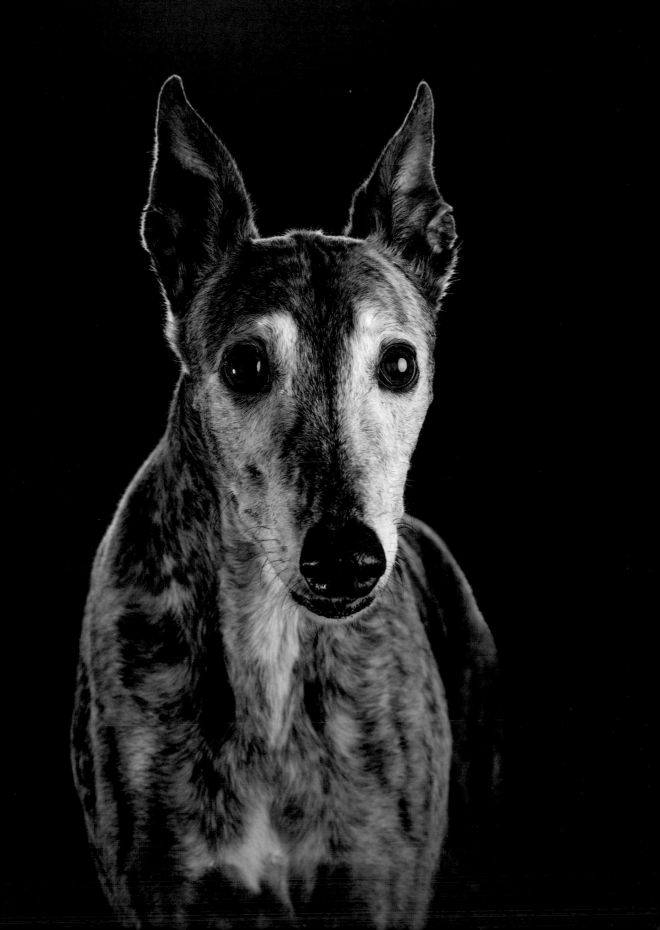

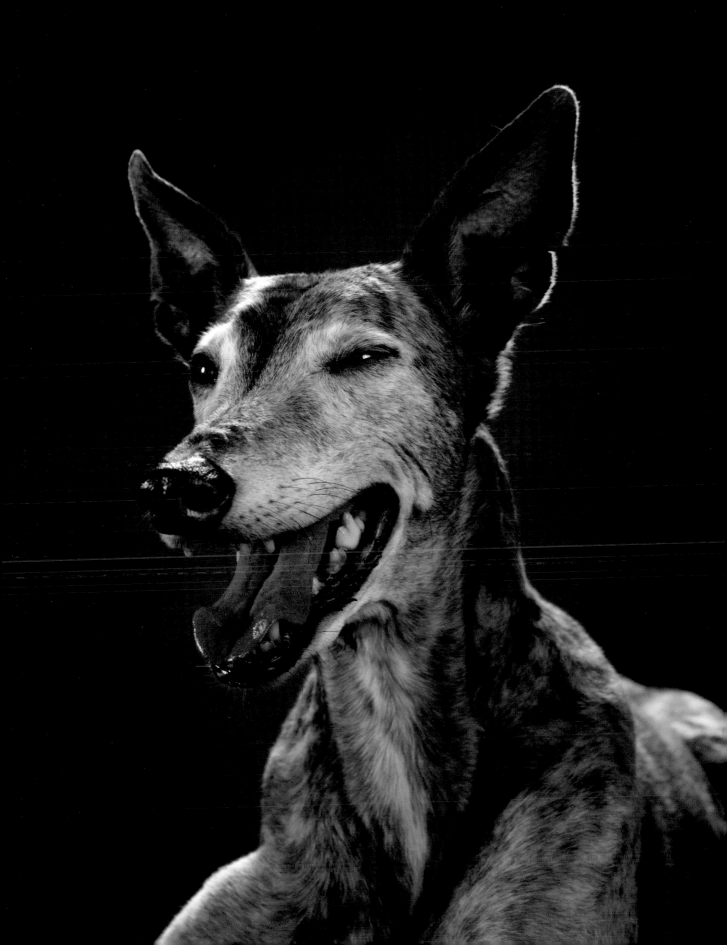

Tolliver

Dogs fart.

That's something they don't talk about in those famous-photographer master classes.

The professional in me says, 'Work through it. Just pretend that nothing happened and it will pass. Your eyes will stop watering . . . eventually.'

And then: boom. It happens again. Silent and deadly, without warning or apology.

When I was a kid, my father would blame our dog Chris for these unexplained disturbances in the force. Chris got blamed a lot.

Size and age have little to do with it. Timing, on the other hand, is everything. I'm at ground zero here with little Tolliver, directly in the impact zone of this French bulldog's indiscretions.

Eventually Tolliver's ears gave it away, like the tell from a crafty poker player. Semaphores that signaled his intentions, and provided instruction to anyone in harm's way.

To those of you who think I have a dream job – think again.

Tipper

Few people may remember the incredible Soviet space dog Laika, who was the first creature of any kind to orbit the Earth aboard Sputnik 2 in 1957. She was a mutt from the streets of Moscow, and went on to become a famous cosmonaut despite her death aboard the rocket.

Tipper is a four-year-old adopted mutt with aspirations of space flight. Yet she needs no spacesuit or even a rocket, as her propulsion system is internal, highly efficient, and runs on dog treats.

In what was planned as a simulated launch sequence with Callie acting as flight director, a premature firing of Tipper's solid rocket fuel booster occurred on a final round of go/no-go checks with the ground crew. At approximately T-minus nine minutes and counting, Tipper ignited and we had lift-off from the photo studio.

According to news reports, the poor girl sustained flight for approximately five hours and eleven minutes before re-entering the Earth's atmosphere, touching down in the South Pacific somewhere near Fiji, where she was recovered by NASA frogmen, shaken but unharmed.

Godspeed, Tipper.

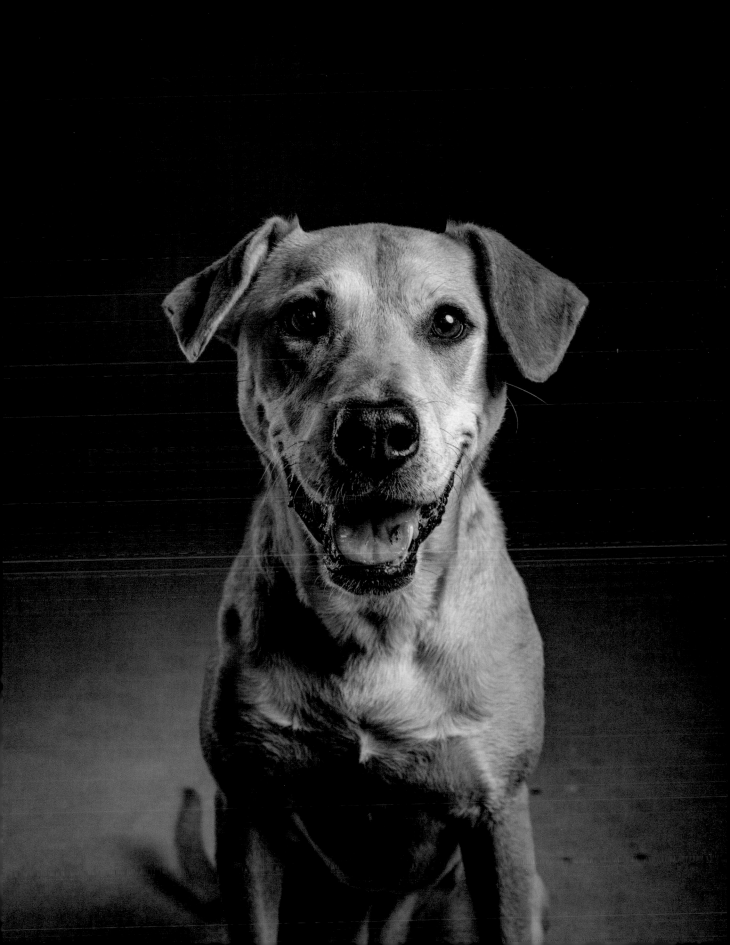

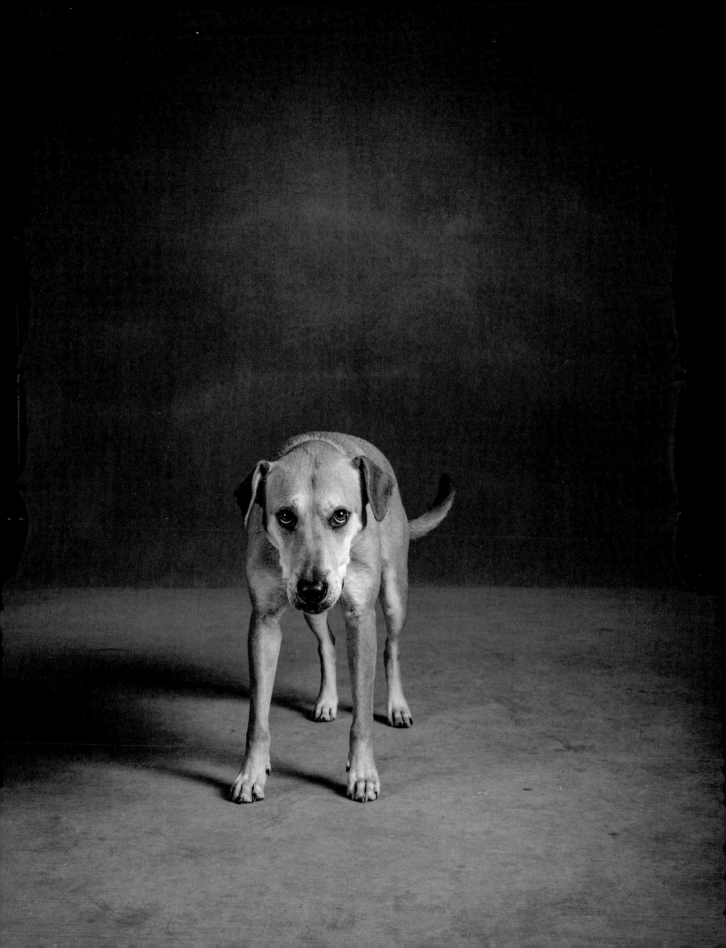

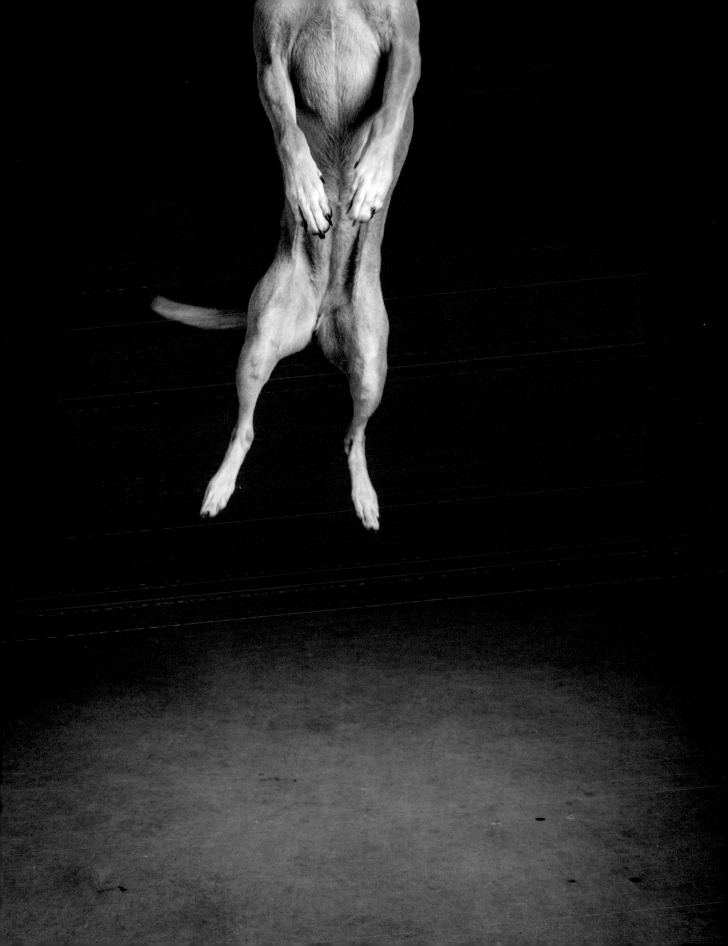

Ozzie

Four-year-old Ozzie is a Labrador mix who was found under a trailer and rescued as a puppy. He's a real rags to riches story.

He is our accountant's dog, and spends a lot of time working in her office. Ozzie is always a great help in preparing our annual tax returns as his knowledge of the tax code is expansive.

When things look bleak financially, Ozzie comforts like a therapy dog and reminds us to take important deductions for squeaky toys and dog treats as they are crucial components of our lucrative dog photography business.

When we invited Ozzie into the studio for a portrait, he exploited our fiscal weakness and used it against us for dog treats. Lots of treats.

We have the receipts to prove it.

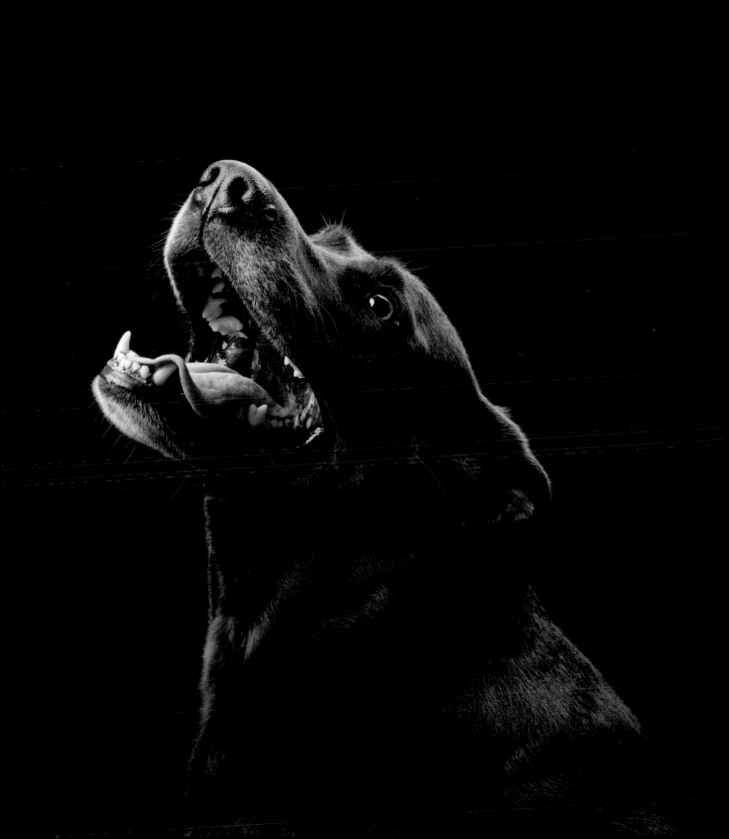

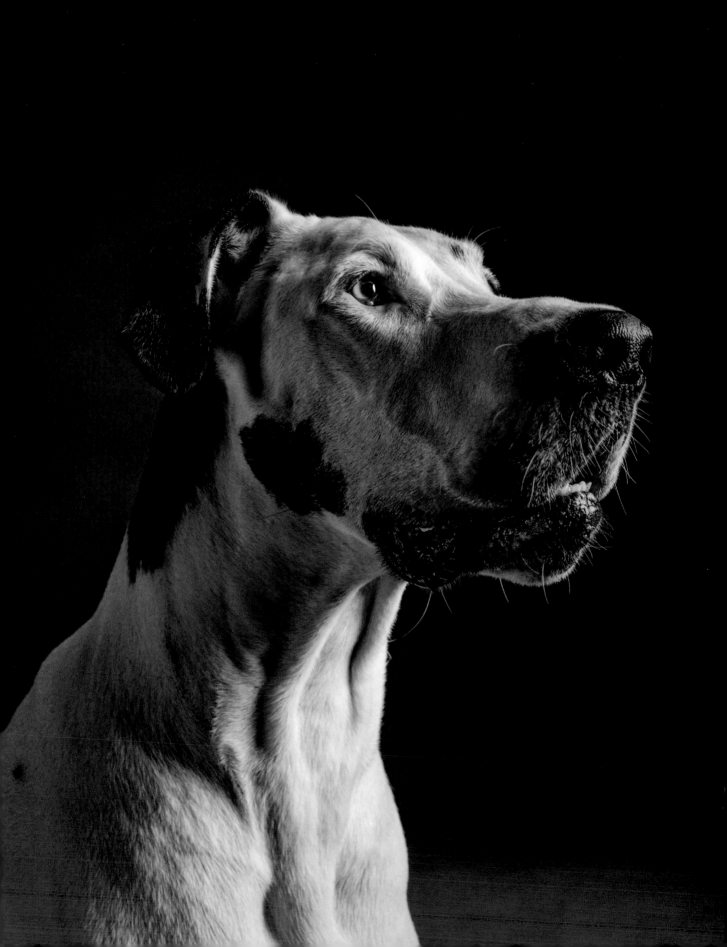

Monty

I have never water-skied, but I have been dragged
in similar fashion across one hundred yards or so
of concrete floor in our warehouse by a 135-pound
Great Dane that resembles Benedict Cumberbatch.

It would be politely accurate to say things didn't go well
the first time we tried to make Monty's photograph.
In fact, it was a bad day for everyone involved –
before, during, and after the dragging occurred.

Monty, a local celebrity with multiple aliases and a
rap sheet as long as her tail, was questioned about
the events leading up to the dragging of 26 April and
conveniently changed her story several times. She
has a public image to protect and it's a small town.

Eyewitness accounts support my sketchy claim that
I was the victim, but in an attempt to show Monty
who can be the bigger dog, we had another go.

The result, seen here, is Monty, a four-year-old
harlequin, a haute couture collage of textures,
tones, random colors, and occasional splotches
that are accented by one eye that is blue and one
that is brown – courtesy of a condition that is both
unpronounceable and strikingly beautiful.

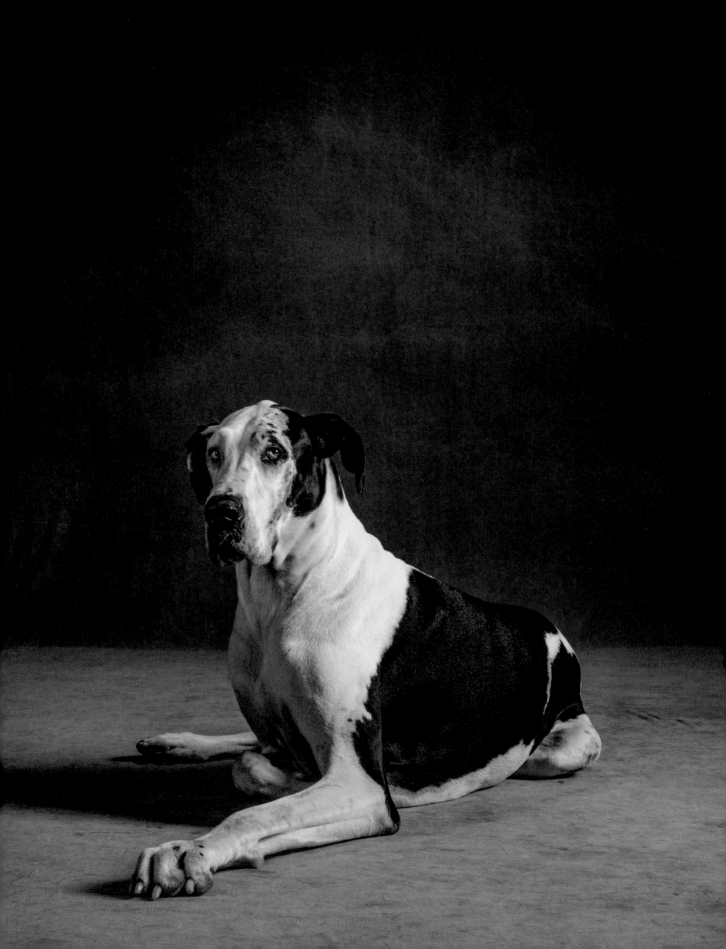

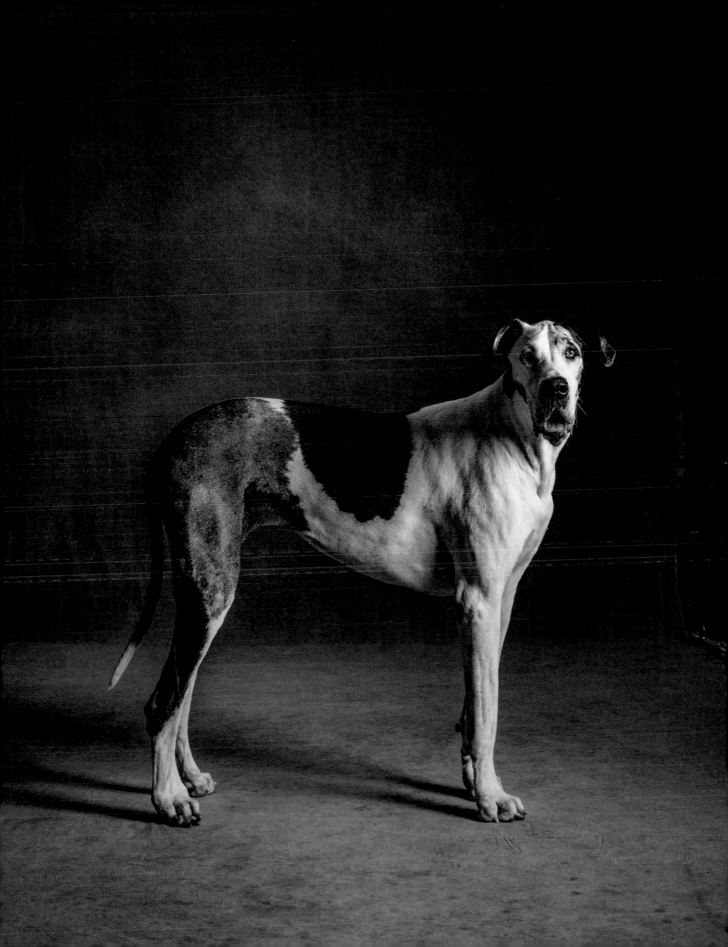

King

King is a hard name to live up to for a dog, or anyone else for that matter, and this four-year-old Labrador handles it well.

Expectations are generally higher if 'King' is preceded by 'the'. It becomes even more complicated when followed by the title 'of Something'. Fortunately King is just King, and he is benevolent in his role as king of all people and dogs who have pledged loyalty to him.

Titles are not important to King – balls are. You may interpret that any number of ways, but in this case I mean the kind used to play tennis.

In retrospect, we ignored all warnings. 'Ball', as we now know, was the trigger word that activated His Royal Highness. What followed was sixty pounds of dog hurtling towards a loosely hung canvas backdrop in a highly sensitive and fragile environment.

Scenes like this make you wish you had followed the directions on the label.

I can say that no animals were harmed or arrested during the making of these photographs. The same cannot be said for one Profoto Acute2 D4 flash head formerly known as flash head #B.

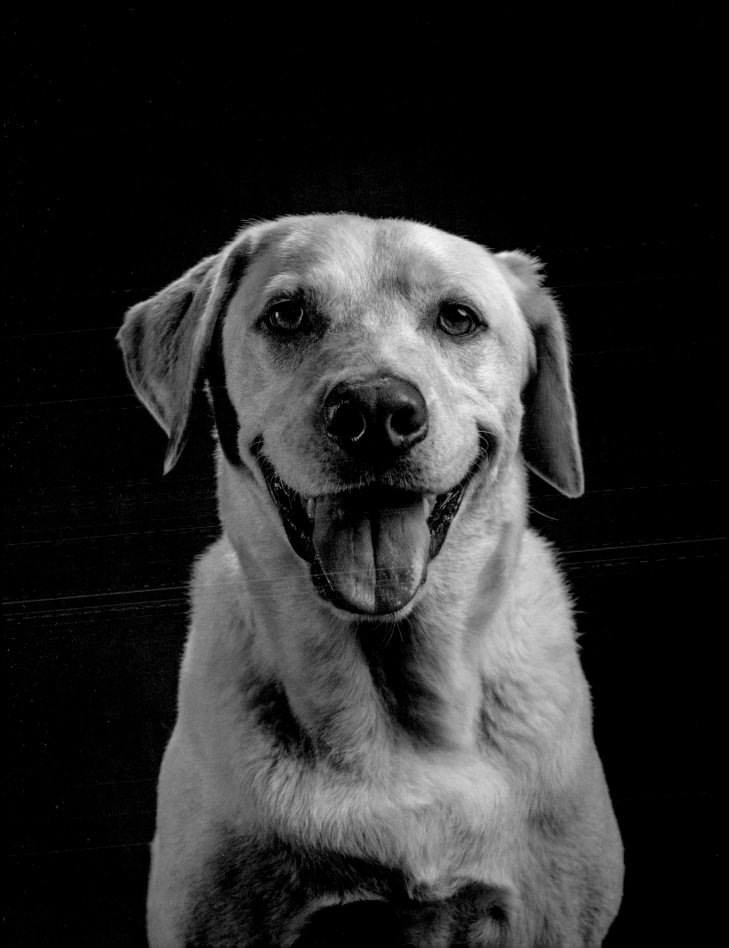

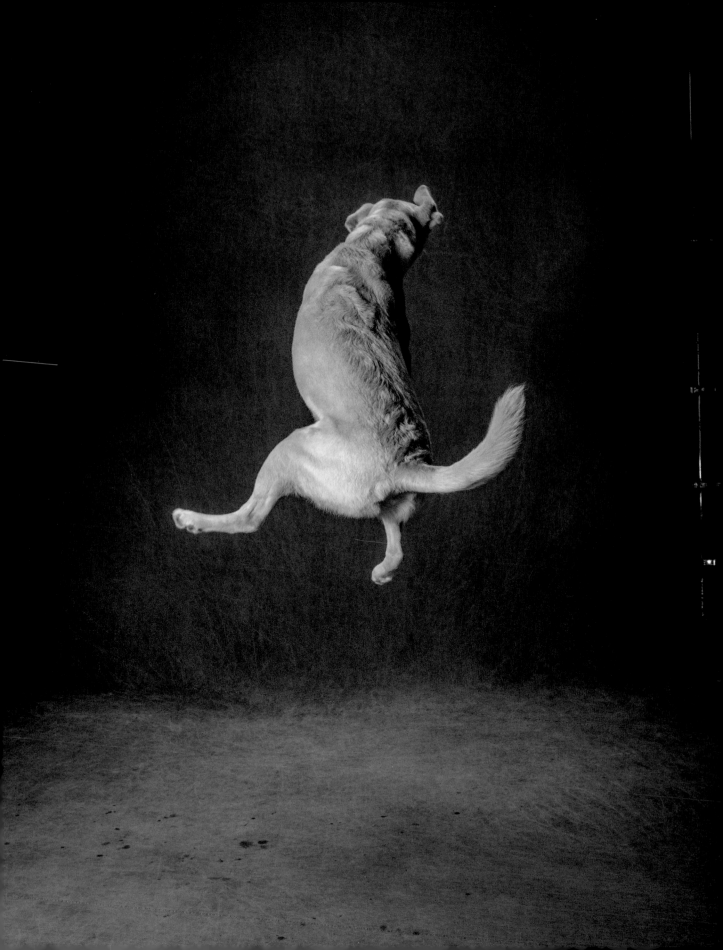

Cooper

The first time I met this dog, he barked like hell at me. That goes for the second and third times as well. There hasn't been a fourth.

I don't blame him. He's a fugitive. He's wanted in the state of Alabama but is holed up in a safe house in one of the two Carolinas. In either place, North or South, you can never be too careful, no matter how miniature a schnauzer you are.

Cooper is kinda related to me, as much as any dog can be considered kin with privileges. This photograph was planned as a birthday present for Callie's niece Hartley, Cooper's owner.

So happy birthday to young Hartley, who, in her youth, thought it would be a good idea to smuggle this once bottle-fed rescue pup into her living quarters and daily routine as a student of higher education.

This, as you might imagine, was frowned upon by some and acted upon by those who owned her living quarters. They drew attention to the part of the lease that said 'no dogs were allowed', no matter how cute. Desperate times call for an equivalent response and here we are, with Hartley getting these pictures and her parents left holding the dog.

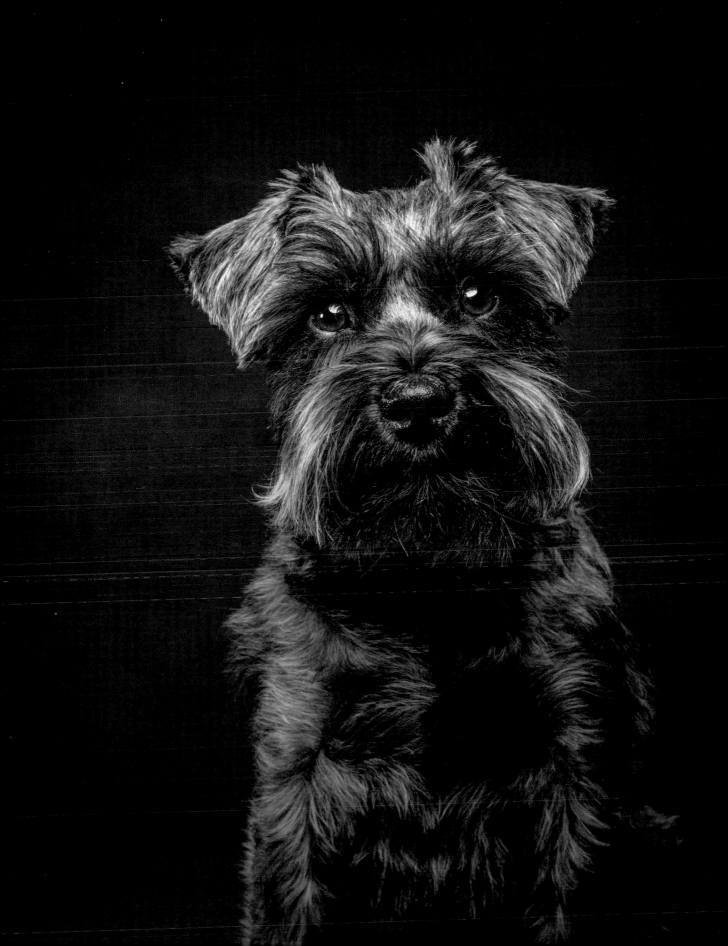

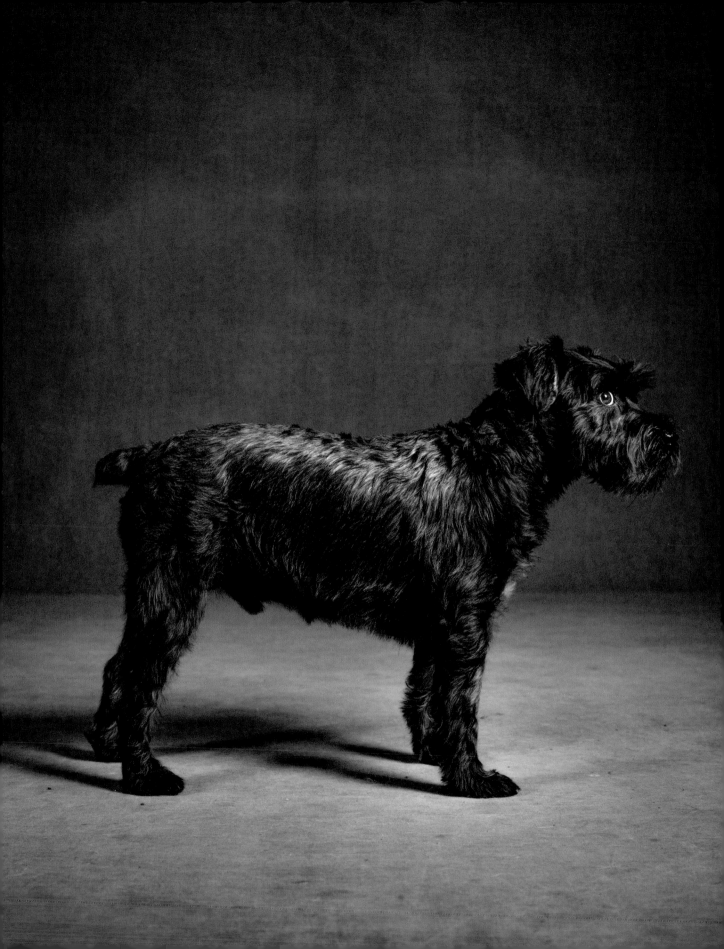

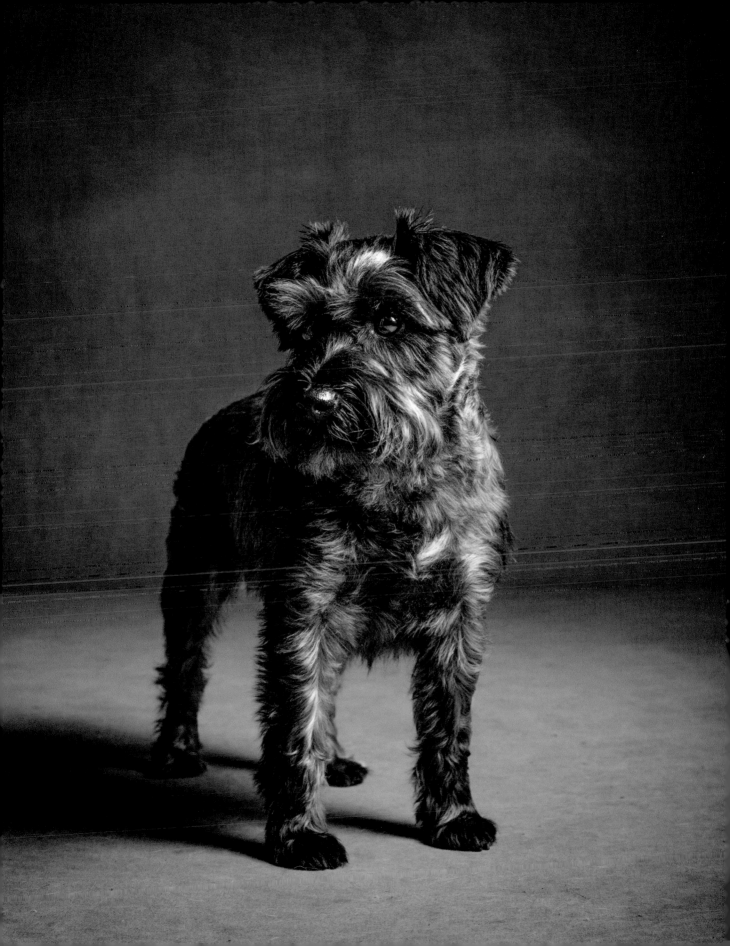

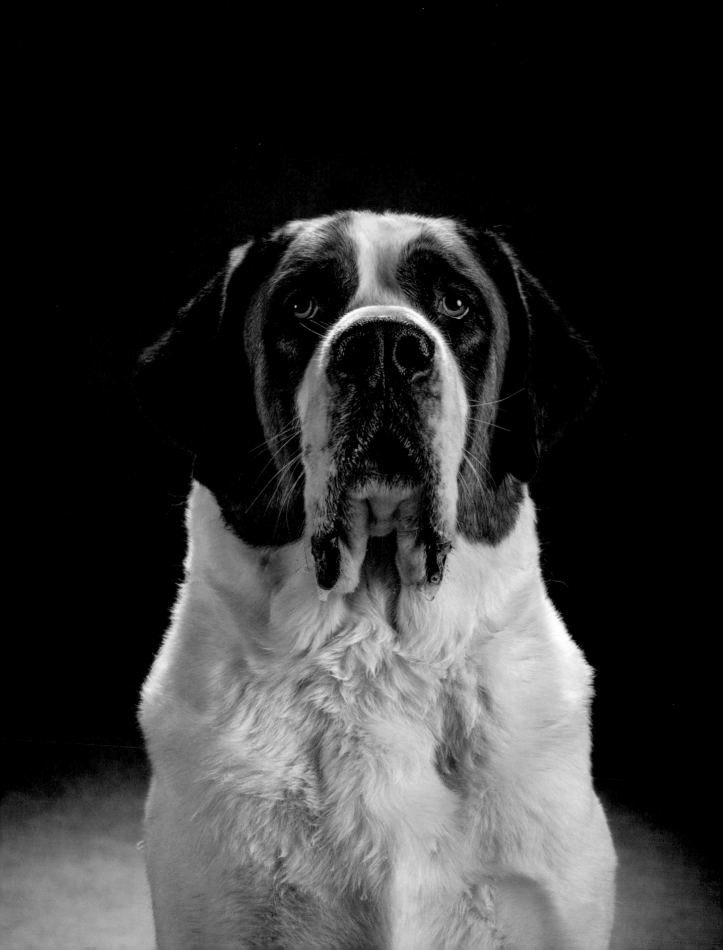

Bear

I knew Bear was going to leave a mark. Callie has become a regular at the neighborhood laundromat where they have those enormous washing machines that can handle 250 square feet of canvas splattered with Saint Bernard drool.

When I first started dating Callie, I secretly wondered if she and her siblings were raised by a pack of Saint Bernards. The dogs are prominently featured with the children, outnumbering them, in every family portrait. I imagined the dogs driving the family down to the local photographer's in one of those station wagons with the wood-grained panels. 'We're getting our picture made today, kids,' the dogs might announce. If the kids behaved, the dogs would pull out ice-cream cones from one of those wooden barrels slung around their necks for lost travelers and cranky kids.

When four-year-old Bear came to us, the whole story was far too complex to recite, but I can say it's a tale of two souls who found each other, who needed each other, and who saved each other.

Shot, terrorized, and left to die, Bear was emaciated when he was found roaming the streets with a twisted stomach and a couple of bullets in him.

In another town, a young woman struggled to break free from the grasp of paralyzing depression and anxiety. She needed help and the dog needed her.

So as veterinarians worked to put the dog's body back together, this young woman went to work putting his life back together. And as Bear's physical and mental scars healed, so did hers.

They rescued each other, and although they both face challenges from their pasts, I'm pleased to report they are in good health and nearly inseparable.

There are times when a dog is going to leave a mark. This was indeed one of them.

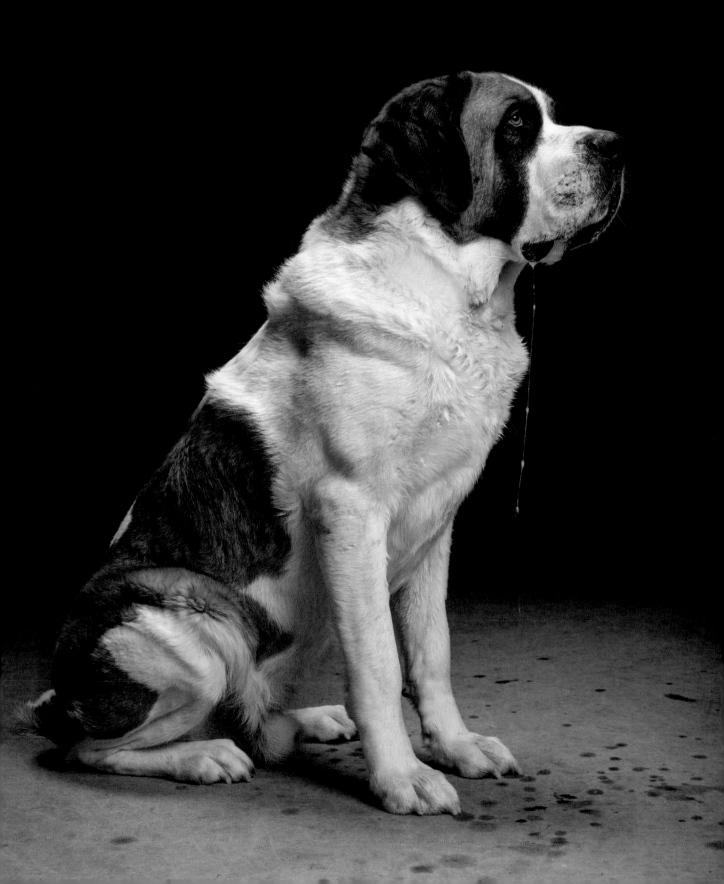

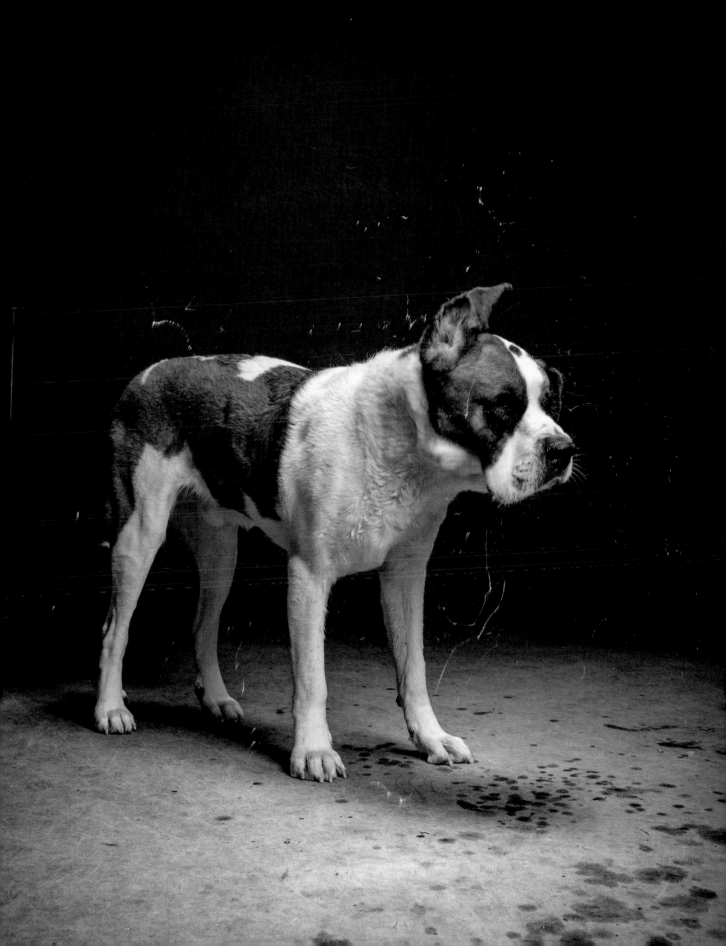

Clyde

If unfurled with caution and stretched with a sense of purpose, Clyde's tongue easily spans the length of a time zone. He doesn't reveal the entirety of it for fear of autograph hounds and other publicity-seeking breeds.

Clyde readily demonstrates that his tongue is indeed retractable, but only so far. It usually stops a few inches short of its intended destination, like the power cord on an old vacuum cleaner.

There's a lot of bull and dog in both of us, but for all of our creative differences during the shoot, Clyde's patina is well earned. His personality is greatly influenced by gravity and a weakness for bacon-flavored treats.

Big shout-out to Callie on this one as Clyde can sure drink a lot of water – he just doesn't hold it as long as he once did.

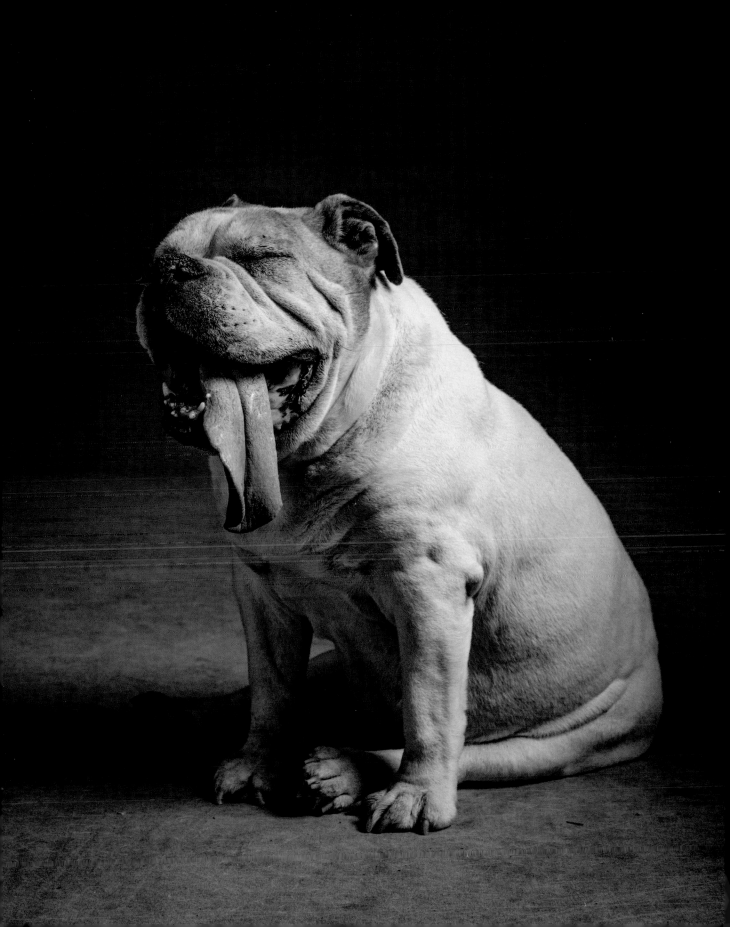

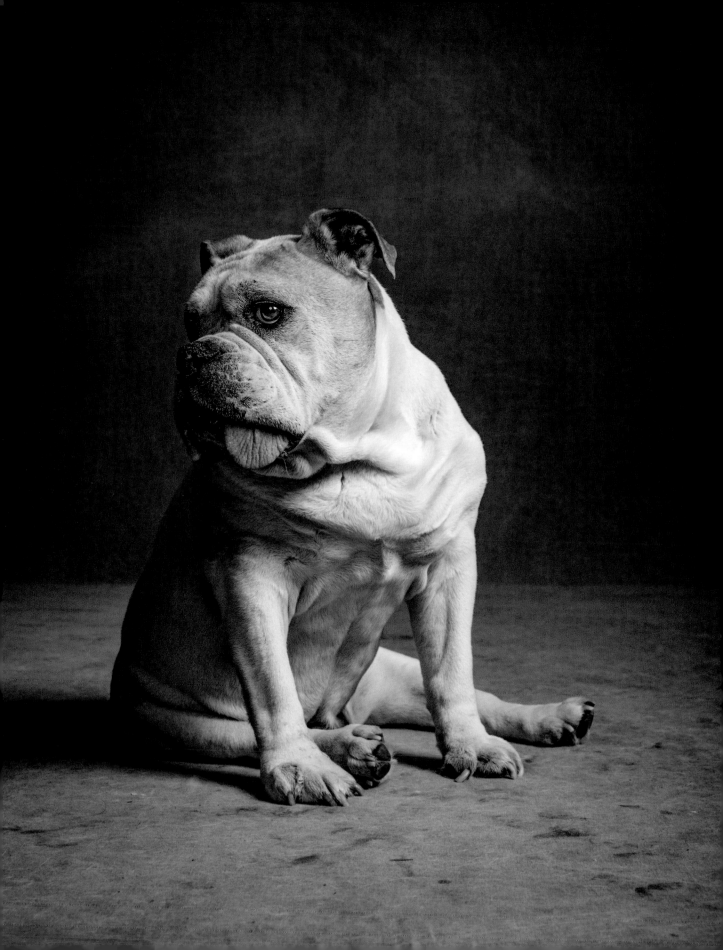

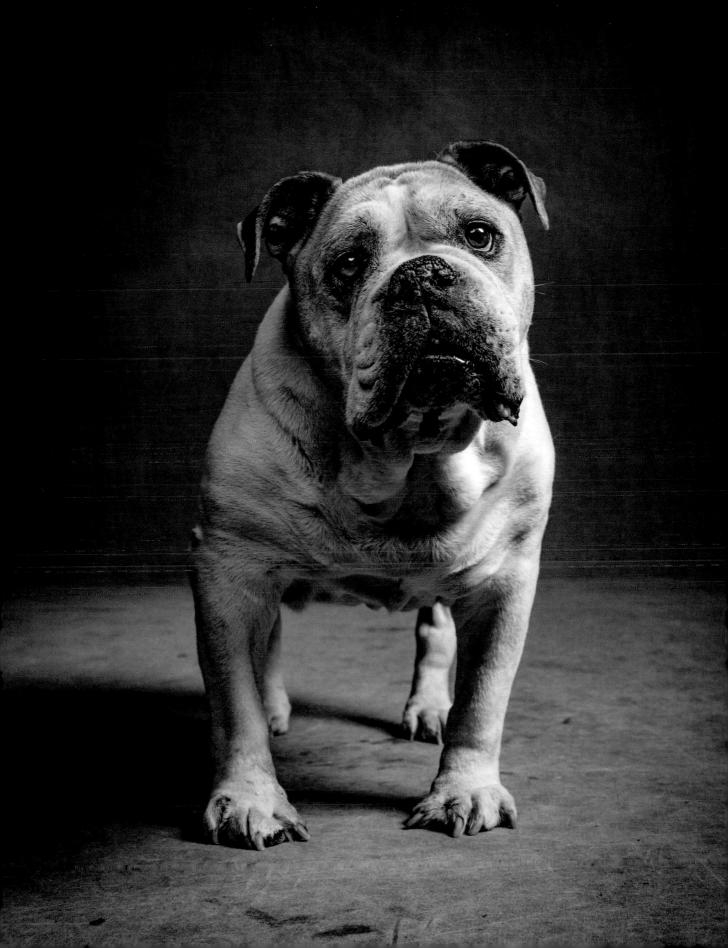

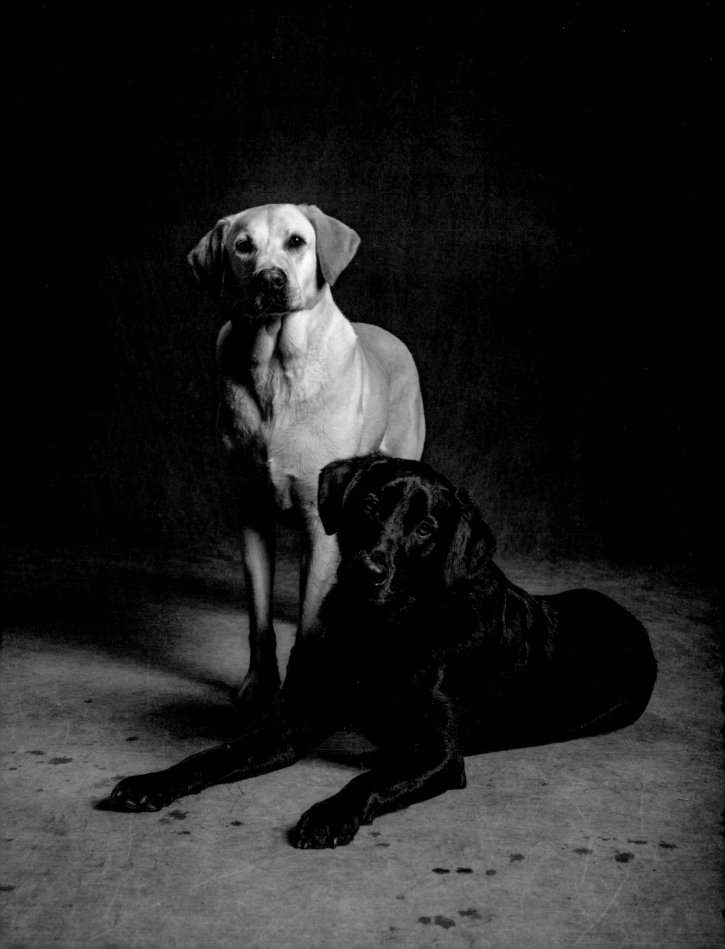

Sawyer and Ozzy

Sawyer and Ozzy, eight and two, are well-mannered
Labradors of different colors who get along just
fine and always have.

This photograph reminds me of what a jerk I can be.
For the record, it was very wrong of me to make fun
of my classmates who toiled away in various studio-
lighting classes in college.

I never took any of these courses, and Sawyer and
Ozzy, who deserved better, certainly wished I had.
You could see the disappointment on their faces.
As a young photographer, the studio was the one
place on campus you would never find me. The class
assignment that drove my colleagues to tears was
something about a dark object and a light object in
the same picture.

I will admit that I rarely agree to include more
than one of anything in a photograph, yet Callie
often reminds me that in business the customer is
always right.

I wish I had some valuable piece of wisdom to share
here, some parting advice. The truth is I'm just damn
lucky – lucky that we made this photograph and lucky
that my friends from college are still speaking to me,
as are Sawyer, Ozzy, and Callie.

Sophie

I'm going to come right out and say it: I have a crush on Sophie, in a girl-next-door kind of way.

When I was a boy, I had a crush on Sandee, an actual girl who lived next door, but I was a number of years her junior and it was never going to work out. Now Sophie's no Sandee, but she's funny, friendly, and intelligent too. I only wish I lived next door to her.

While difficult to see in a photograph, her fleece is plush and as white as the snow that occasionally falls here in the south – which is to say it is more of an eggshell color – and contains a higher thread count than that of most dogs you meet.

She's a sweet two-year-old teddy bear English goldendoodle, which is a breed name that sounds made-up – but I can assure you it is as real as Sophie.

I recently spent a delightful afternoon with Sophie in the studio, but I haven't heard from her since. It might be the age difference. If you happen to see her at the local dog park, would you ask about me?

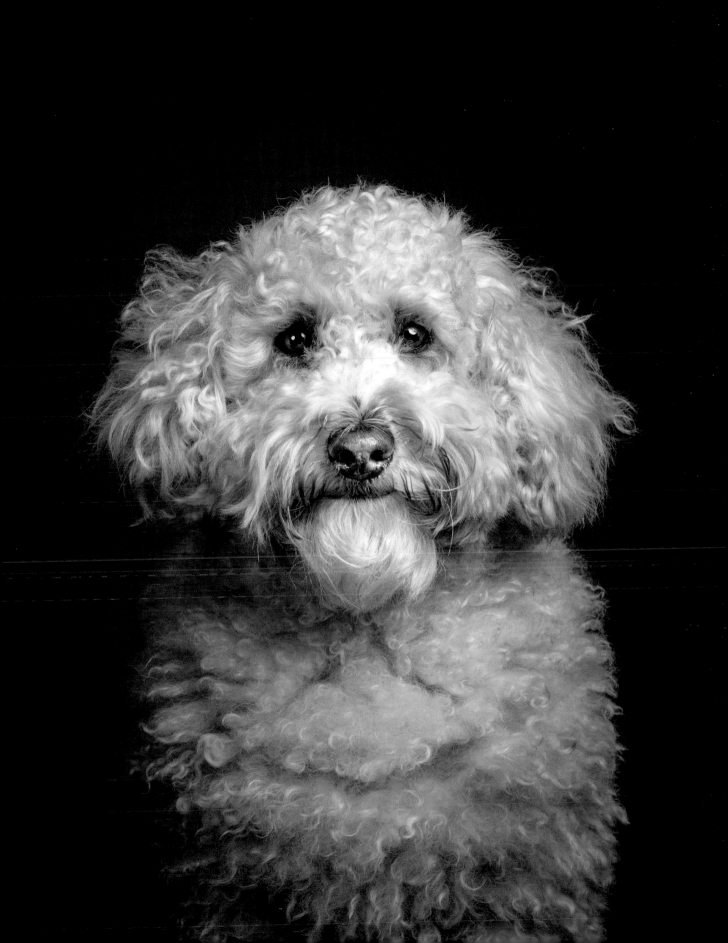

Dovewood's Millie

When I was in college, I worked for a short time
as a disc jockey for a radio station, back when you
extracted vinyl records from their sleeves and played
them at random and with abandon. My shift was from
11 p.m. to 7 a.m. Maybe that's why I never graduated.

Unlike me, Millie's educational background includes
graduation from obedience class.

She is conversant in a range of instructions, the most
significant being 'Wait', which, to be effective, must
be performed with an assertive voice and an index
finger held within eyeshot. Pleading, incidentally,
does not work, but was attempted numerous times
before we understood that presentation of said index
finger is as important as the message.

Millie is a five-year-old Boykin spaniel, which is our
state dog in my adopted home of South Carolina.

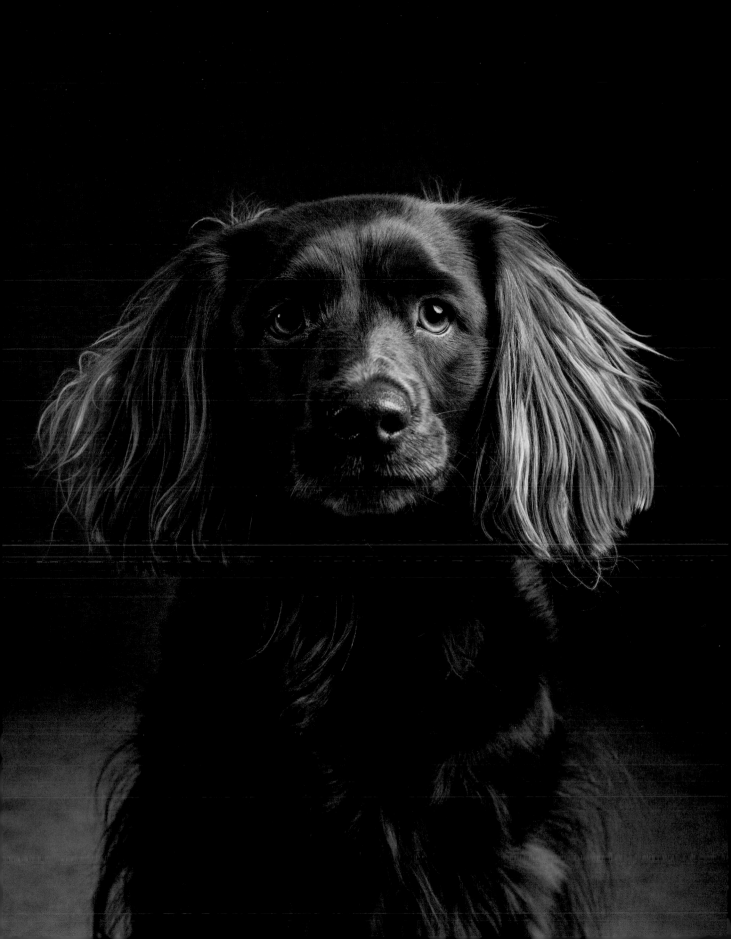

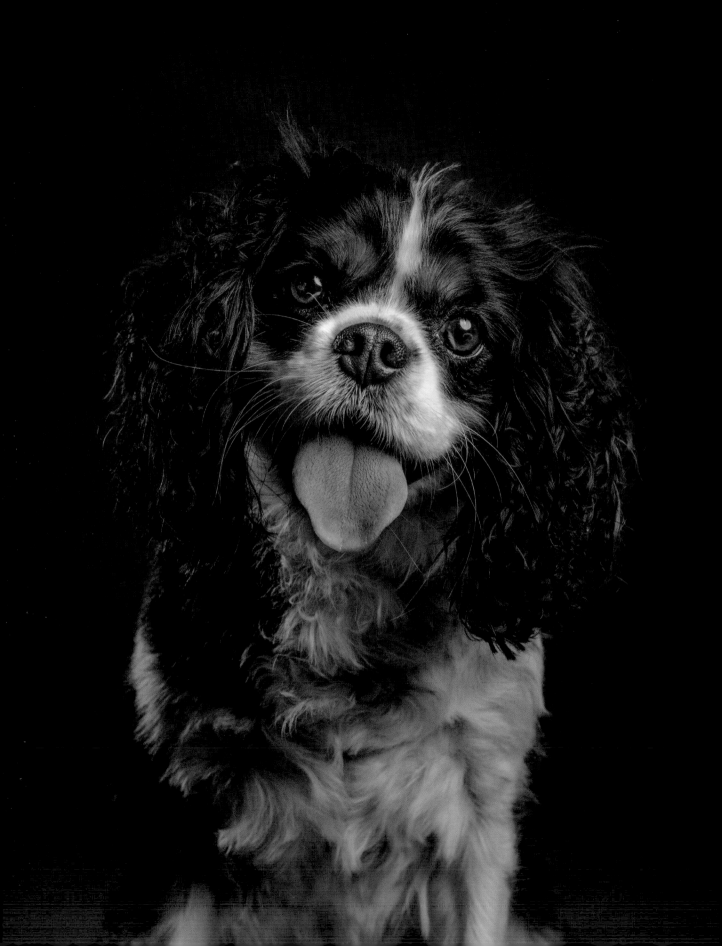

Nessie

Those of you who think a sweet dog like Nessie would never try to escape would be wrong.

Callie and I pride ourselves on our elaborate precautionary measures, but perhaps we didn't follow protocol the day Nessie showed up. She posed for one photograph and then made a break for the door, reminiscent of a thoroughbred barreling down the home stretch at the Kentucky Derby.

This was not expected, as you might expect. It could be the whole 'cavalier' part of being a Cavalier King Charles spaniel. More likely is the connection to her namesake, the fabled Loch Ness monster, who also posed for one photograph and was never seen again.

Fortunately, our 'Loch Nessie' was found, returned, and photographed without injury or arrest.

Django

This looks a lot worse than it was.

Django is a tiny Maltese with a huge personality.
It's just that there are limits to good behavior and
we are always trying to do better.

At times like these, it's important to remember
the dog is always right.

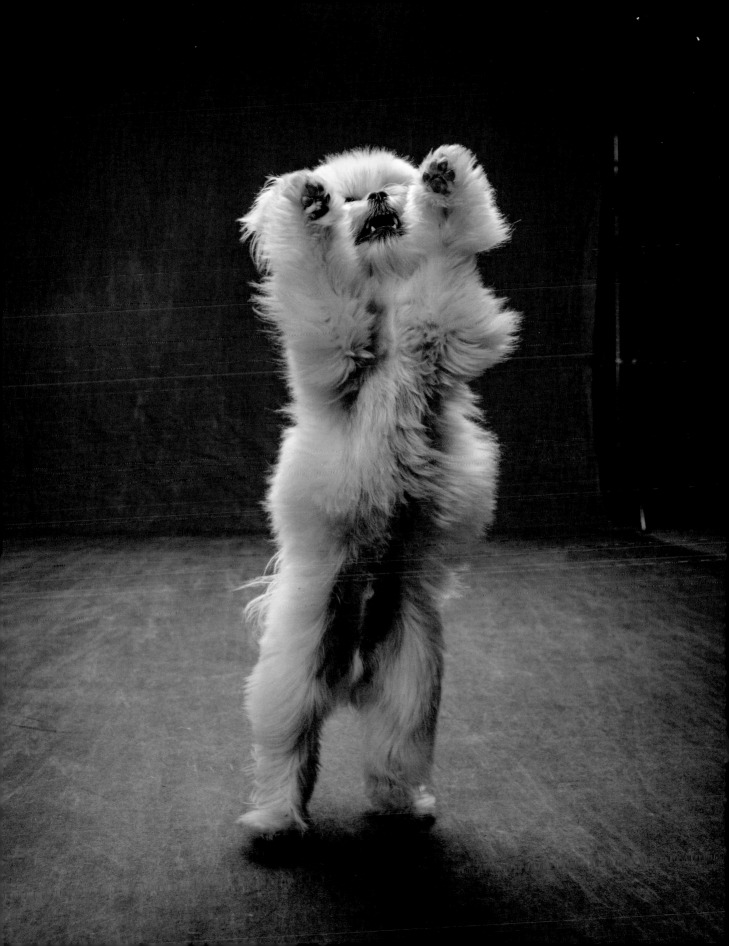

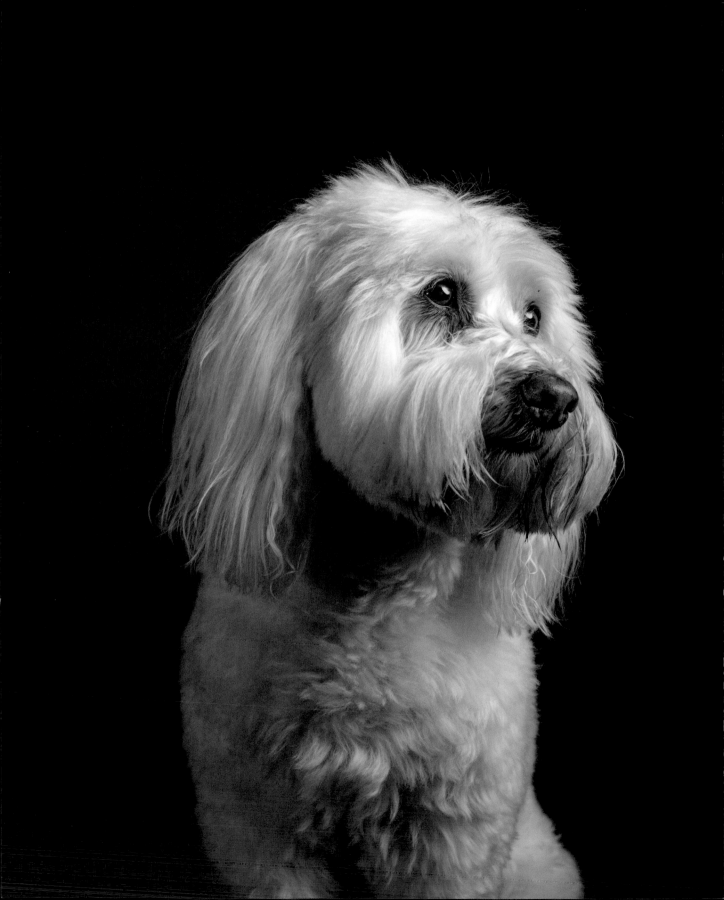

Jack

This gentleman is an eleven-year-old Coton de Tuléar, which is pronounced 'EE-lev-N-Yeer-Ol koe-tondeeh-two-lay-ar'. Or you can just call him Jack, which is pronounced 'Jack'.

Jack is a traveler. He came to our studio from far away in the pursuit of fine dog photography and inspiring conversation. Callie prepares me for such visits with briefing materials – a packet of background information, such as the head of a major corporation might expect.

It's worth mentioning that Jack didn't shed when he was in the studio, despite some saying these dogs have hair rather than fur (which I still don't completely understand or have any interest in because I'm not bothered by things like dander or shedding).

Hair or no hair, we enjoyed our time with Jack, a clever dog who has used his hypoallergenic talent to his advantage by uniting a family around him that might otherwise not have been able to have a dog.

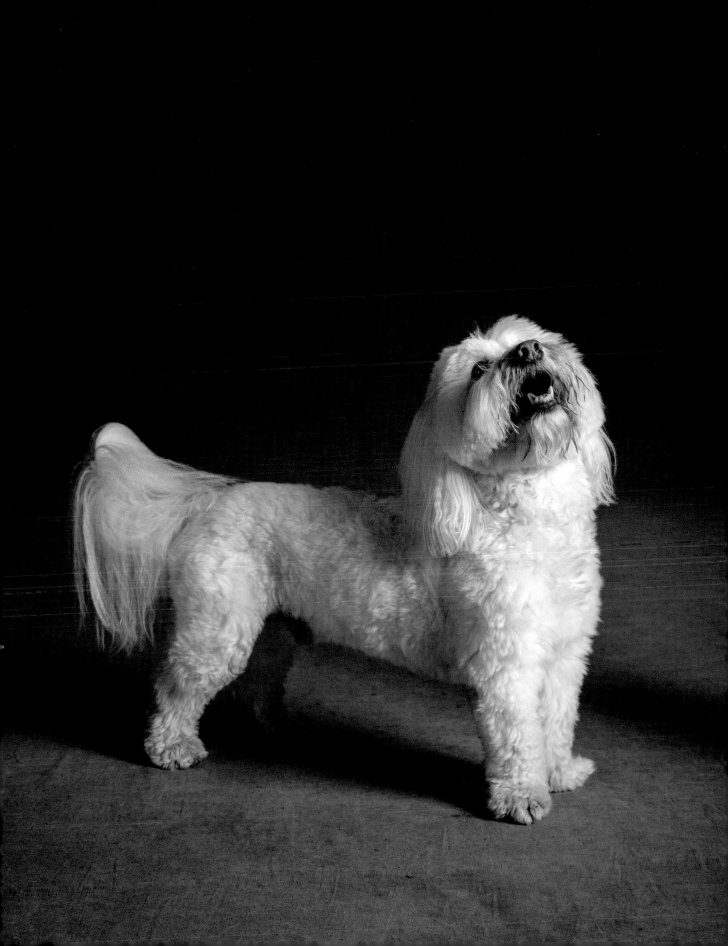

Boomer

Boomer, or Sir Boomer, as he is likely to be known after this reaches you, frequently serves as a knight of the wall, perched outside a local Irish pub like a steward from *Game of Thrones*. Dogs, no matter their royalty or family lineage, are not permitted inside such establishments in the kingdom of South Carolina.

As a knight of the island where we live, Sir Boomer is as loyal and dedicated as all retrievers of Labrador are known to be. His yellow coat is a symbol of respect and authority in matters relating to or disputes among the citizenry.

He does not smoke or drink, but he does snore like a sailor – which is not meant as an insult to him or sailors.

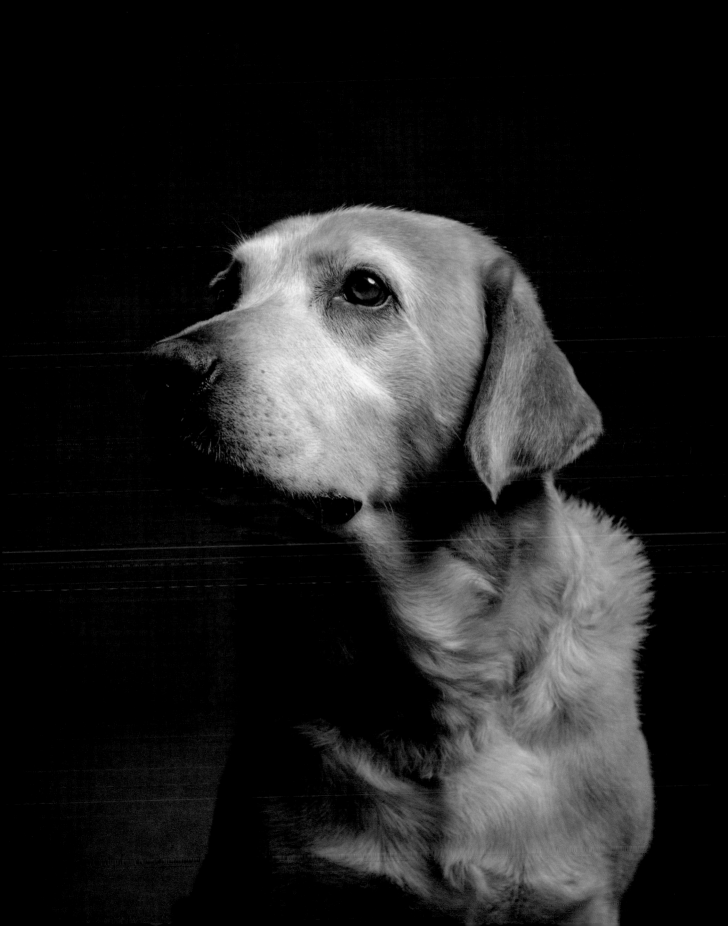

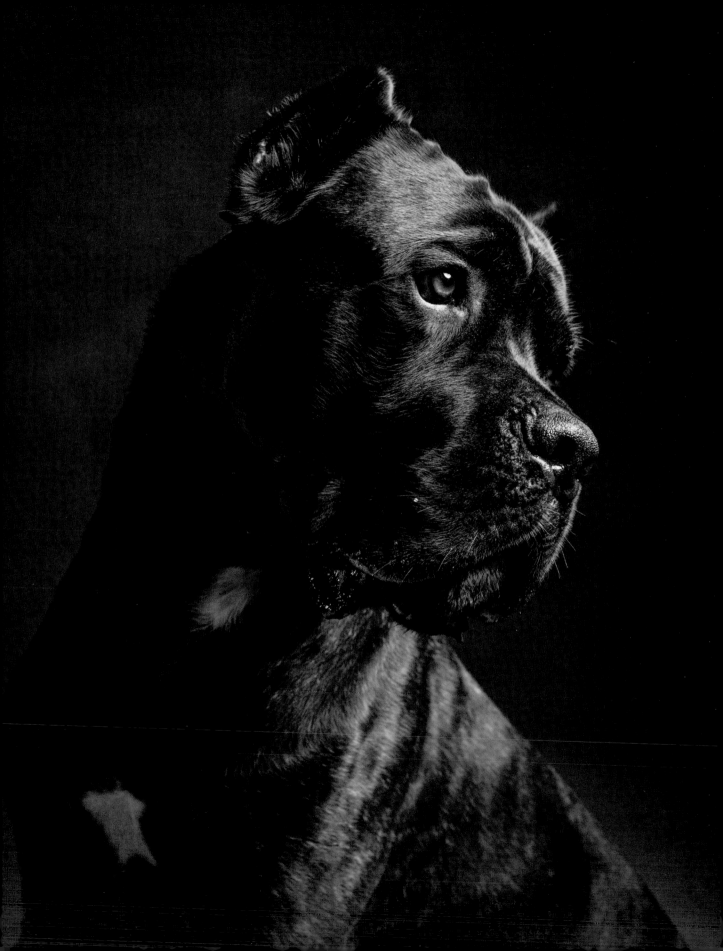

Drifter

He's like the 'Big Lebowski' of dogs, the 'Dude', one of the seven wonders of the canine world (if such a distinction existed).

Drifter is 140 pounds of chill, cardigan-wearing, Cane Corso who prefers to stay up late and sleep in. He is laid back, four years old, and still lives at home. When only using two of his legs, he stands well over six feet tall.

An Italian mastiff identifying as Appalachian, his breed is fondly recognized by at least one person in his adopted home state of West Virginia.

Almost heaven.

Where country roads take Drifter away from home when he scales his six-foot-high perimeter fence and determinedly makes his way to a local pub, where his owner can find him when Drifter wants to be found.

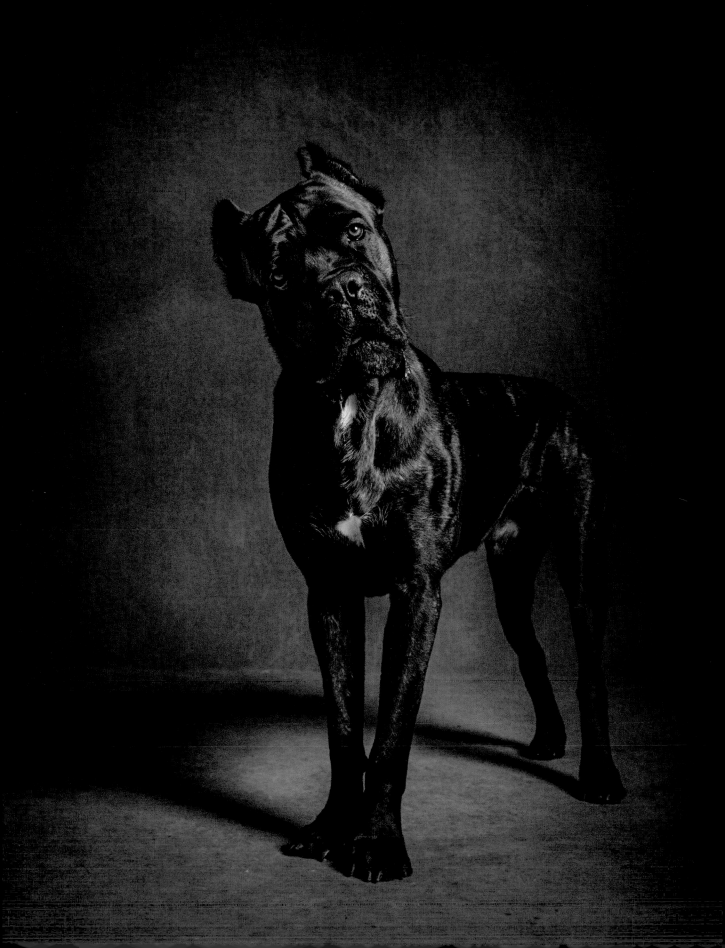

Ginny

The fifteen-year-old dachshund you see here is
Ginny, and she's a miniature one at that. As if these
dogs weren't already proportionally unique and low
enough to the ground, they had to go and make
them even tinier and harder to see.

In the movie *Ant-Man* an average-sized couple
transform into tiny insect superheroes through
risky science, clever writing, and special effects.

As to whether she is superhero material or not, on
the matter of size Ginny makes up for her diminutive
scale with enormous independence and questionable
breath – the latter being one of her superpowers.

In the comic-book world, the hero must always
overcome bad in their lifelong pursuit of good.

Ginny has been conquering bad for some time now.
Her back and neck haven't been holding their end
up, and her eyes and ears do not see or hear so well.
She suffers from dementia and is recovering from
a stroke.

However, she would never let on unless you
asked. She's just happy to be here, with no special
effects needed.

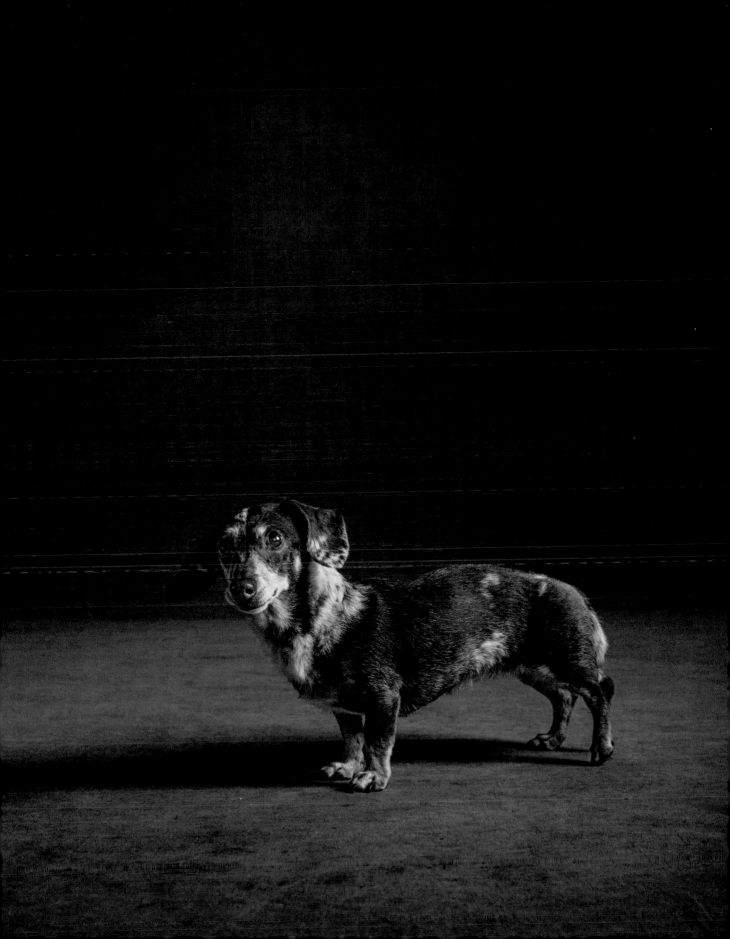

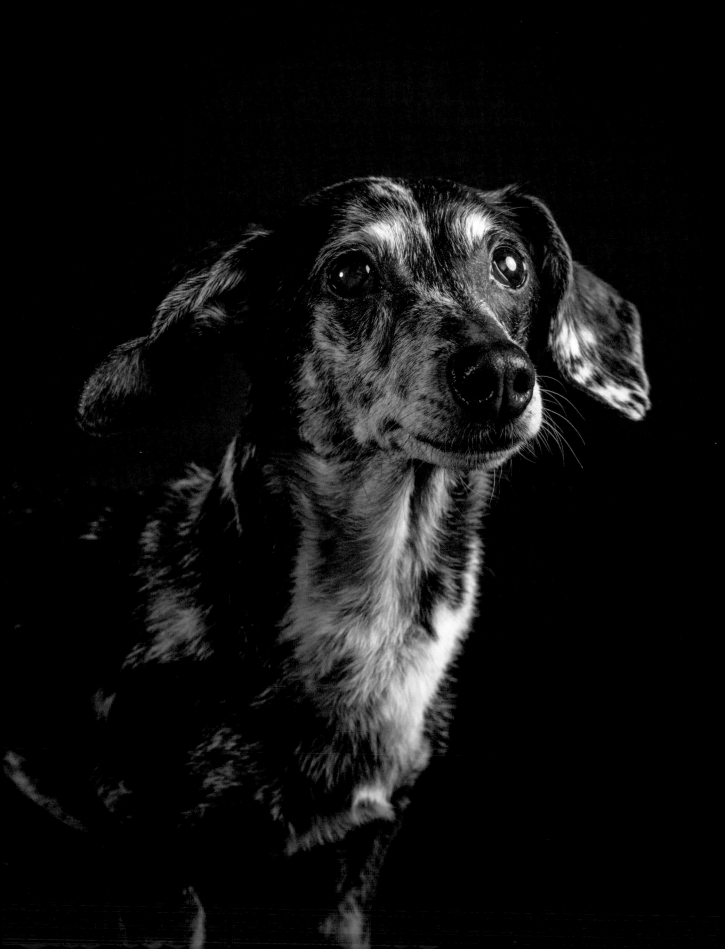

Thurston Montgomery

My father sported an egg-sized bald spot throughout most of his life, yet he always expressed a fondness for television private eyes with healthy hair. 'He's got a great head of hair,' he would say, as he rooted for *Knight Rider*'s David Hasselhoff or *Magnum, P.I.*'s Tom Selleck, stars of those eighties shows, going about their well-coiffed lives, foiling criminal activity and looking marvelous from the front seat of a sports car.

My dad would have liked Thurston, a two-year-old Bernedoodle, who gets his name from his uncanny resemblance to Mr. Thurston Howell III from the 1960s 'reality' show *Gilligan's Island*. Both have great hair, and although Thurston's namesake is no longer with us, the two are often mistaken for each other at social engagements in the Los Angeles area.

Despite Thurston's fondness for sports cars, he has no interest in crime fighting or three-hour cruises, but he does have plans to work with children in local children's hospitals who could use a friend with a great head of hair.

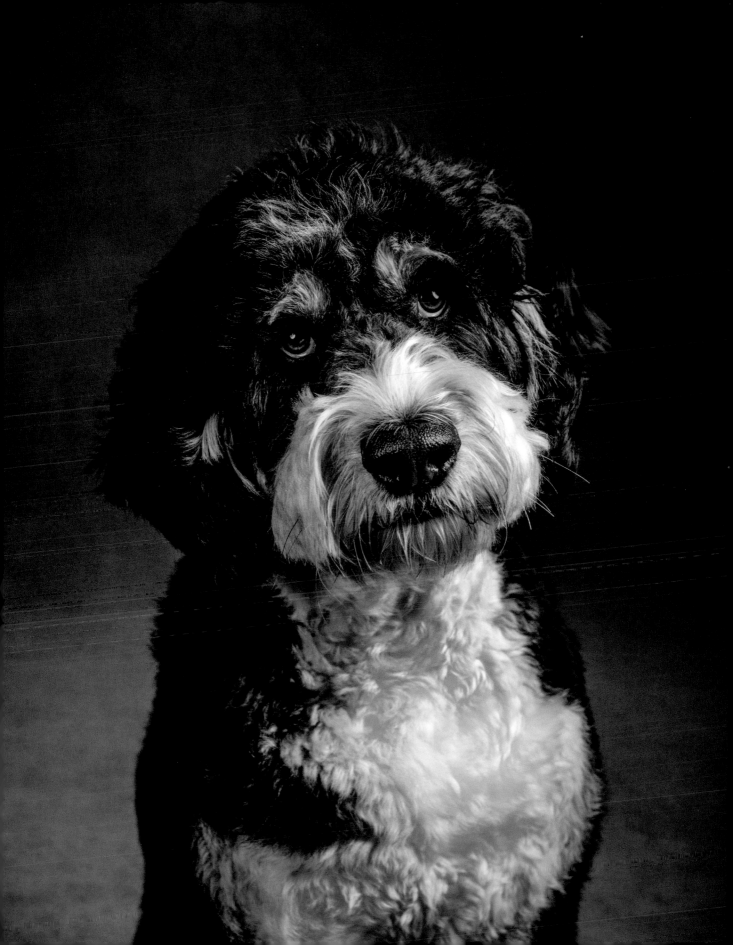

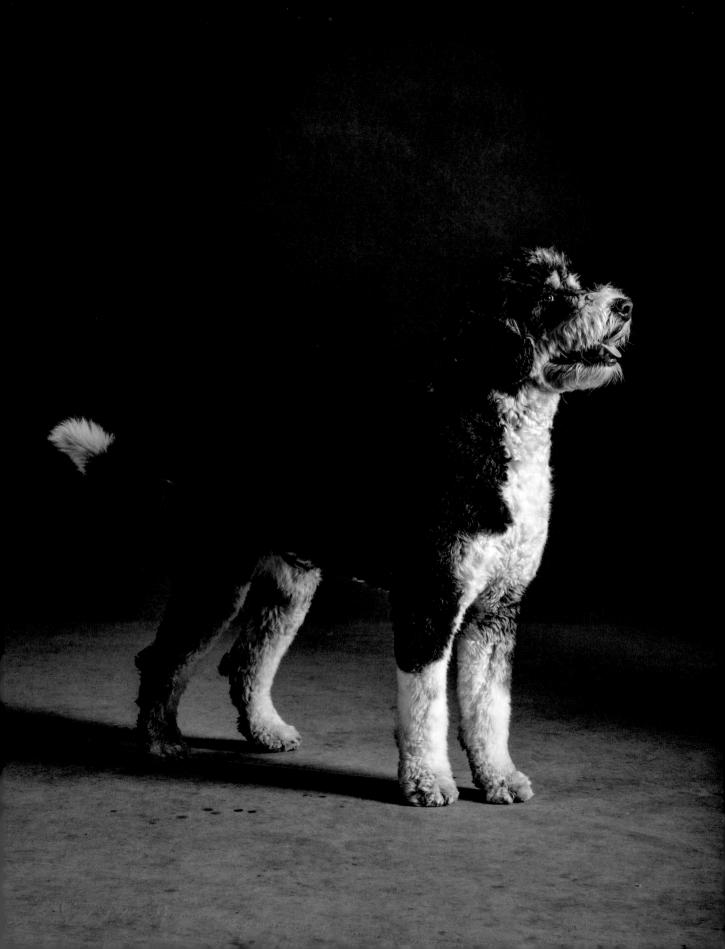

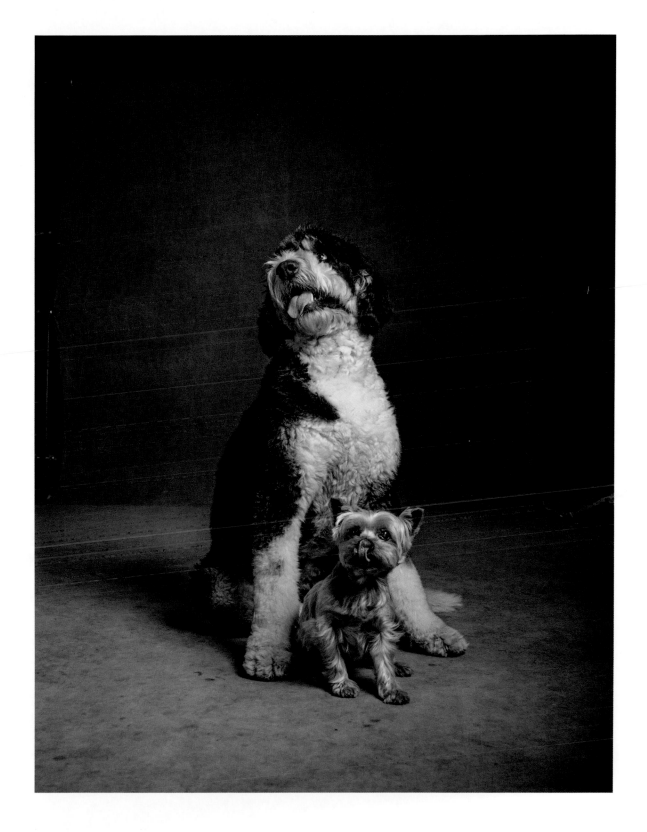

Simon Cornelius

Simon is a small dog – barely the size of a dog at all. Any smaller and he might not qualify. But do not be fooled by this, as he looms large by other measures.

He's a fifteen-year-old Yorkshire terrier with breeding and degrees conferred upon him that qualify him as awesome.

While 'awesome Yorkie' is not a breed currently recognized by any of the official governing dog bodies, his letters and accomplishments are well known, well accepted, and welcomed by our studio.

No matter the size, we've never officially lost a dog in the studio – but I'll admit that it was hard to see Simon at times in the expanse of our backdrop. He was usually found unharmed.

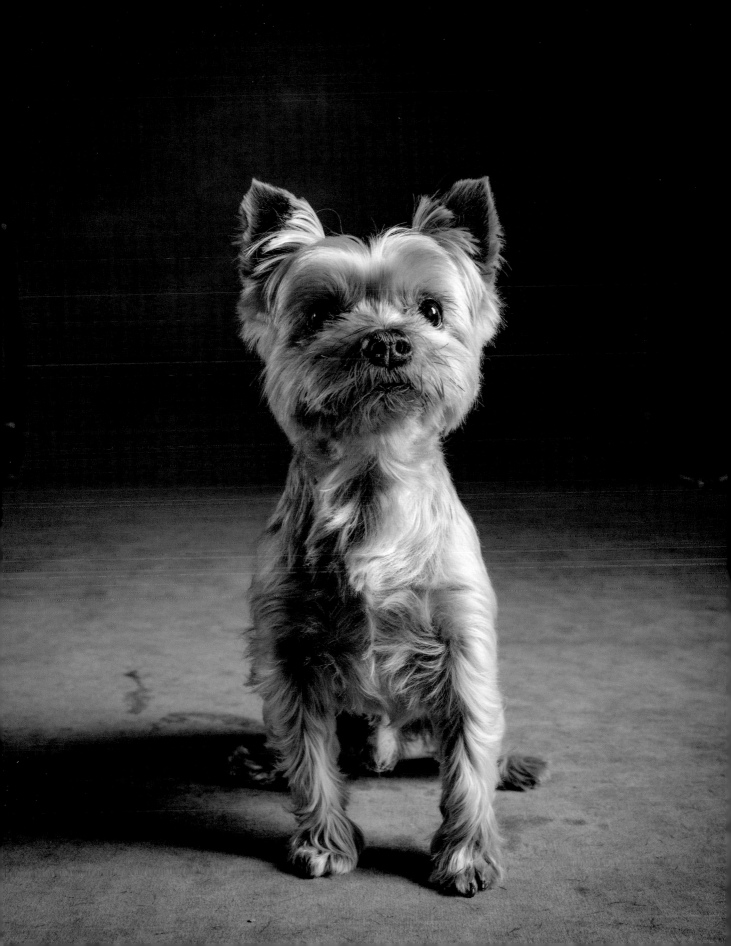

Jojo

I have never stolen a dog, intentionally or otherwise.

The thought had never even crossed my mind until
I met Jojo, a hip, laid-back, fascinating 'oodle' of
some kind or another who was brought to us in strict
secrecy. Nondisclosure agreements were agreed
to and security precautions were secured.

Like many of the dogs we photograph, Jojo's portrait
was commissioned as a surprise gift. No one could
know that I had him; I couldn't even speak of him
freely, let alone admit that I wanted to keep him.
How would I even get away with that?

Jojo's an eight-year-old ball-chasing, butt-sniffing
beach dog. He's an avid paddleboard surfer and male
model, giving him some kind of strong Owen-Wilson-
as-Hansel-in-*Zoolander* vibe.

I like to think there was some chemistry between us.
(Callie has talked me out of many crazy ideas over
the years but I think she should have gone along
with this one.)

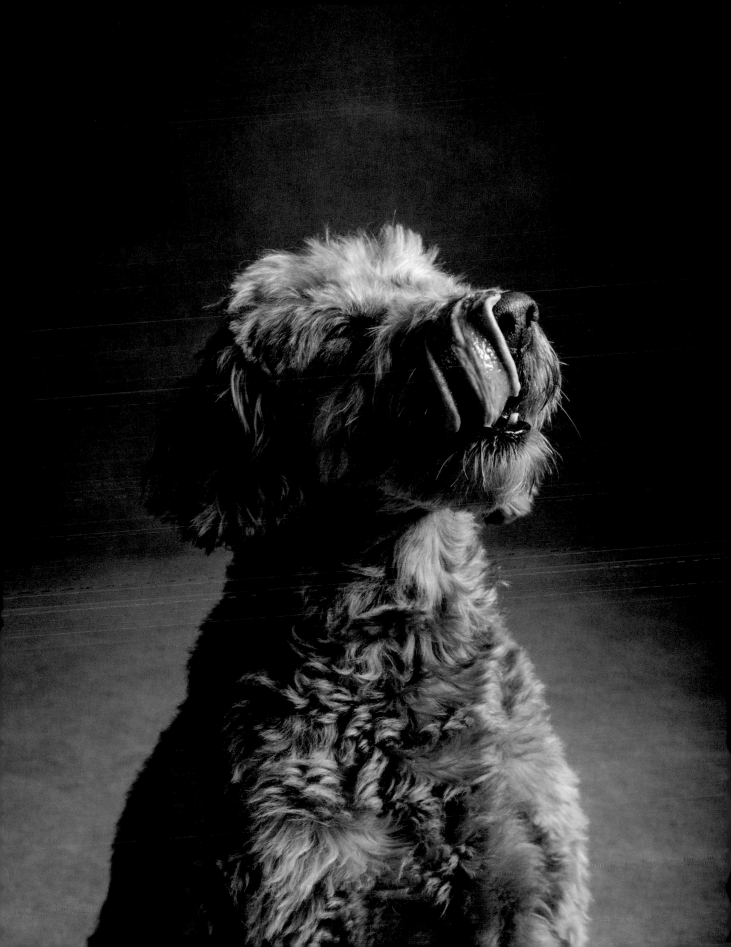

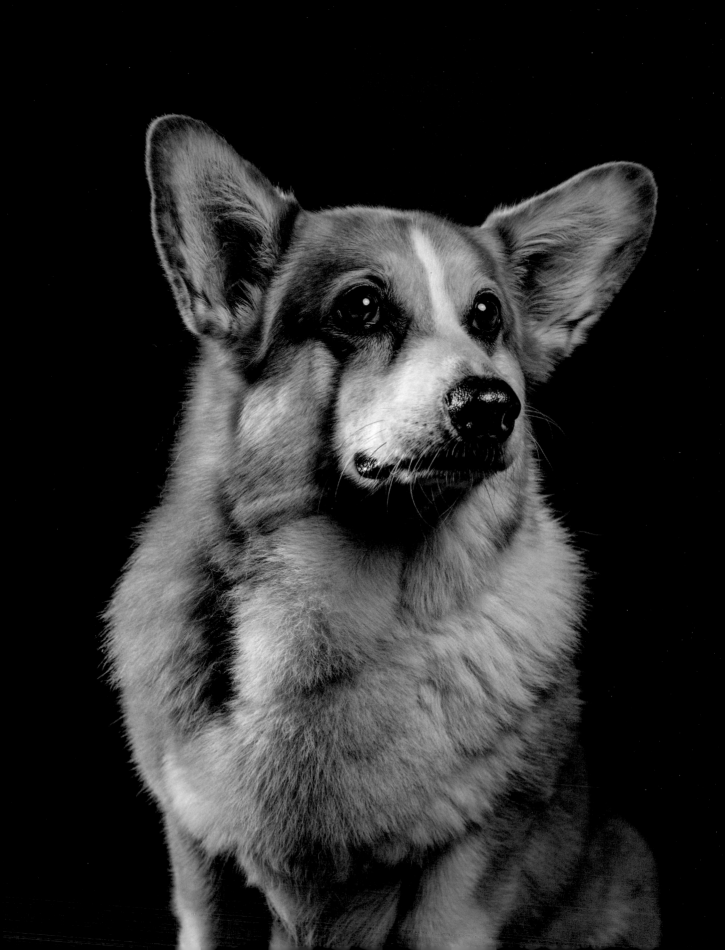

Darcy

After watching *The Crown* on Netflix, Callie now considers herself something of an authority on the queen and her royal Welsh corgis. That's usually my game. Watch a documentary and pontificate about obscure matters with authority, impressing your friends.

Callie's background is a hodgepodge of nationalities from that part of the world, so I'll give her this one. She's also actually met Queen Elizabeth II (but not her dogs).

Darcy, or Mr. Darcy, if you please, is not a royal. He is an easy-going gent and a fine representative for this noble breed – his youthful vim and vigor belie his ten years.

Like the Queen's Guard, he's loyal and sturdy, and he could easily hurl his short-legged frame in the path of danger if it meant thwarting an attack. What else could you or the queen want, expect, or deserve?

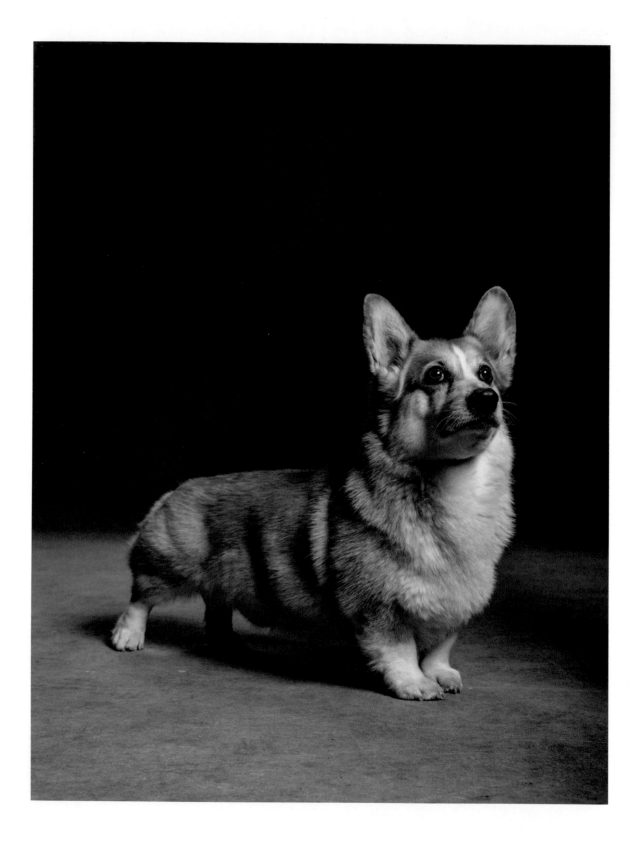

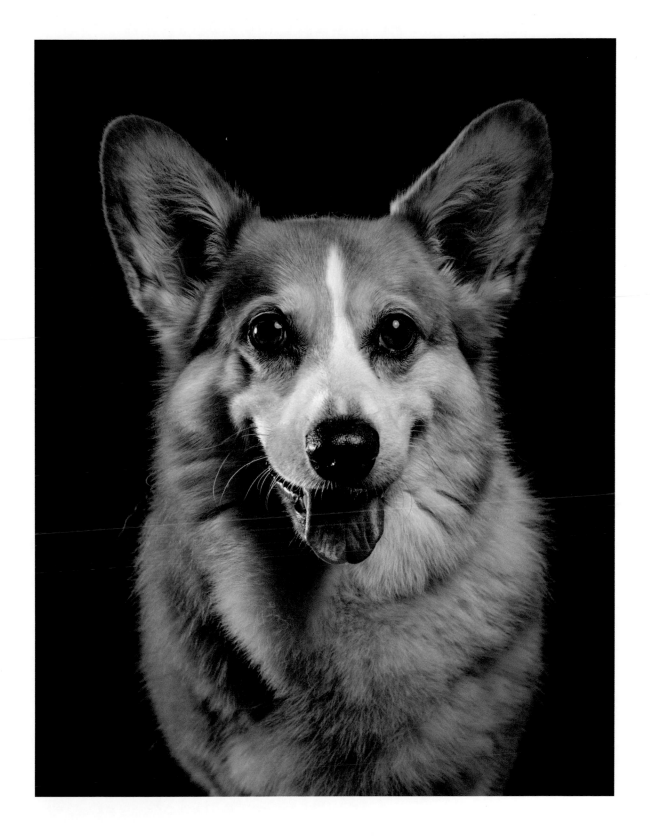

Toby

You are safely looking down the gullet of Toby, a 'wired' five-year-old fox terrier with one lung and a bum leg. I didn't ask how these particulars came to be, as there was way too much going on.

For a period of time that can be measured in years, I played a pinball machine called FunHouse at a local pub. The bonus multi-ball round was achieved by skillfully flippering a pinball into the open mouth of a giant talking doll head named Rudy. This launched what is known as THE FRENZY, when all hell broke loose.

In our inventory of tricks and gimmicks at the studio, we have a pathetic faded orange rubber squeaky pig that, when squeaked properly, will elicit a curious response in most animals – a head tilt or a pause. In Toby's case, it unleashed THE FRENZY. Anyone who dared to enter the air space between Toby and the orange pig was in danger. Callie had lost control of the beast and both were looking disapprovingly at me.

We had no real contingency plan and leadership was called for. Toby's owner just paced apologetically back and forth, explaining that we had made a grave mistake. Let the record reflect that I did not actually perform the squeak, but I did order the squeak so I take full responsibility.

The squeak stops here. Callie and what's left of the pig are still not talking to me.

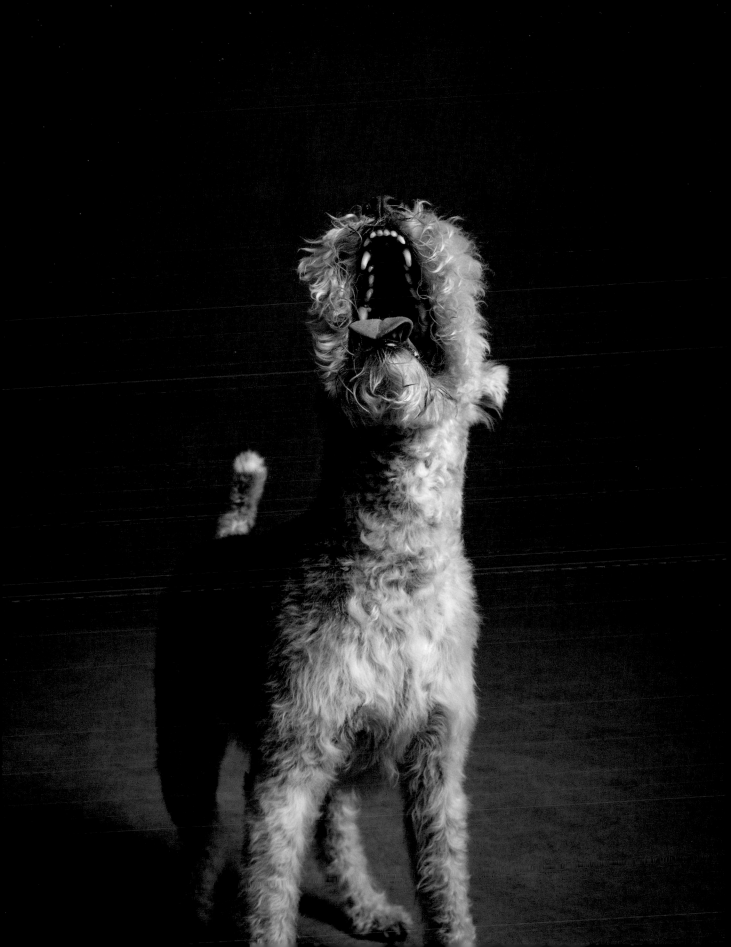

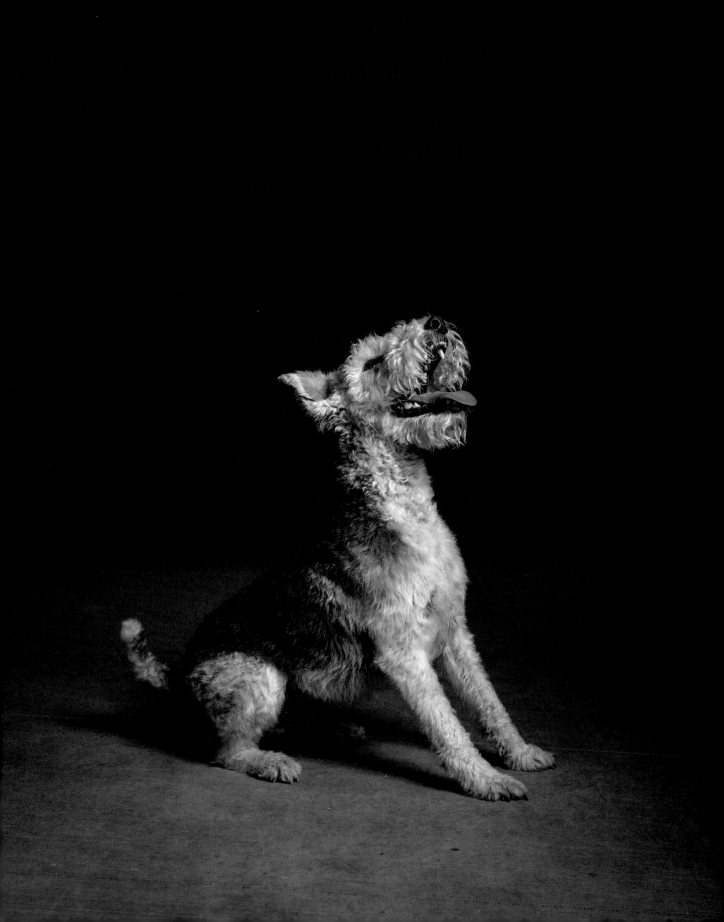

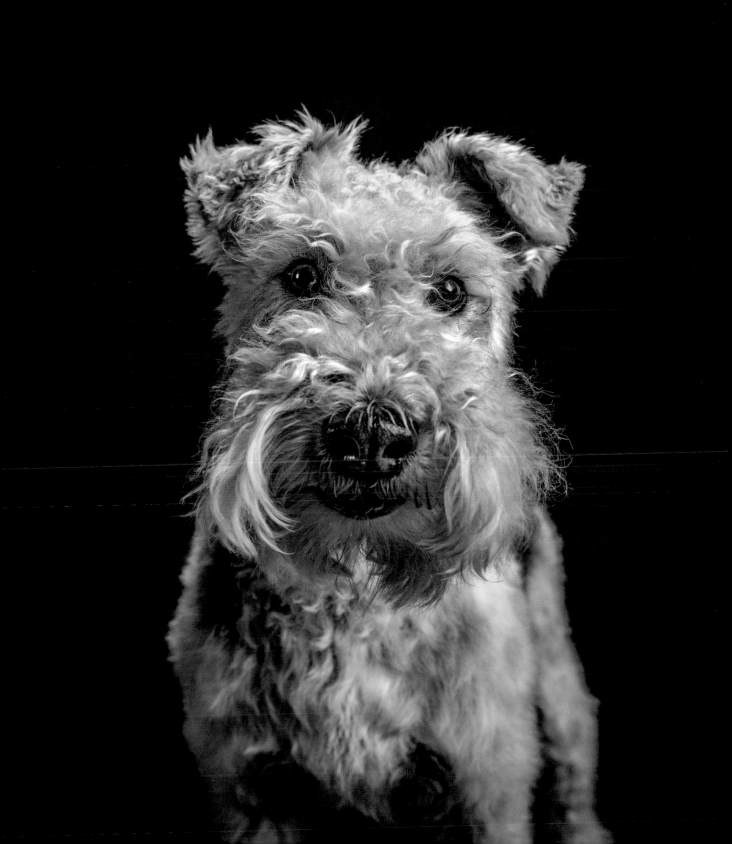

Harry

Harry is a two-year-old standard poodle who is more hairy than standard, but all poodle.

I was very nervous about photographing Harry. Dogs can smell fear in a photographer, but if Harry knew I was afraid, he never let on.

It took me forever to figure out what I wanted to do, and I knew his time was valuable. Respectfully, I thanked Harry for his patience as I fumbled around with the lights while Callie made small talk with him, apologizing for my incompetence. I addressed him as 'Sir'.

There is an awe usually reserved for royalty that I express for a dog that can maintain a flawless 'blue steel', scratch himself, and remain really, really, really ridiculously good-looking all at once. It's off-putting at first, but once you get to know a famous dog you realize they are a regular dog, just like the rest of us. Don't judge them only by their good looks and impeccable manners. If they wore pants, they would still put them on one leg at a time.

To those inquiring about Harry's status, he is currently in a relationship with a young Bernedoodle named Versace.

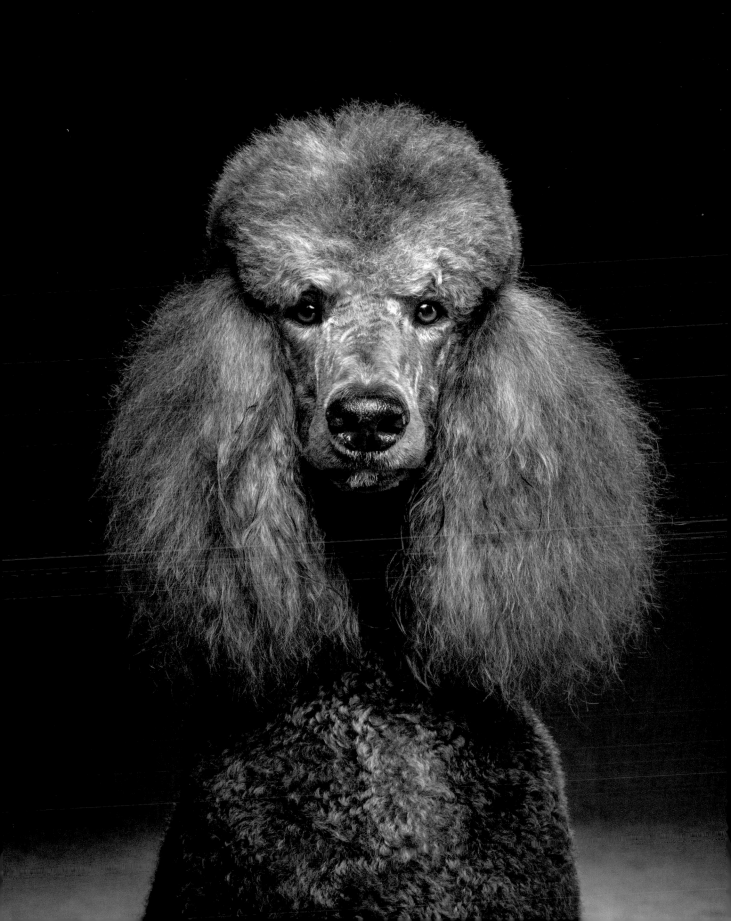

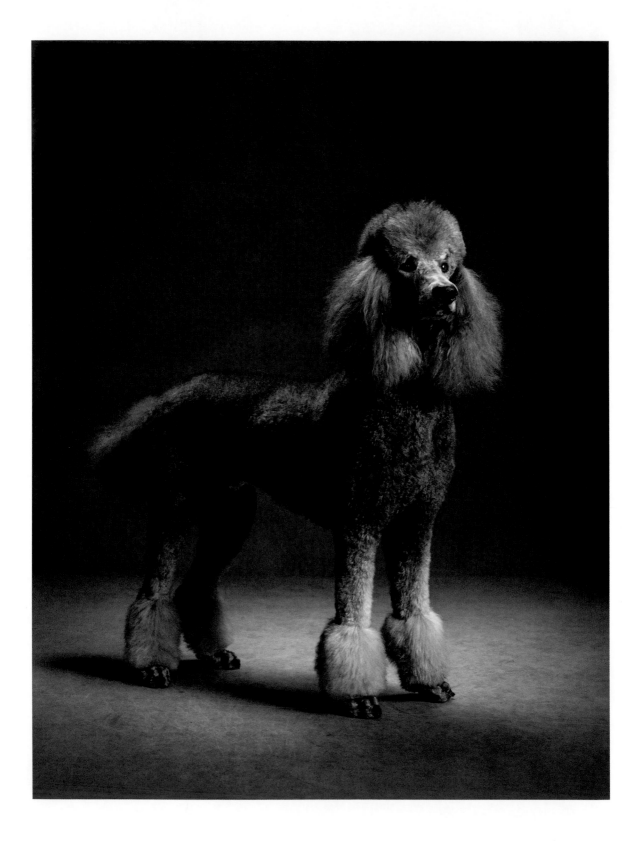

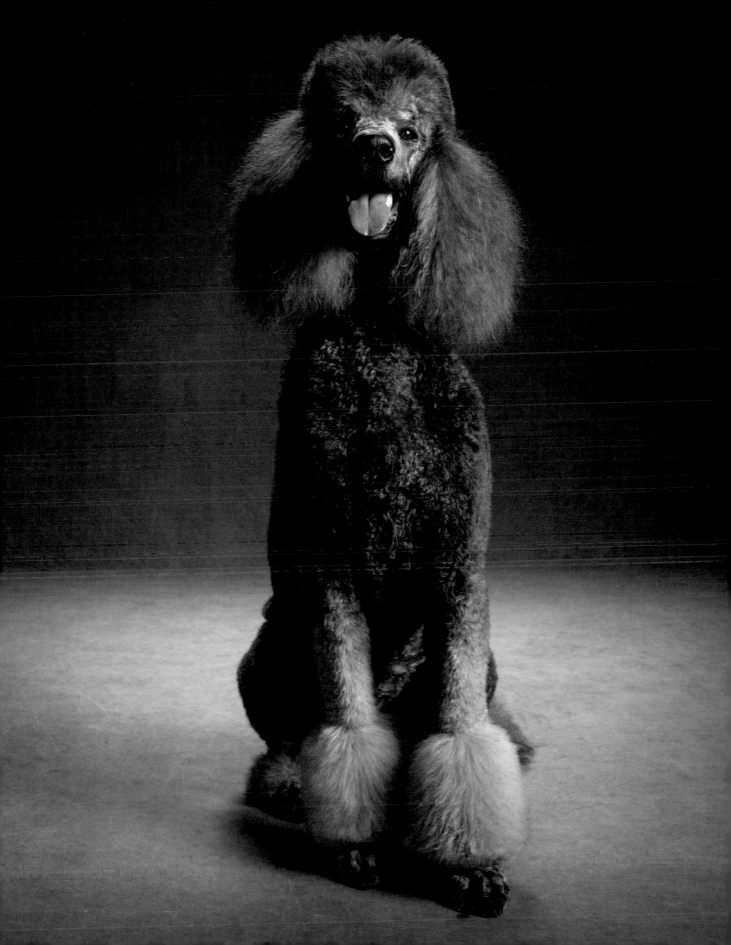

Peetrie

Yes, I had, and still have, a troll doll.

Safely preserved in a cardboard box of childhood artifacts, it hails from a time when The Beatles were still together, although the details are as fuzzy as the hair. The doll is naked, as I don't think my parents could afford the clothing – just the doll.

Depending on which way the wind is blowing, Peetrie sports a tiny tuft-like collection of hair. I don't know what to call the style, except 'Troll Dog'.

Seven-year-old Peetrie, a teeny toy poodle, quietly came into the studio with a local bulldog, who is involved in the music business and something of a big deal. It was his portrait we were making, when Peetrie stole the show. The bulldog (Louie, page 154) is probably looking at this photo and saying, 'What about me?' We'll be hearing from his publicist, I'm sure.

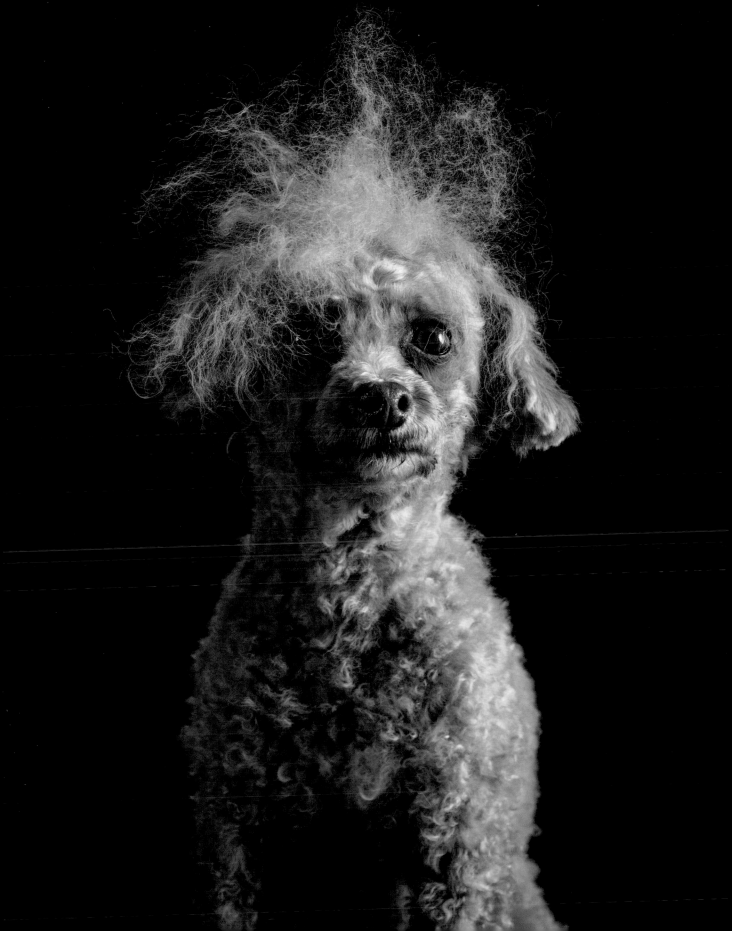

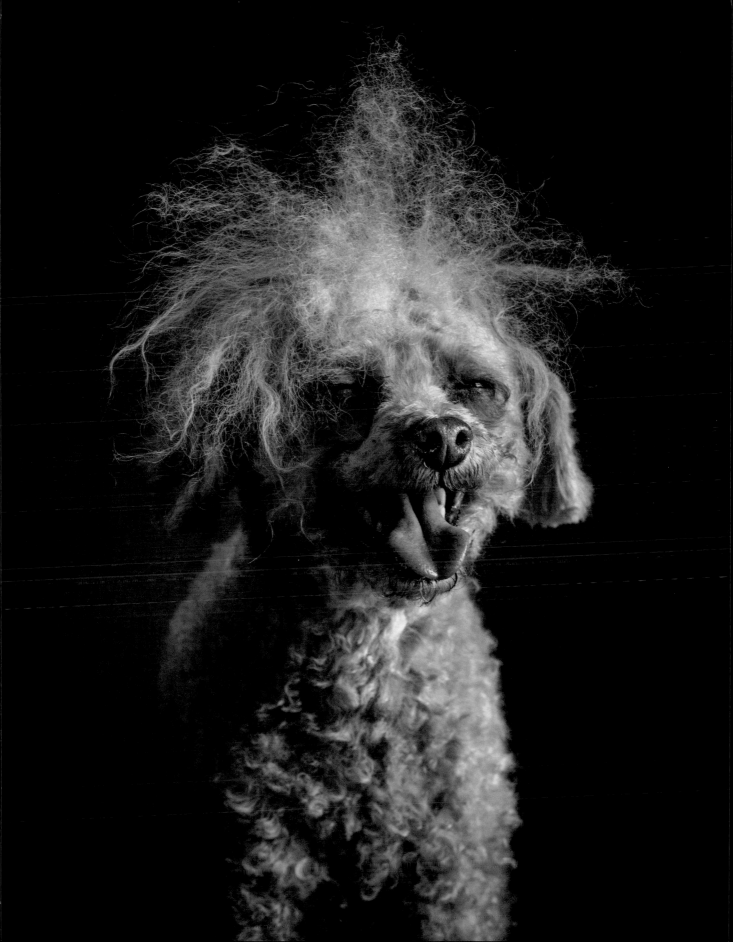

Boo Radley

If you were picking a buddy for a buddy trip, Boo would be your buddy, your boy, your wingman. If he could only reach the pedals he would help drive – but he probably wouldn't pay much attention to the road.

Boo would pick good music without consulting a playlist, and there would be no complaining if your dinner came entirely from a gas station and consisted of a corn dog, a giant bag of nacho cheese Doritos corn chips, and a giant cherry-flavored Icee. None.

It's never too late for a case of puppy love.

Six-month-old Boo is one of the happiest and luckiest dogs ever. He's a unique recipe of basset hound with a generous pinch of cocker spaniel to spice things up. Boo would rather roam the aisles and meet people at the hardware store than prance around at a dog park. He's happy, really happy, in a better than-Pharrell-Williams-'Happy' kind of way, and can't nuthin' bring him down.

Because Boo almost wasn't. Wasn't like he almost died, it wasn't like he almost didn't get that far in the first place. His mother was liberated from a horribly cruel situation in the middle of a harsh North Carolina winter. She was pregnant, padlocked to a tree, and starving. Rescued and fostered by a kind soul, she delivered Boo and his six siblings two weeks later. All of them survived.

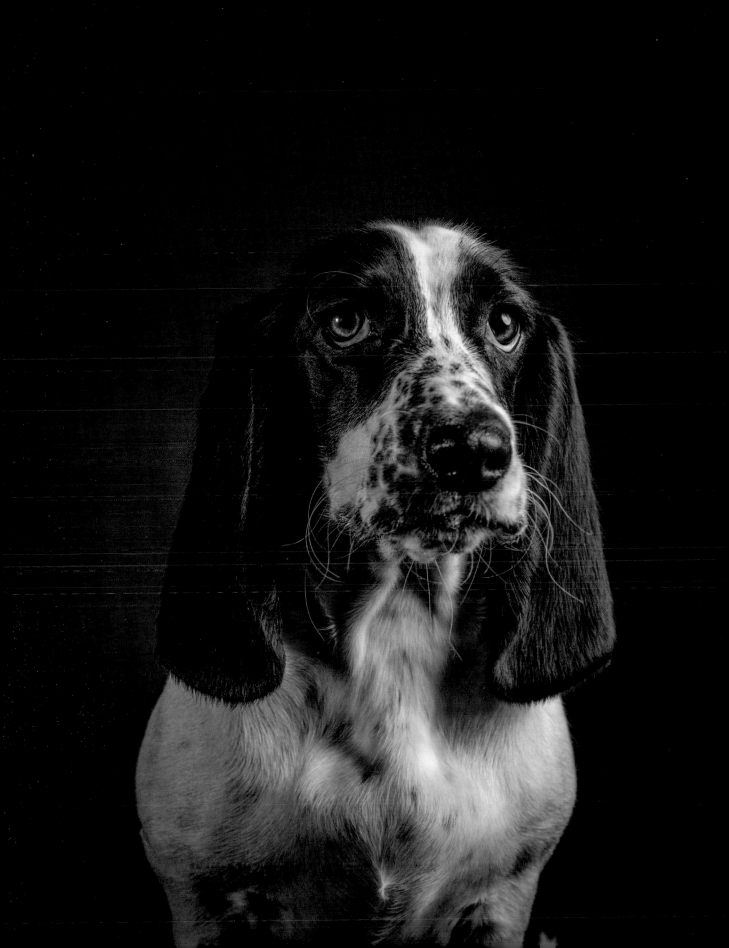

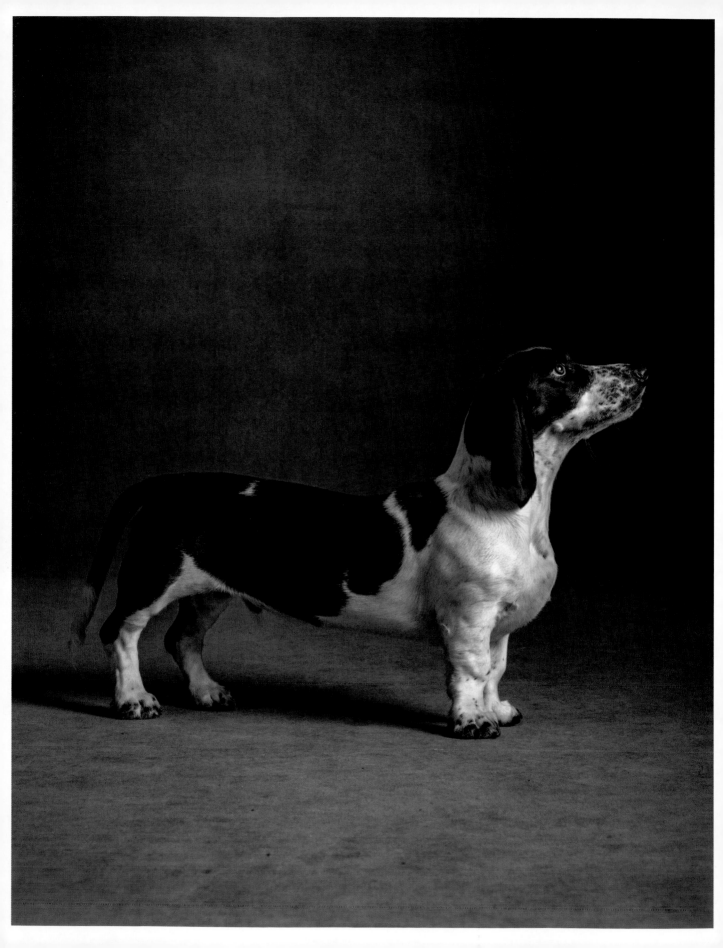

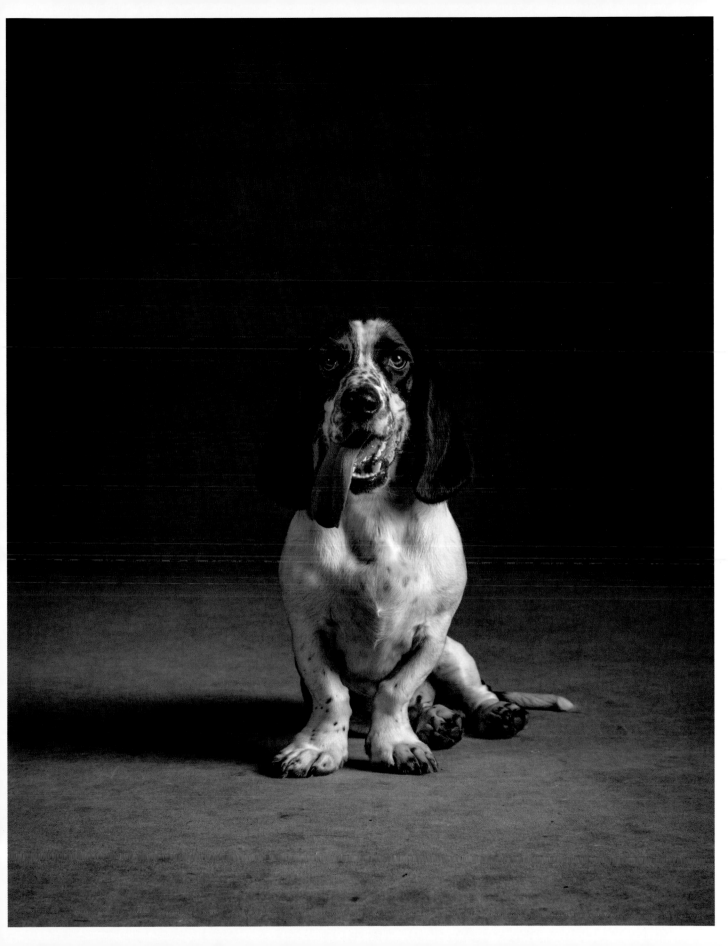

Ellie-Bou

The incredible legacy of photographers Irving Penn and Richard Avedon has influenced me throughout my career. Their portraits are intimate, majestic, indelible, and revealing. I can stare at them for hours.

Maybe it's the responsibility and control of nearly every element in a photograph, from the lighting to the background, that inspires and terrifies me into attempting studio work. Maybe it's the illusion that I'm in control of something I'm not.

This was the case with the adopted beabull known formally as Miss Ellie-Bou. Occasionally hyphenated but always on time, I have known Ellie for a number of years since her arrival in our neighborhood. Some were worried about her in her youth; others never lost faith. Ellie has matured into a friendly sort, seen often on the sidewalks of this fair town.

She is very much a type A personality. For better or worse, so am I. Some call me a control freak, yet I've never heard them say a bad word about Ellie.

My guess is that if you met Ellie on the street you might not recognize her from these photographs – but you will know her better because of them.

I could never have made Ellie pose like this – it was a present, maybe a reward for good behavior from one type A to another. These moments are gifted by the subject, to see them in a new light.

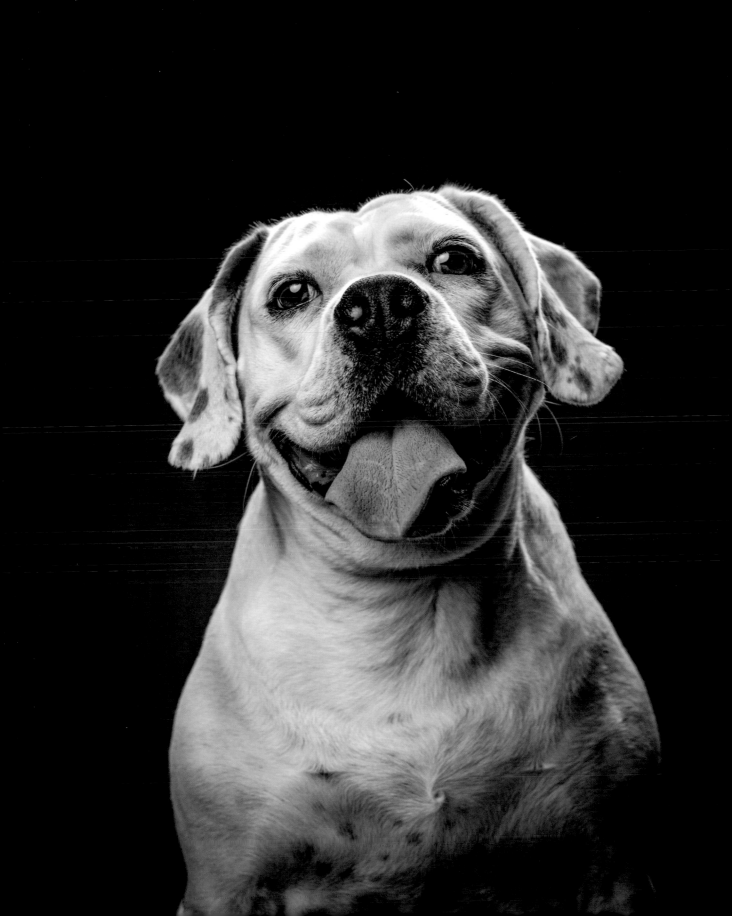

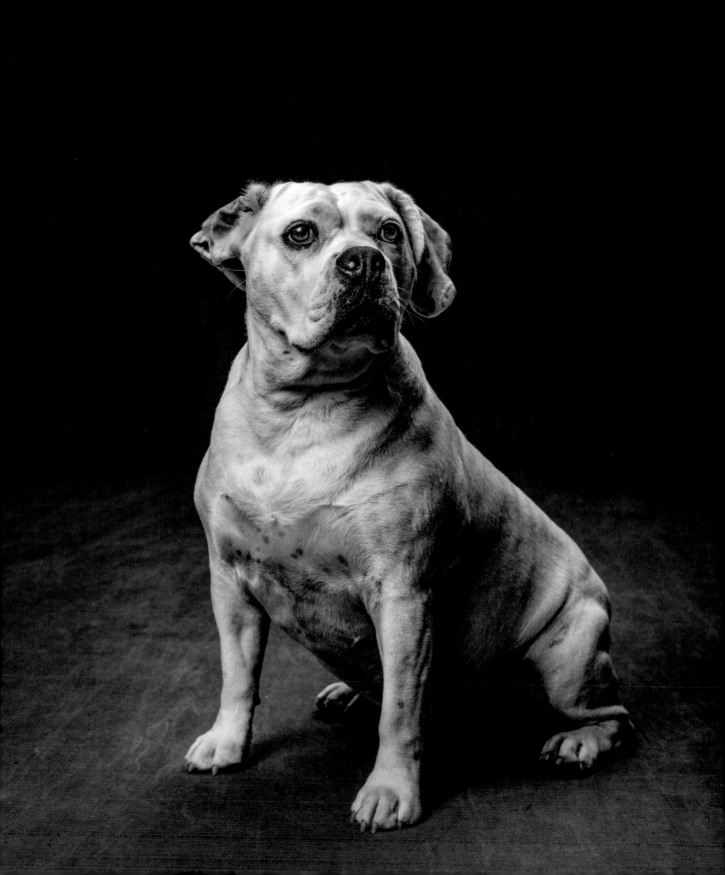

Lee Lee

When I was nine years old, I spent many hours in my parents' basement drawing portraits of a dog and a pirate, trying to win a scholarship to a correspondence art school that advertised in the Sunday newspaper.

'Draw Winky' was a heavily promoted challenge. The creature was sort of an innocent and sweet-looking deer-like character, with a skinny neck, flop of hair, tiny button nose, and large pointed ears. I was sure that if I could just draw Winky or the dog or even the pirate well enough, I was bound to be famous like Mr. Charles Schulz, the cartoonist of Charlie Brown and *Peanuts* fame. Schulz himself was an alumnus of the correspondence school.

Apparently, nobody liked my Winky. The call never came. No congratulatory letter arrived. I'm pretty sure my well-meaning mother, fearful of what fame and fortune would do to a child prodigy like me, never actually mailed my entries. I put my colored pencils down and turned to photography.

Lee Lee, who was almost named Lu Lu, is sort of like Winky – innocent and sweet except she has the correctly proportioned ears of a Chinese crested powderpuff. She is three years old. I don't think I ever knew how old Winky was supposed to be.

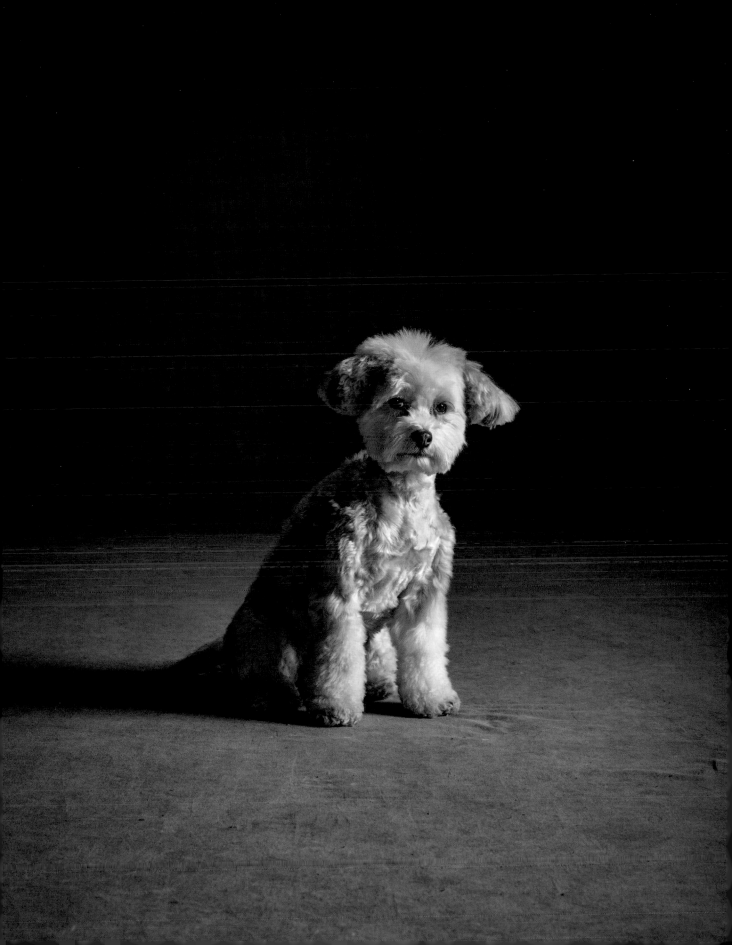

Bliss

I photograph all dogs naked.

Not me, just the dogs.

I certainly respect the right of all dogs to wear
anything they please (especially those hairless
breeds). I'm an artist, and it's just that, as an artist,
I need to be taken seriously by the art world, and
I have a lot of catching up to do. Nudes are my
last hope.

You see, it's too late for me to become one of those
'petfluencers' – a tastemaker, babbling on about the
latest trends in sundresses for coonhounds or why
you should be using jewel-encrusted poop bags.

All your famous artists worked with nudes, the
guys with one name from long ago – Michelangelo,
Rembrandt and Raphael. Even Leonardo (DiCaprio
not Da Vinci) was sketching a nude Kate Winslet
right before the Titanic hit that iceberg.

None of them worked exclusively with nude dogs like
I do. That would be my gimmick, my art.

At nine years old, Bliss still has lots of modeling in
her, nude or not. She's the perfect muse for an artist,
regardless of how many names that artist may have
or want. She's comfortable with her body and not
shy in the least, and it should be noted that Bliss has
swagger – and swagger goes a long way when you
have to drag your hips like she does at her age.

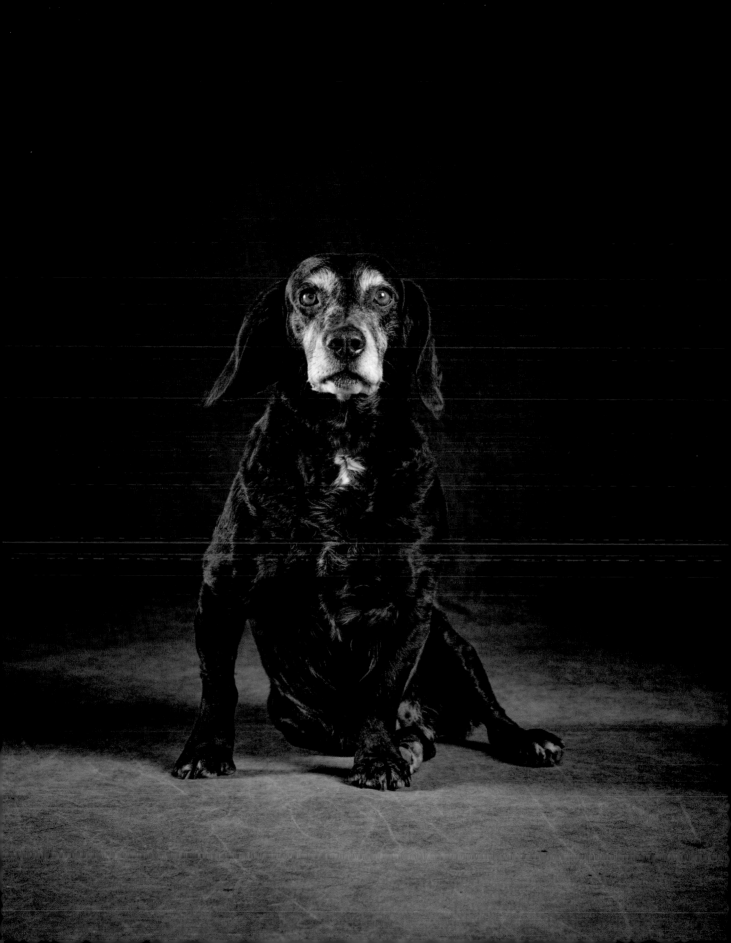

Sammy

Many people make incredible claims about their dogs, yet few will drive over a thousand miles to prove them. Such is the case with Sammy, a cultured and wise fourteen-year-old yellow Labrador who visited us recently from the great state of Texas, where he was born, bred, and raised, and still has voting privileges.

Among his many interests, Sammy has a soft spot for opera. With all due respect to Maestro Pavarotti, Sammy prefers sopranos to tenors.

So we played Sammy Kiri Te Kanawa and he was instantly mesmerized by her performance of "O mio babbino caro" from Puccini's opera *Gianni Schicchi*. These photographs were made during the playing of this aria, I *Schicchi* you not.

When you look into the eyes of an old dog, you learn a lot of things. But none of those things are to do with opera or classical music.

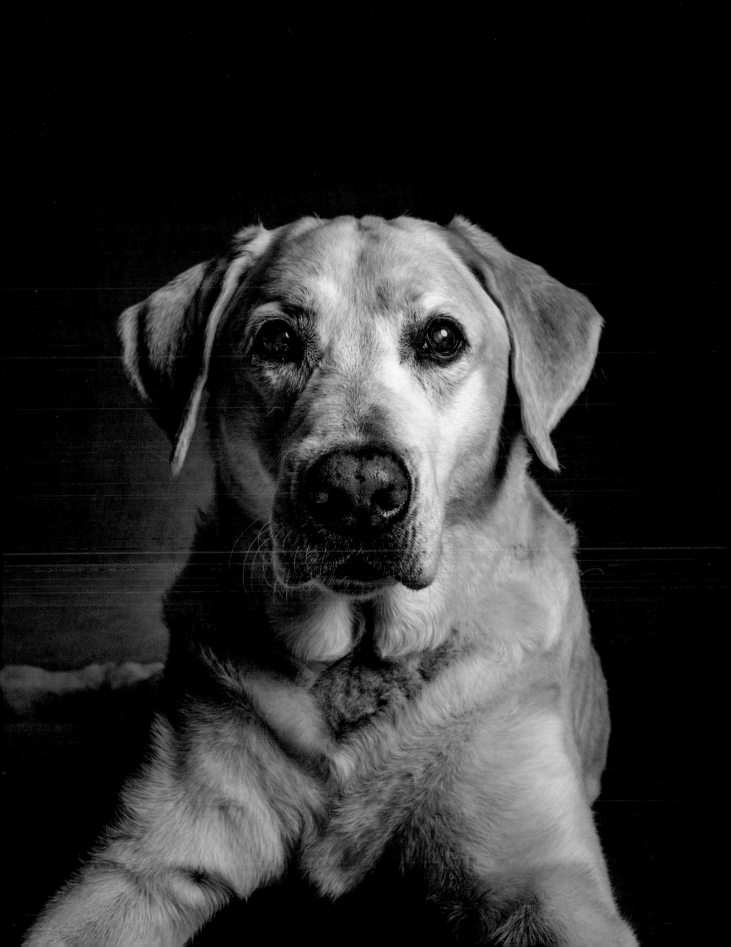

Archie

My son is a liar.

He's been lying to us his entire life. Please forgive the ramblings of a frustrated parent. Hunter has been promising us that he would never get any bigger, never get any older, and he was never going to grow up.

Liar.

Dogs will never lie to you, although they will get bigger, older, and grow up just the same.

It's doubtful that Archie, a Gordon setter, ever made a promise he didn't keep, but he's growing up so fast that I doubt he makes a lot of promises.

We photographed Archie when he was a little over two months old and then again a year later.

They grow up so fast.

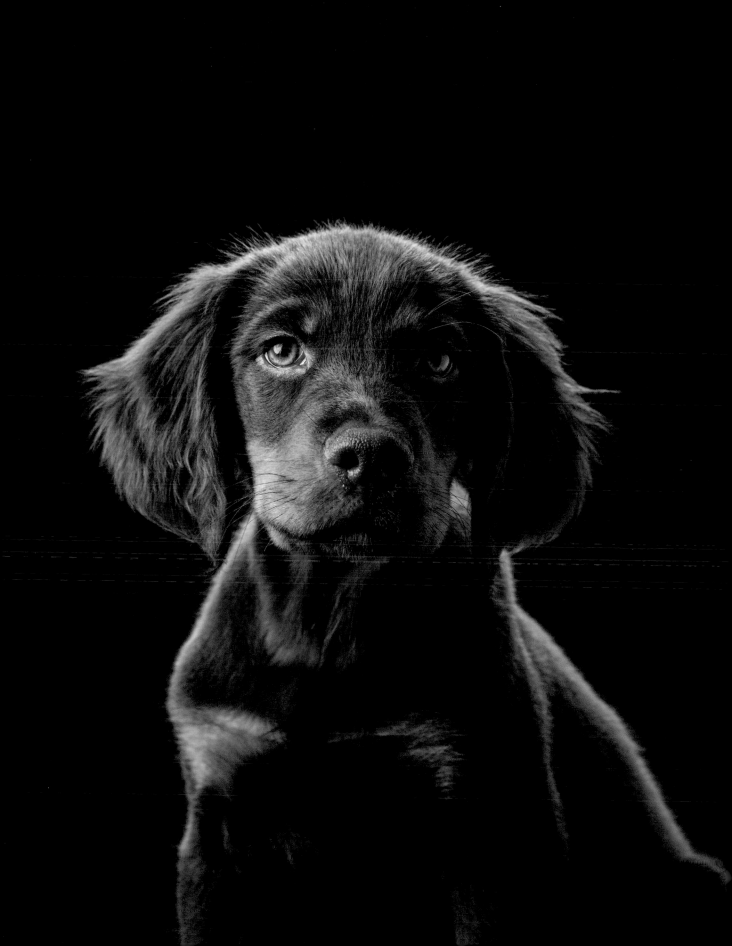

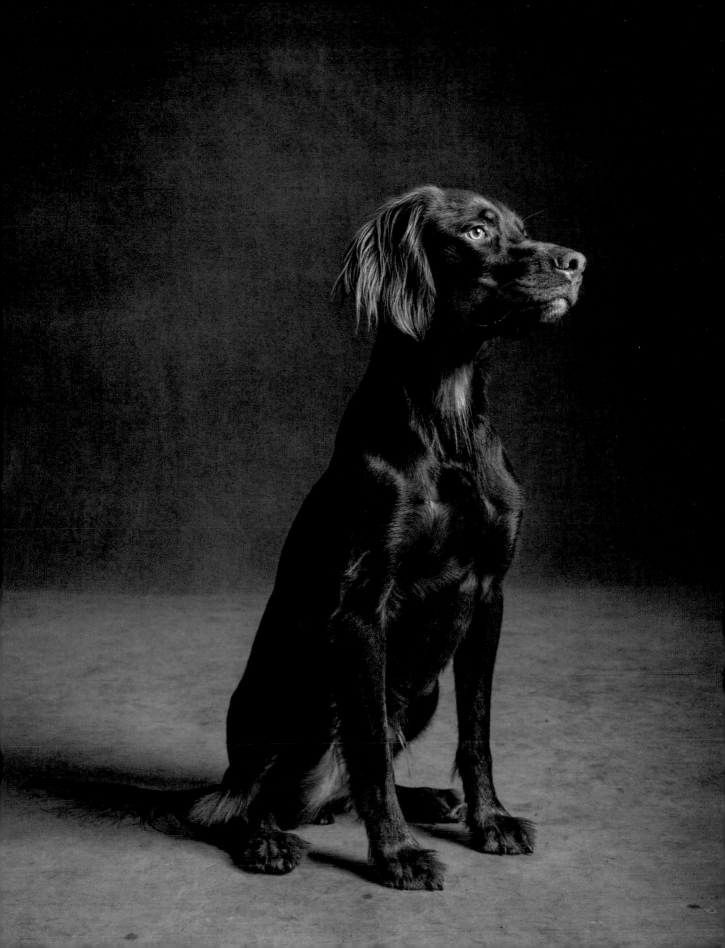

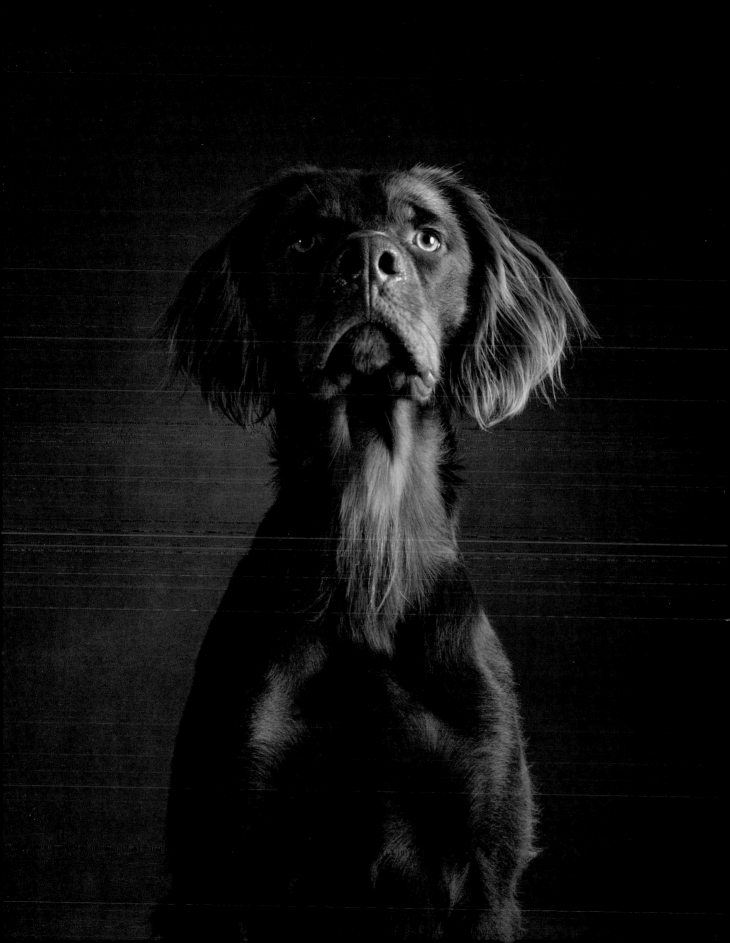

Louie

Sex, dogs, and rock and roll.

Louie lost his virginity to a much older woman in a bright yellow trailer in suburban Atlanta on a Super Bowl Sunday. He became a man in the name of science and good music by producing a DNA sample, but his exploits did not involve cloning as in the case of Barbra Streisand's dog.

When I became of 'the age', my mother's idea of 'the talk' was forcing my older brother to take me to see Monty Python's *The Meaning of Life*, a film that featured a grand song-and-dance number called "Every Sperm is Sacred". I was twenty-one.

Seven-year-old Lou Dog (his stage name) is in a rock-and-roll band, a boy band of sorts, where he is the frontman but doesn't sing or play an instrument. Nor does he need to.

As Louie tells it, what happens in Atlanta does not stay in Atlanta, and after a series of successful gigs the band wanted to preserve his legacy by recording a 'single' for future use.

The limits of good taste and privacy laws prevent me from being more specific except to say the rest is football history, with New England Patriots quarterback Tom Brady and Lou Dog scoring big that day.

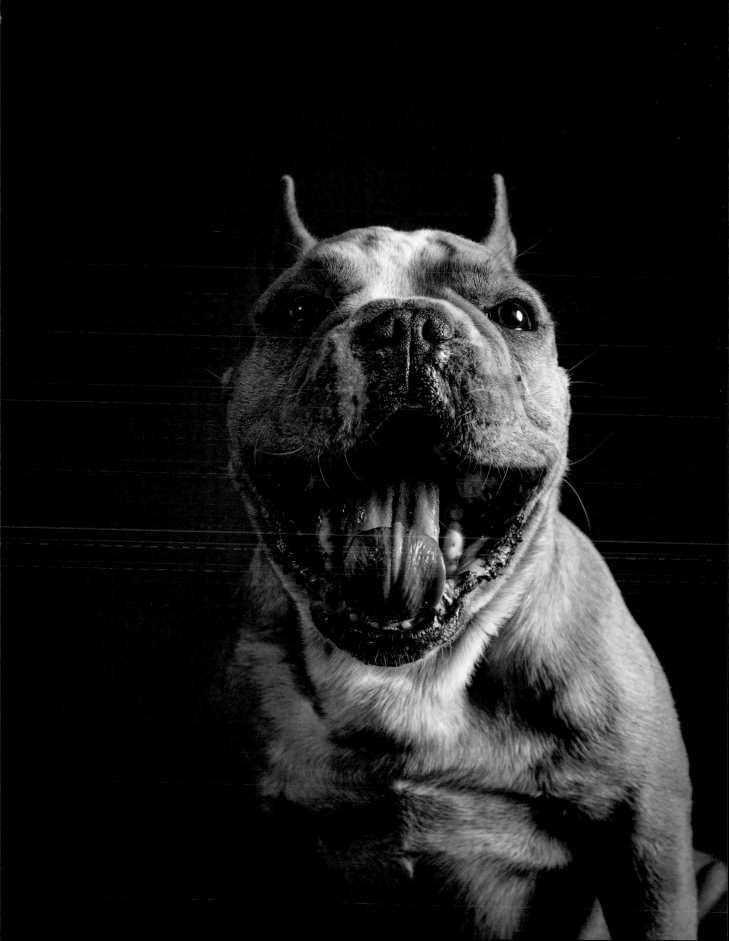

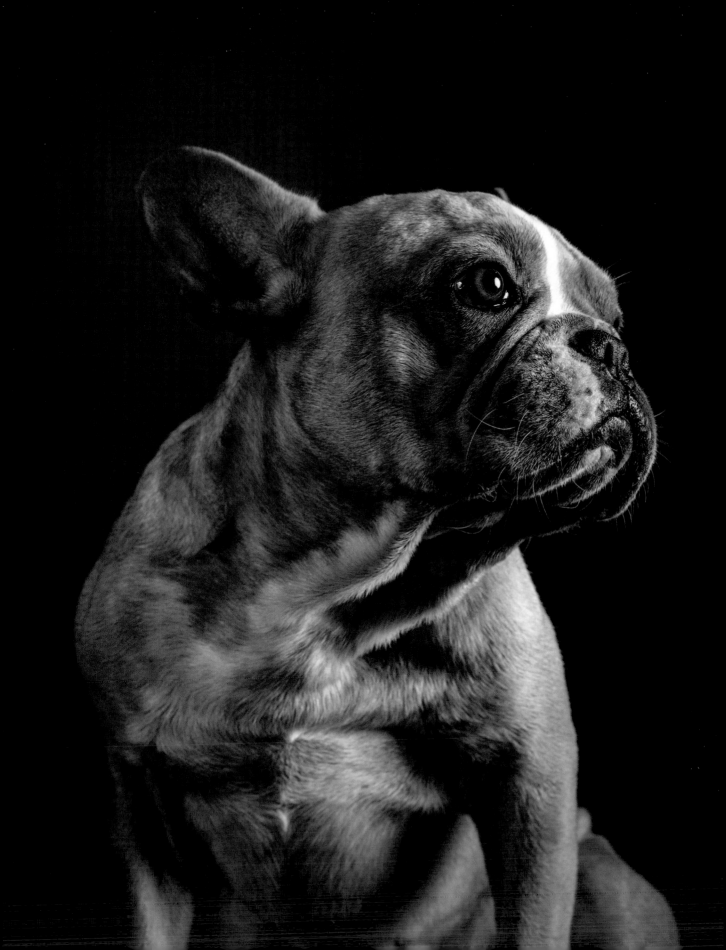

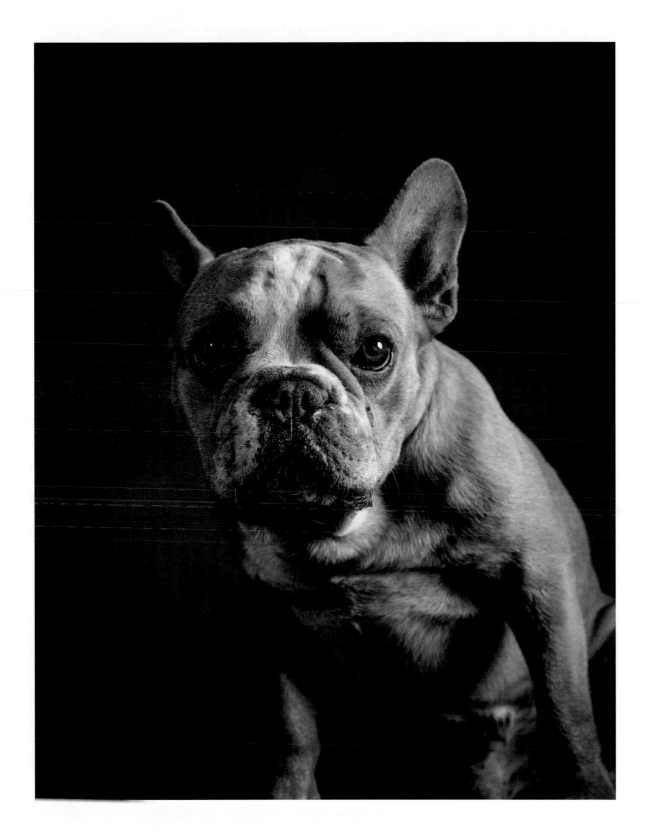

Mishka

I am an admirer of obituaries.

In many ways, the highest calling for photographers and writers and artists is to chronicle and document and preserve the present for the future.

The *New York Times Magazine* runs an annual feature called "The Lives They Lived" – vignettes and reflections on notable people who departed during the year. Some are famous, many are not, but all are fascinating. Each one is represented by a poignant photograph and story; it is easily my favorite feature in the magazine.

Mishka, the German shepherd-Siberian husky known fondly by locals and tourists in her neighborhood for her friendly demeanor and command of public spaces, was born in rural Virginia. She was previously known as Nikki, but only for the first six months of her fifteen years. During that brief time, she developed a severe mistrust of humans and closed rooms.

She quickly overcame those fears when given the security of a home and oversight in the raising of three children during their formative years.

Always a howler more than a barker, Mishka temporarily visited Charleston on holiday and never left, spending her last nine years in the Holy City where she was deeply committed to historic preservation and served as an unlicensed tour guide. Photographs of her appeared from time to time in the local newspaper and she was an accomplished fashion model.

She will be missed.

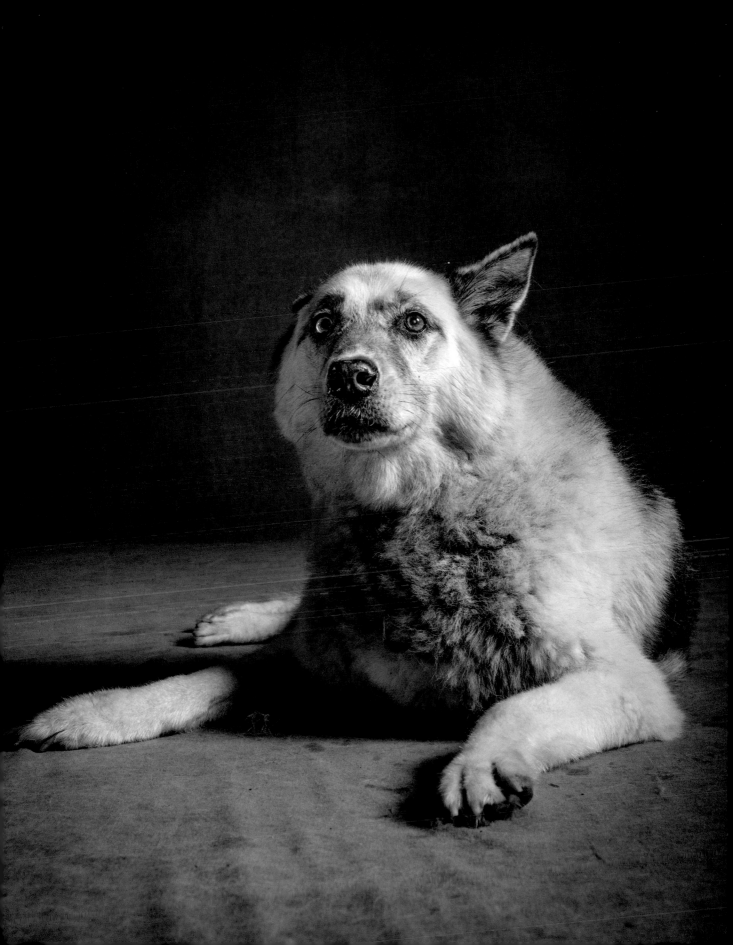

Rocco

I have long been afraid of photographing Jack Russell terriers, regardless of how many eyes they may or may not have. This is not meant to unfairly malign Rocco or his spirited bloodlines; it's just that one-eyed Jacks are always wild.

That paragraph came to me in my sleep after we photographed Rocco. It was chasing a ball around my subconscious, and I jumped out of bed to scribble it down before it was lost.

When these spirited epiphanies come to me in the middle of the night, I like to wake Callie up and run them by her, like a stand-up comedian practicing new material at a comedy club. Callie pretends to be asleep and says she doesn't hear me calling her name.

Ten-year-old Rocco lost the eye not seen here to a run-in with a cat. He was a much younger man then, but holds no grudges that I'm aware of. He makes perfectly good use of his remaining eye.

Rocco is a damn good dog who never sleeps or stops, even to pee or eat. He is in a state of perpetual motion, slowing only to calculate wind speed and change direction. More than that, he would never pretend to be asleep, no matter how bad my jokes were.

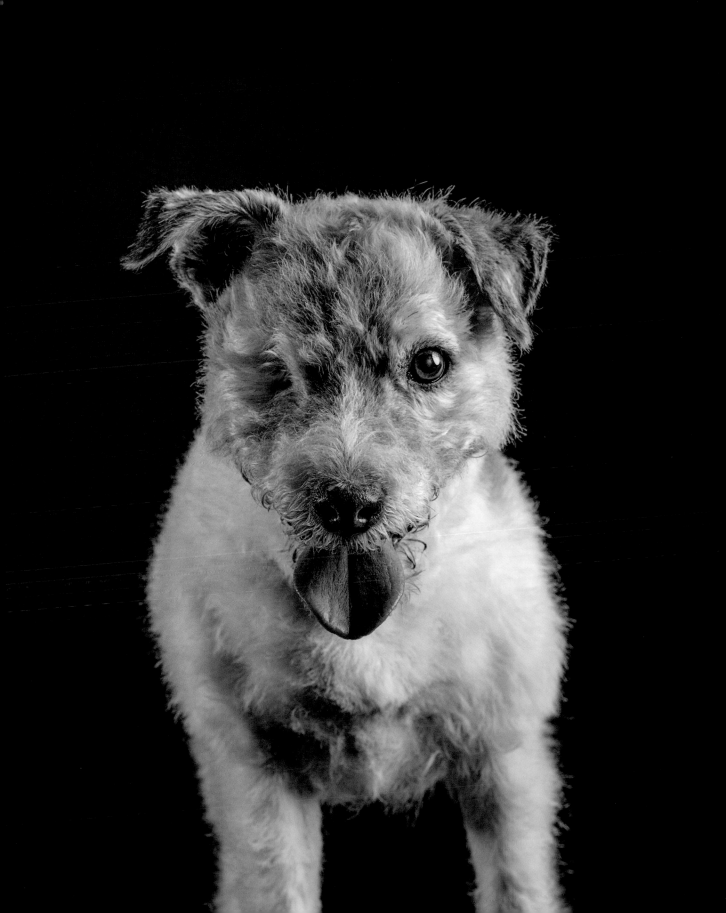

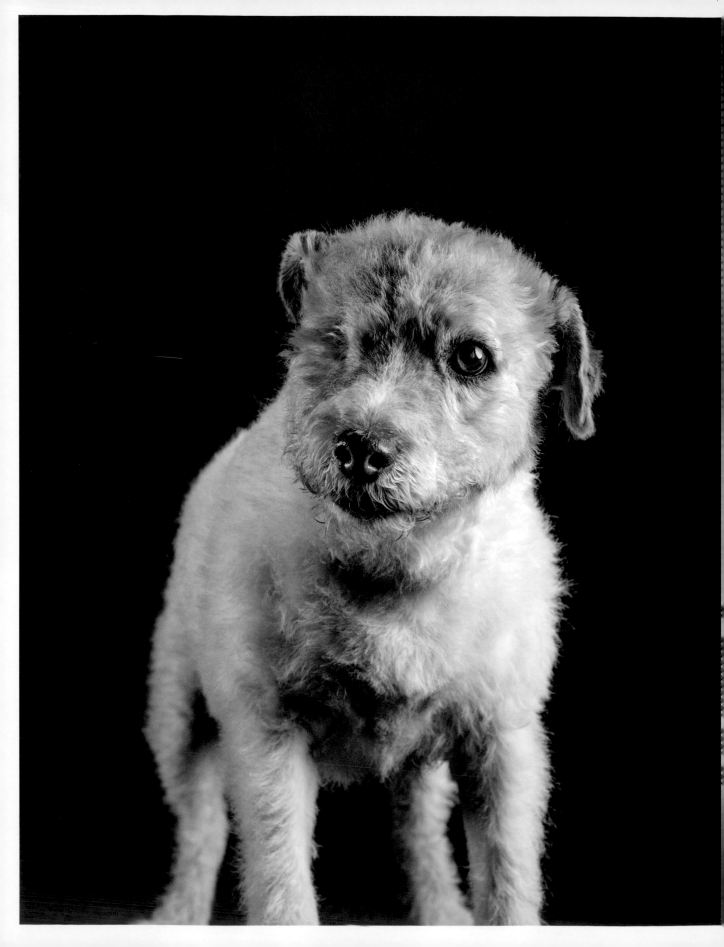

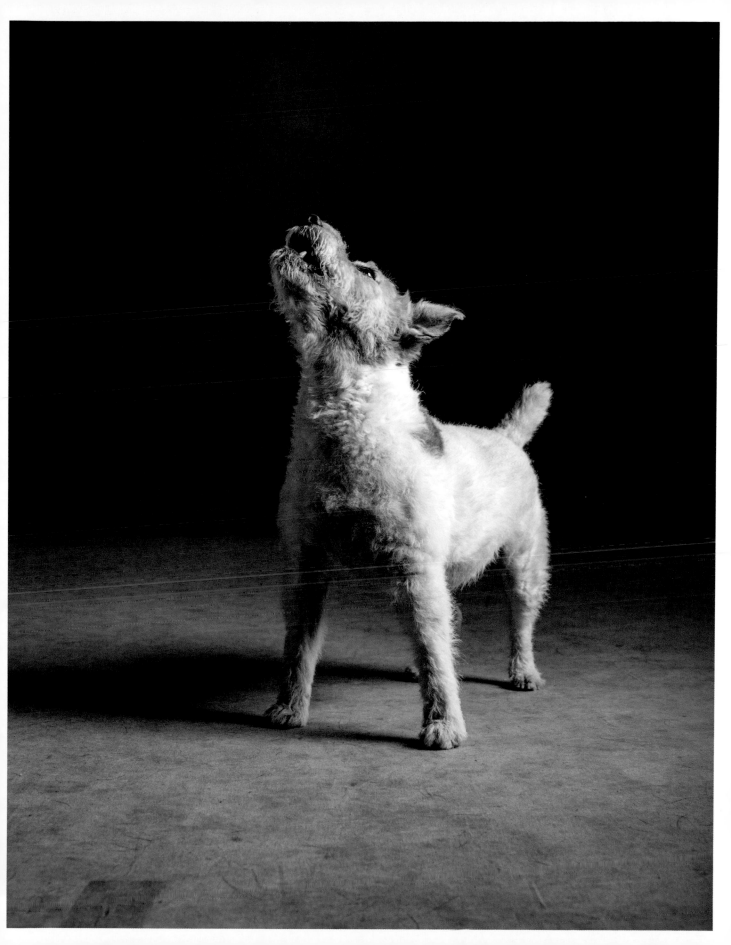

Luna

I have long had great admiration for the band
KISS and the tongue of Gene Simmons. I'm also
a huge fan of Luna, a lovely three-year-old blue
Doberman pinscher.

While she and Gene share some similar qualities and
interests, Luna does not breathe fire or wear platform
shoes or makeup like he does. I do believe dogs have
a keen sense of humor even if they don't dress up in
funny costumes and play smoking guitars. Luna has
great comedic timing, going from goofy to deadpan
at the drop of a tongue.

That said, it's disappointing that the tongue is virtually
ignored as a unit of measurement. Why is that? We
freely accept the use of feet for nearly everything.
We measure the height of our horses in hands and,
although horses can win things by a nose, they are
not able to hold anything at arm's length or within
earshot. Don't even get me started on head height.

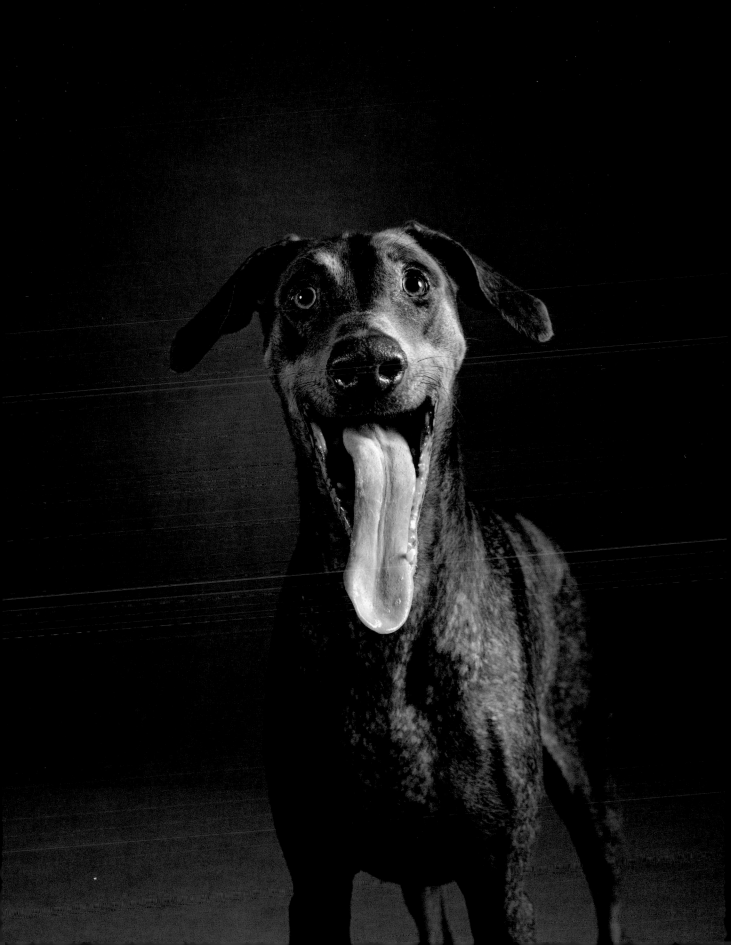

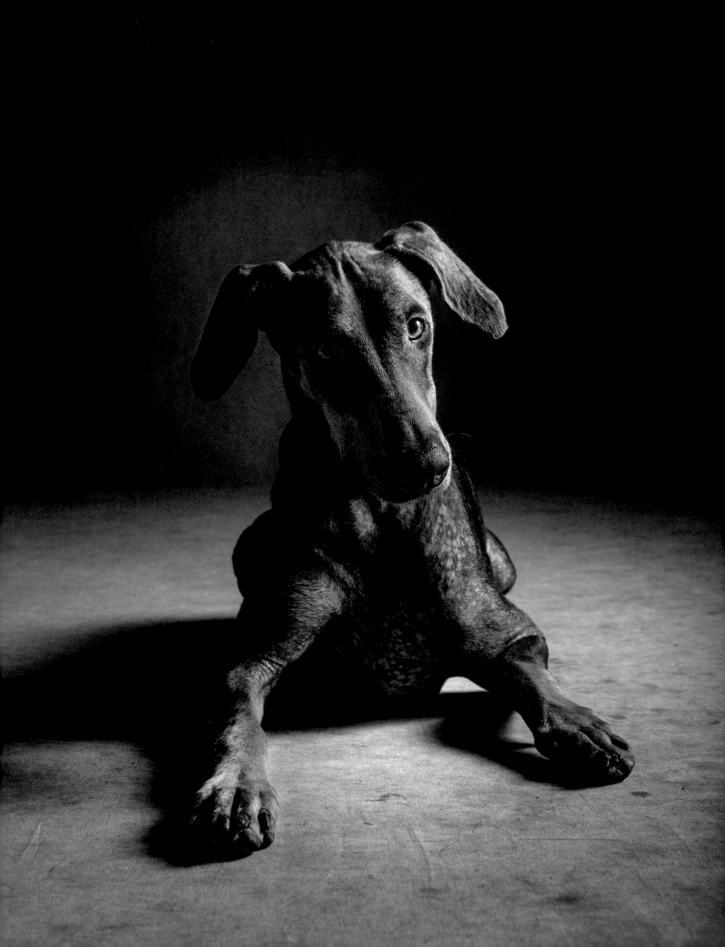

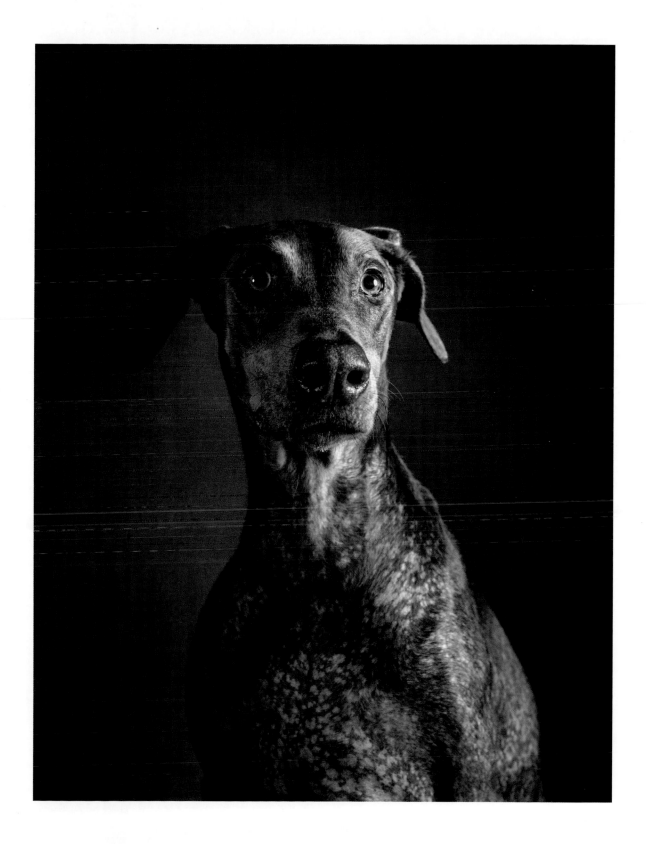

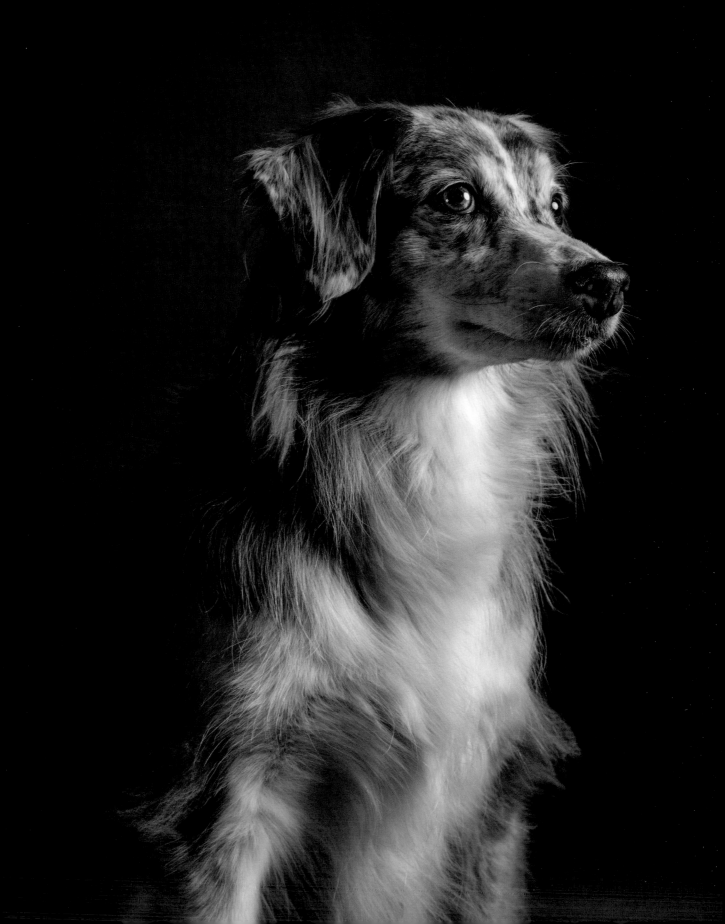

Miller

For a brief period when I was a teenager, my life revolved around the popular music duo Captain & Tennille. They were the perfect couple, posing with two giant bulldogs on the cover of their first album. I had a crush on Tennille and thought, as in the title of their hit song, "love will keep us together". Once I got rid of the Captain.

The key to Tennille's heart was to be a mood ring. Mood-ring mania was at its height in 1975 and my mother, unaware of my intentions, took me to Kaufmann's department store to get one. Properly used, it would translate my complicated teenage feelings and overcome any barriers that would prevent a small-town boy from getting noticed by a big-time pop star.

Miller is nearly a teenager himself, a miniature Australian shepherd with eyes like mood rings. He uses them for the same purpose as I intended – getting adopted at ten years old and going from small-town dog to the limelight of *The Year of the Dogs*. If he uses them on you, be warned: you are powerless to object.

My mood ring never did work. It just sat there mocking me and ignoring my mood swings. It stayed black and never changed color, no matter how angry I got. I'm sure if I'd had Miller by my side, the whole thing would have gone differently for Tennille, the Captain, the two bulldogs, and me.

Bullet and Shug

In our studio, there is occasionally something of a debris field. The leftovers from the previous dog: a scattered mix of fur, hair, drool, and food particles that are too small to be detected by the naked eye but trigger alarm in the olfactory department of a curious and food-motivated hound.

Upon arrival, the great brother–sister basset hound team of Bullet and Shug immediately began working over the place like those robot vacuum cleaners; canine Roombas executing a search warrant with the speed and grace of Olympic figure skaters locked in an intricate dance routine.

It was a sight to behold. Like gold-medal hopefuls, the dogs gave it their all and left nothing on the floor. Bullet's signature move is his triple axel, a flop maneuver performed on cue when food is nearby or he desires his belly to be rubbed – or both.

He nailed it, a perfect ten.

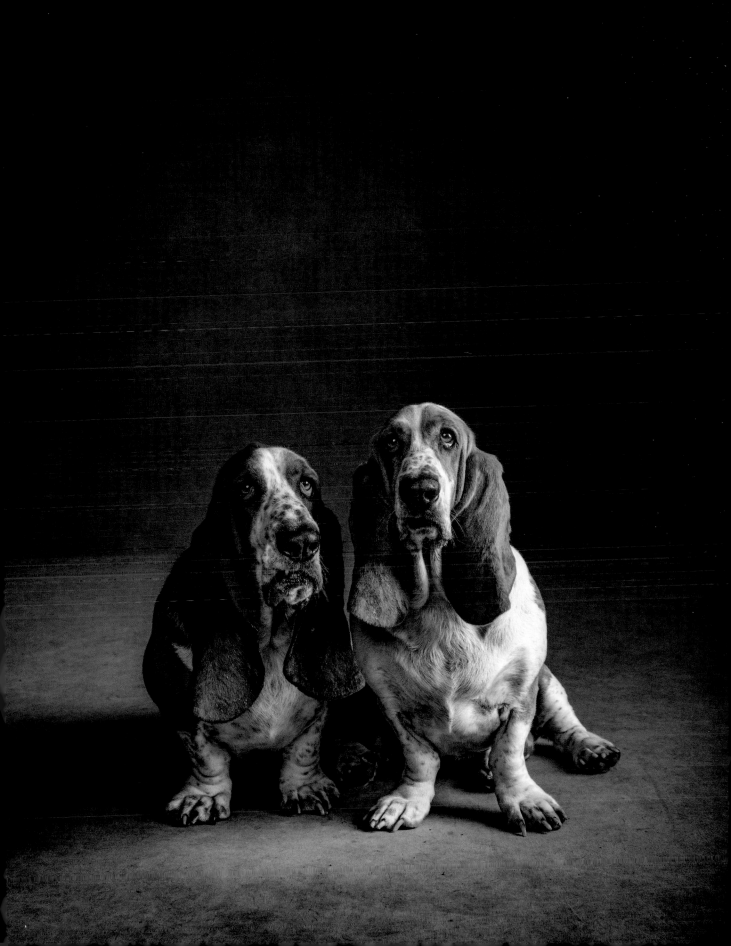

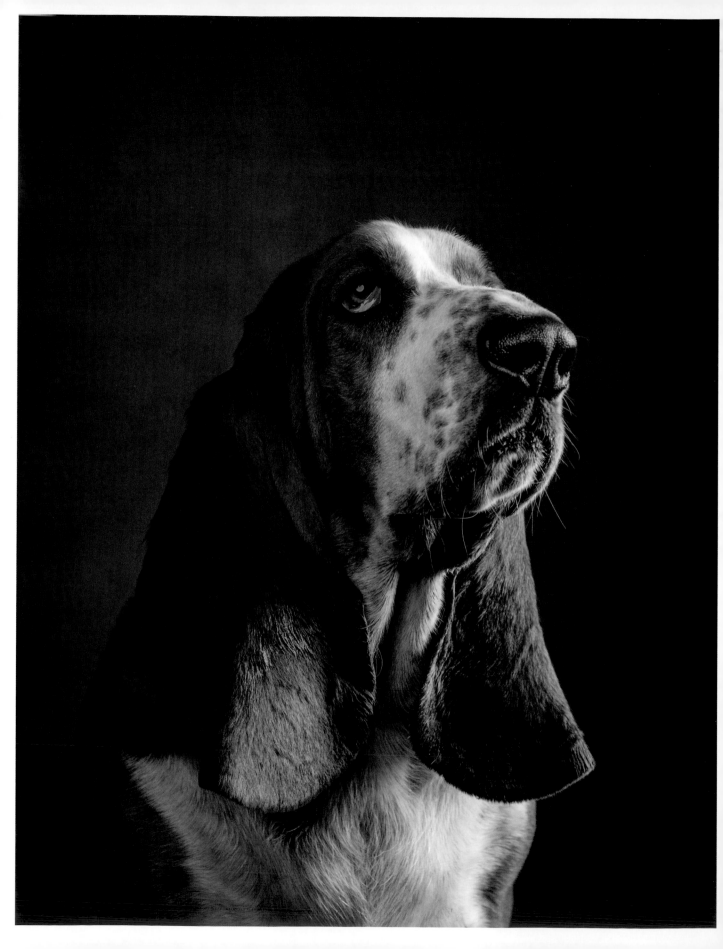

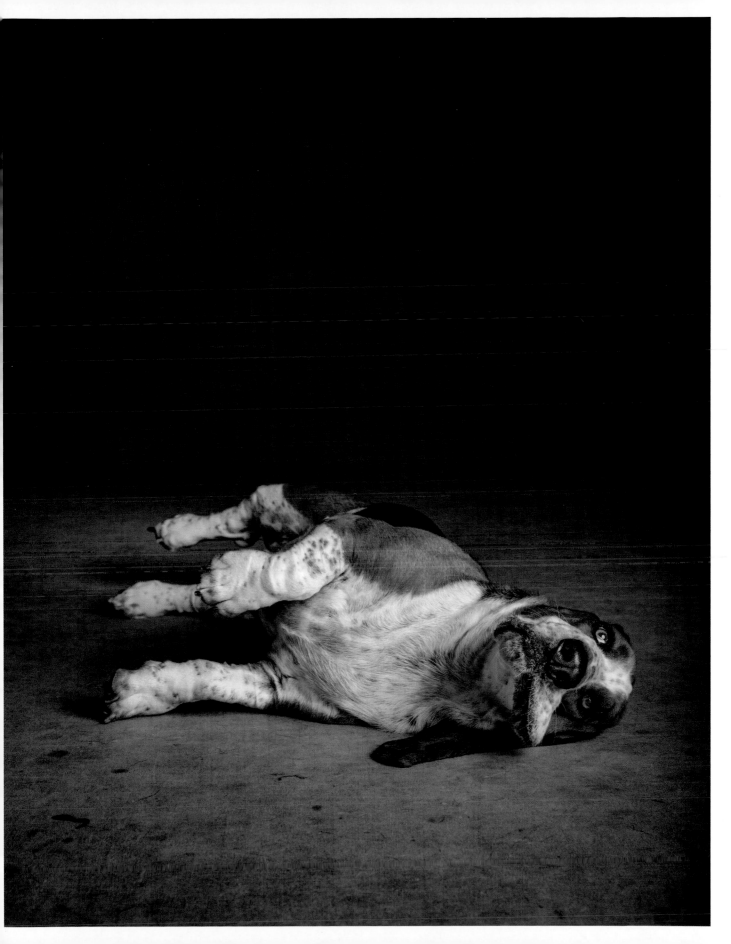

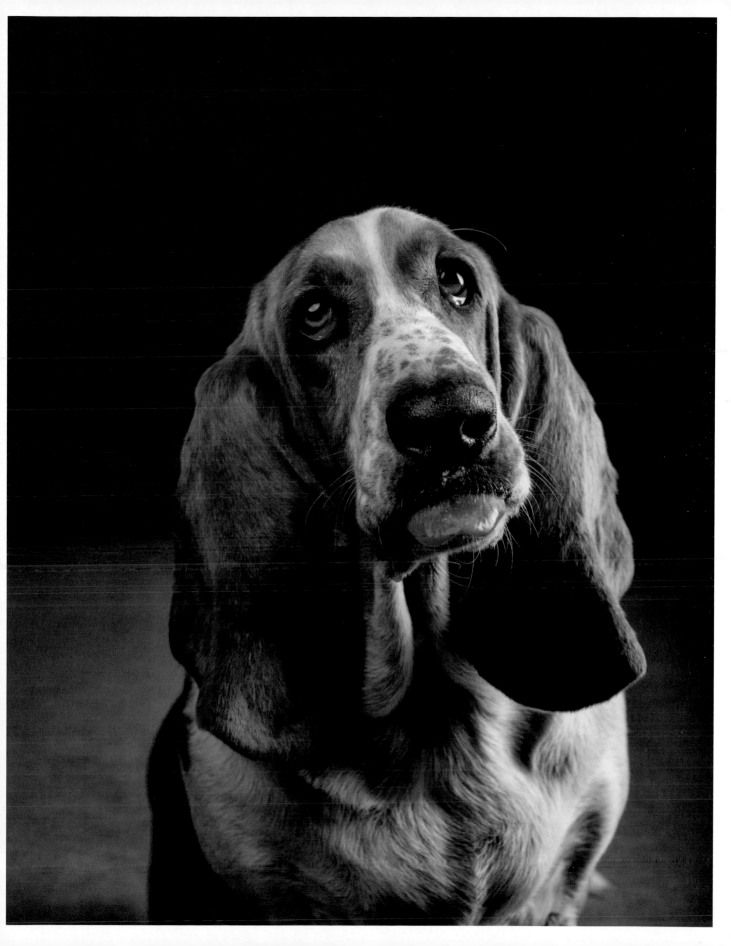

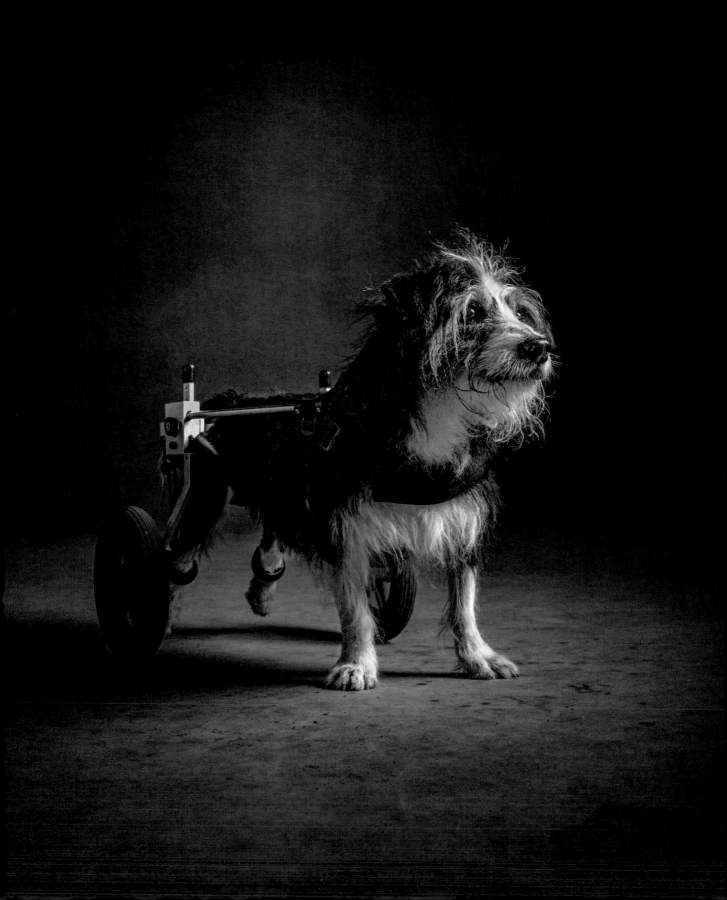

Oliver Twist

Who knew it could be so hard to photograph an old dog in a dog wheelchair? I didn't.

It doesn't matter what breed Ollie is; he's not into labels or posing for photographs. What matters is that, at nearly sixteen years old, Ollie's not getting any younger – but he's definitely getting faster.

Lee Majors gained fame in the 1970s as *The Six Million Dollar Man*. The US government spent a whopping six million dollars outfitting him with bionic gadgetry that made him better, stronger, and faster in order to be more compatible with Farrah Fawcett.

Ollie's contraption does much the same thing for a fraction of the cost. Without it, he gets around okay, as long as okay doesn't involve stairs or slippery floors.

When he was known by another name in another home, Ollie was bitten by a disease-laden tick, the aftereffects of which are chronic and slowly damaging to his neurological system.

Ollie's spirit, on the other hand, is unharmed by his illness. He has a well-deserved reputation as a southern gentleman, and he fancies a miniature poodle by the name of Wopsy.

Meikka

At one point I thought Callie was going to run off with another dog. It happens. The thought has crossed her mind more than once. We, who do not have a dog, spend much of our time with other people's dogs and we fall in love with them more often than you might expect.

Meikka was one such dog. We are still smitten with this gentle nine-year-old whippet. He crossed international borders to meet us, and you can easily see how this cultured, graceful, tall foreigner with a clever sense of humor and a Canadian accent is hard to resist.

While Meikka is conversant in the finer points of the North American Free Trade Agreement, he would rather wax on about important literature that his family regularly reads to him, like the misadventures of *Clifford, The Big Red Dog*, or the case of mistaken identity that almost cost *Harry the Dirty Dog* his home.

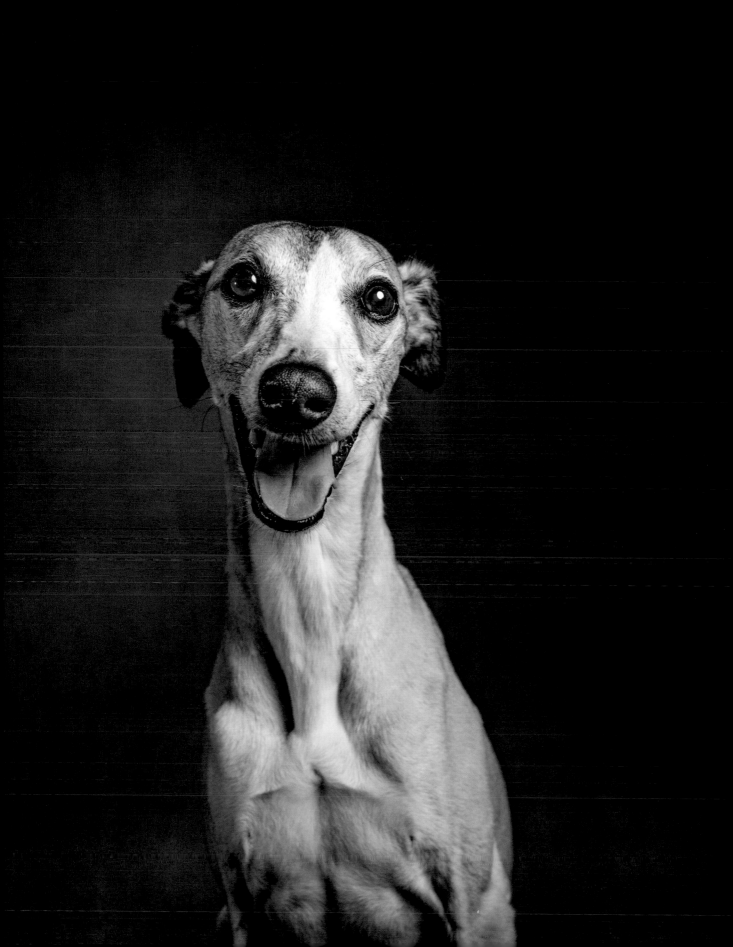

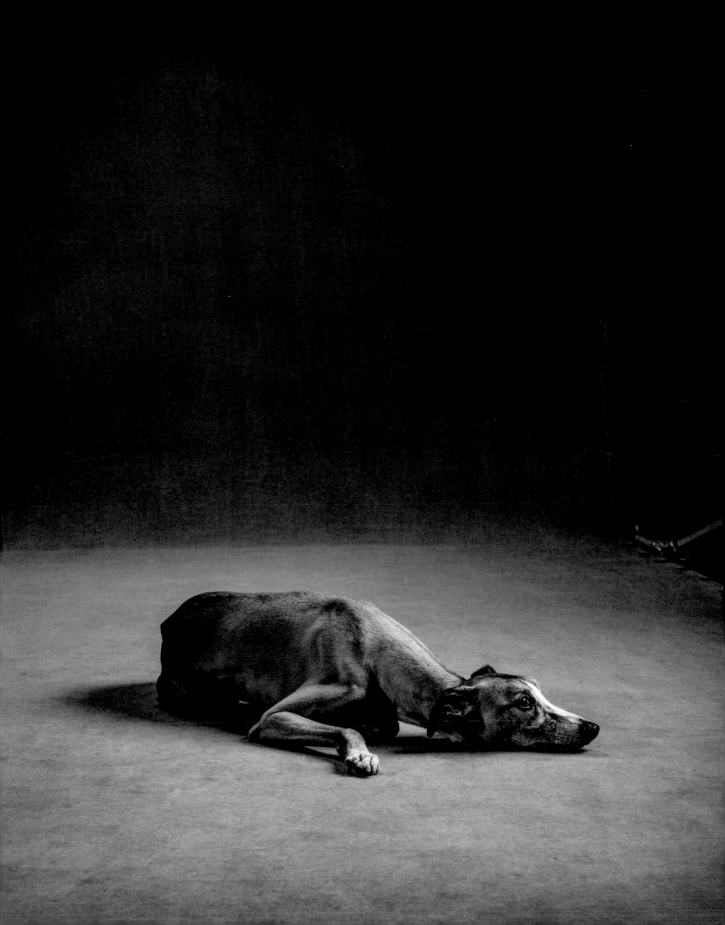

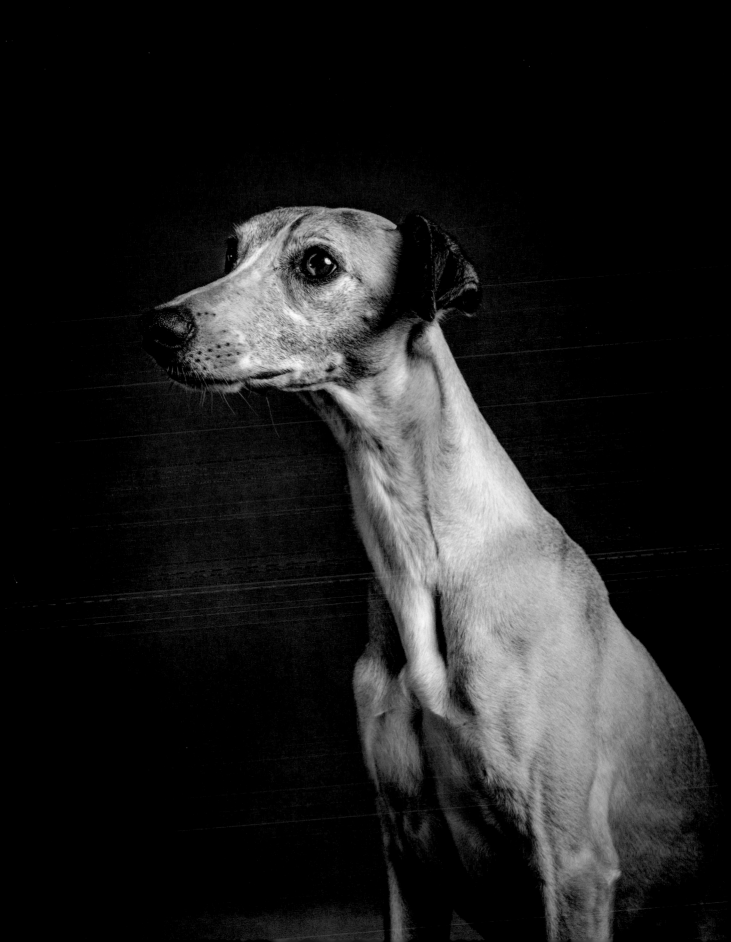

Lilly and Bella

Lilly is a Great Dane and Bella is a Weimaraner and they are both blue, although they look brown here and in person. This is confusing to me as some brown dogs are apparently considered chocolate, but not candy. I'm also learning that not all yellow dogs are golden and not all goldens are yellow, or even tan. In fact, they might even be red – or should be.

Thank goodness black is black, and white is white, unless it happens to be a cream color but only if it's not dirty, in which case it's probably just a dirty white dog.

I've also seen a silver dog that I swore was gray and a gray dog that I was sure was silver, but was really blue and did not look brown like Lilly and Bella. Several dogs we photographed were described as harlequin and some were brindle or merle and they might have been flecked or ticked but not always speckled or spotted.

Don't even get me started on liver.

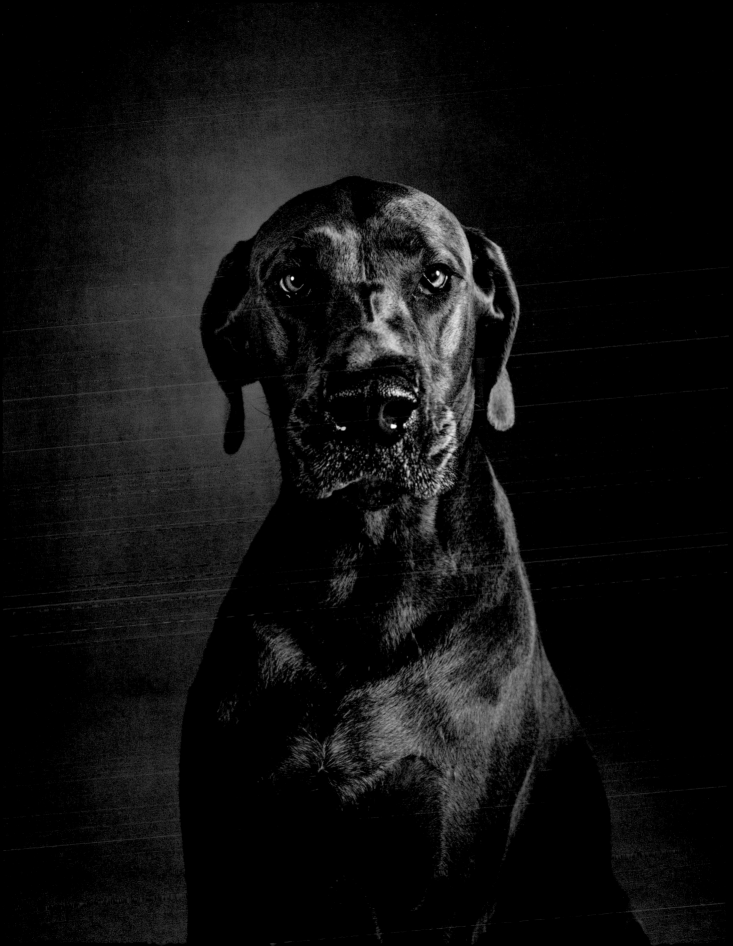

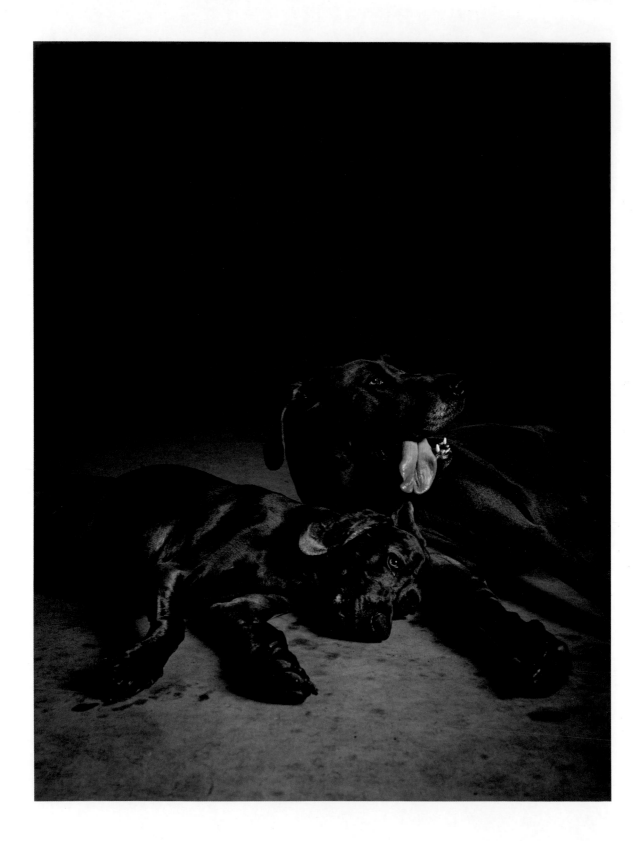

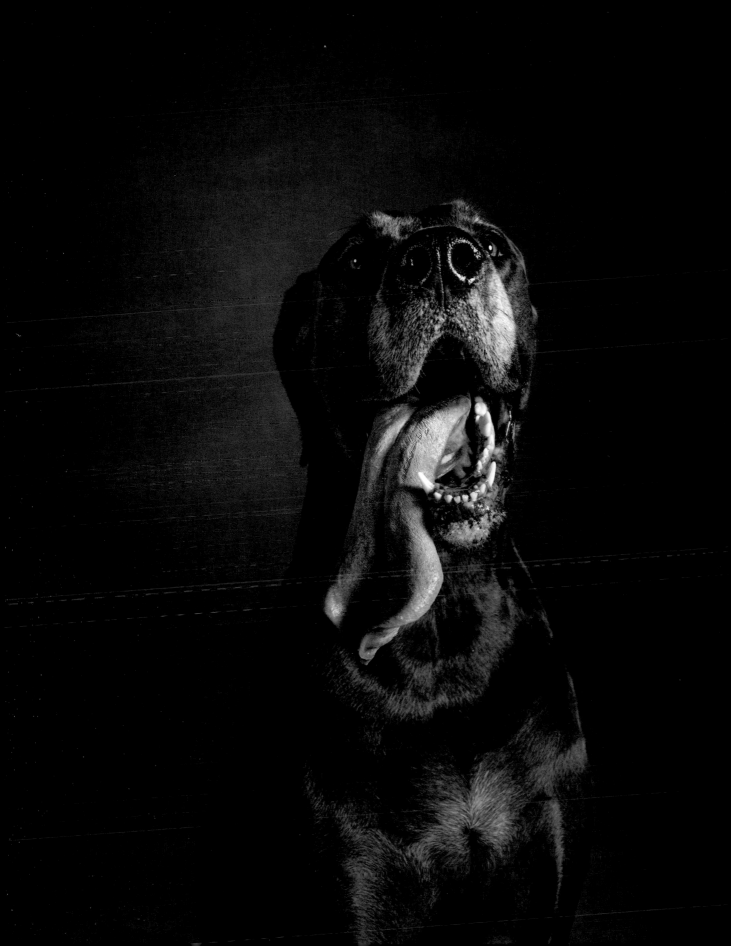

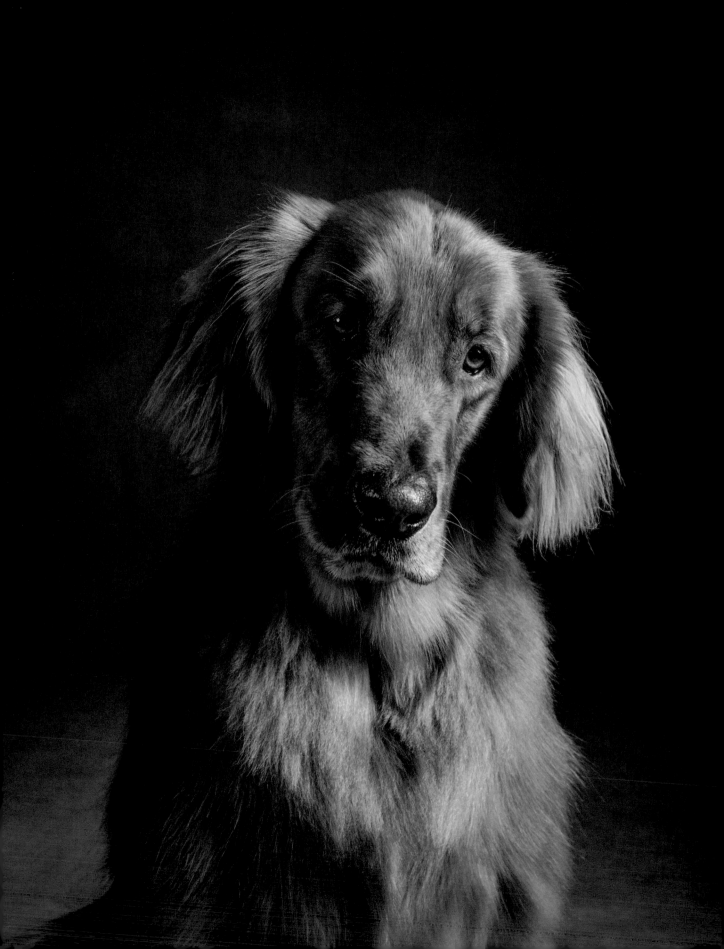

Finn

Finn is a golden retriever who is barely golden and only passing as a retriever. Neither of these things is expected to change.

Finn may only be three years old, yet he looks all the part of a well-dressed sage, a wise dog, an oracle, and the kind of dog you would seek out for romantic advice and limited financial planning. Sure, he would be hard on you and talk in circles, but later in life, after you bought a Tesla, married your childhood sweetheart, and invested in Apple stock, you'd thank him for it.

For all his bravado, Finn is a simple dog who is very afraid of his own shadow.

I understand fear. For more years than I wish to acknowledge, I slept with the light on and my head under the covers because my parents exposed me to a terrifying episode of *The Twilight Zone*, in which a man in a diner revealed a hidden third eye beneath his hat in an attempt to scare off a Martian with three arms.

At Finn's insistence, neither he nor I watch much scary television, lessening the chances of being taken in and frightened by such surprises. He is very wise.

Jesse

Stories that begin with a dog being found on the side of the road usually end poorly. This is not one of those stories.

Jesse was found on the side of the road. A lot of Jesse was broken, except for his spirit. He was barely the blue-tick coonhound you see here. He was emaciated, covered in tick bites, thick with heartworms. He had a busted tail and a broken femur. He was not in the best mood, yet nobody gave up on him.

I'm in awe of those who simply do not give up. It's a nobility of character that can be seen in the folks who saved Jesse, rescued Jesse, adopted Jesse. It can be seen in Jesse.

Jesse's still bothered by some things he shouldn't be bothered by. I'm told he was one of the most frightened dogs they had ever seen at the rescue.

He's shy in a humble way; wary but trusting.

He's a real comeback kid, who, despite his crooked leg, runs like the wind a little further away from the side of that road each day.

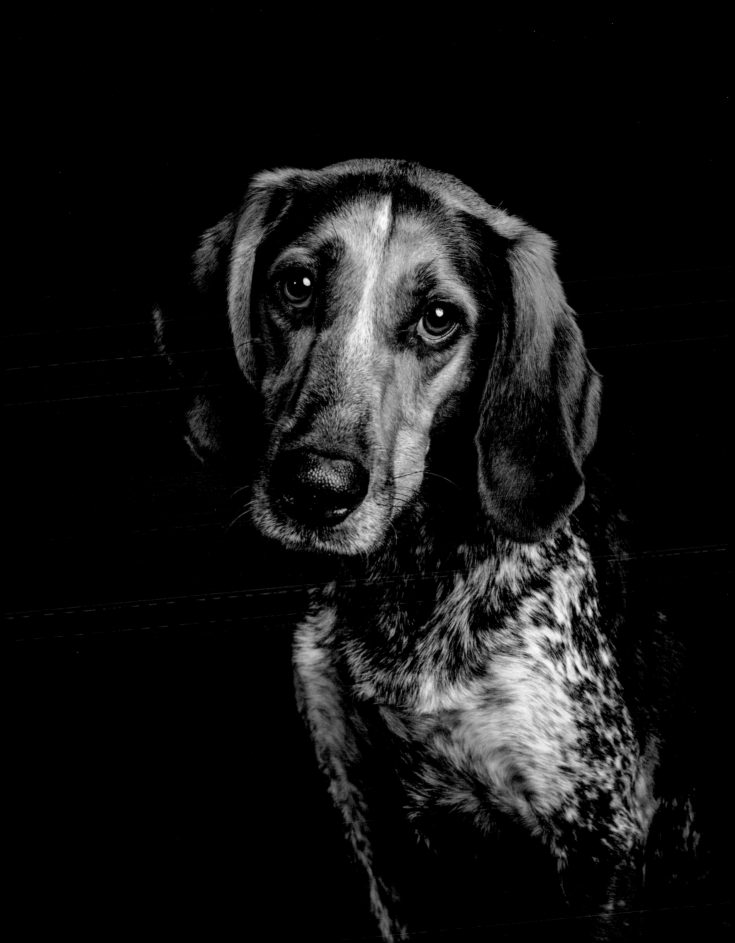

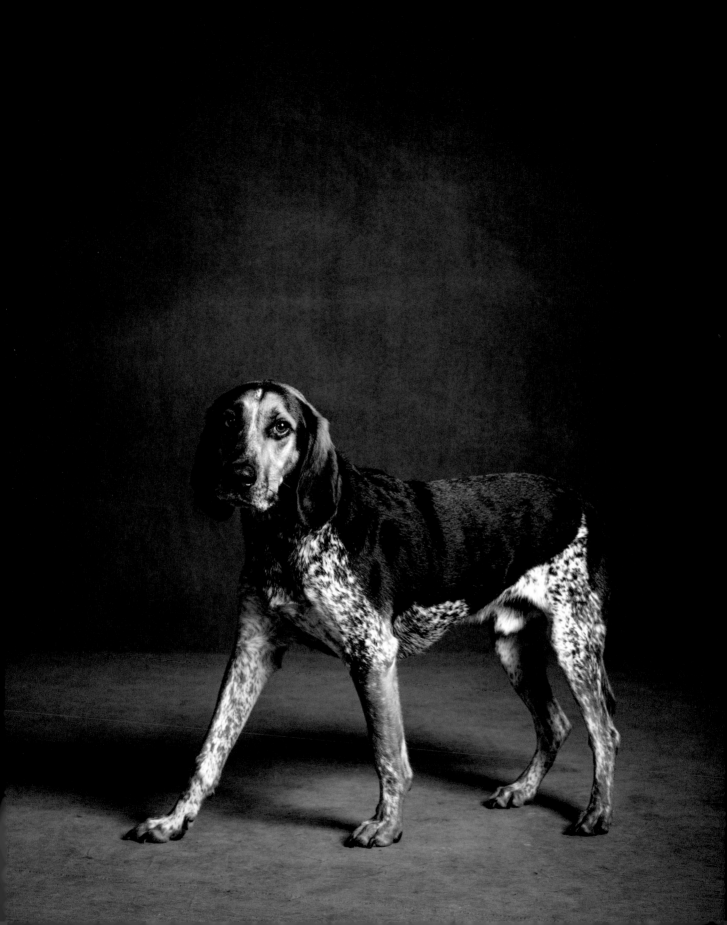

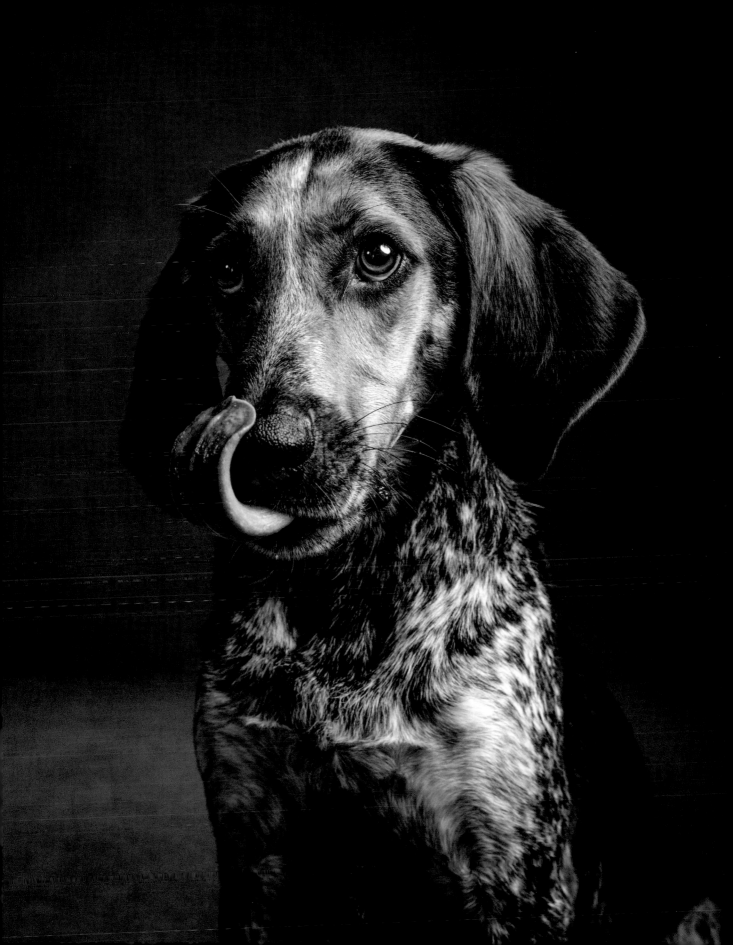

Louis

Size mattered greatly during Louis's formative years. The pug previously known as 'Meatball' was the "doggie in the window" of a New York City pet shop, where he was seen daily – until he wasn't.

Meatball had grown too big for the window and was reassigned to a less prominent position in the store when his owner-to-be came looking for him.

And, while Meatball may have been too large for the window, the pug now known as 'Louis' was just small enough to be smuggled past the doorman, in and out of a building that didn't allow dogs. The things we do for love.

Size matters less these days to this twelve-year-old, although his five front teeth are locked in a constant battle for space with his tongue. A world traveler, he has exquisite taste in food, music, women, and cats.

Between frequent naps, Louis is known to regale visitors with colorful stories about his time living in the city that never sleeps.

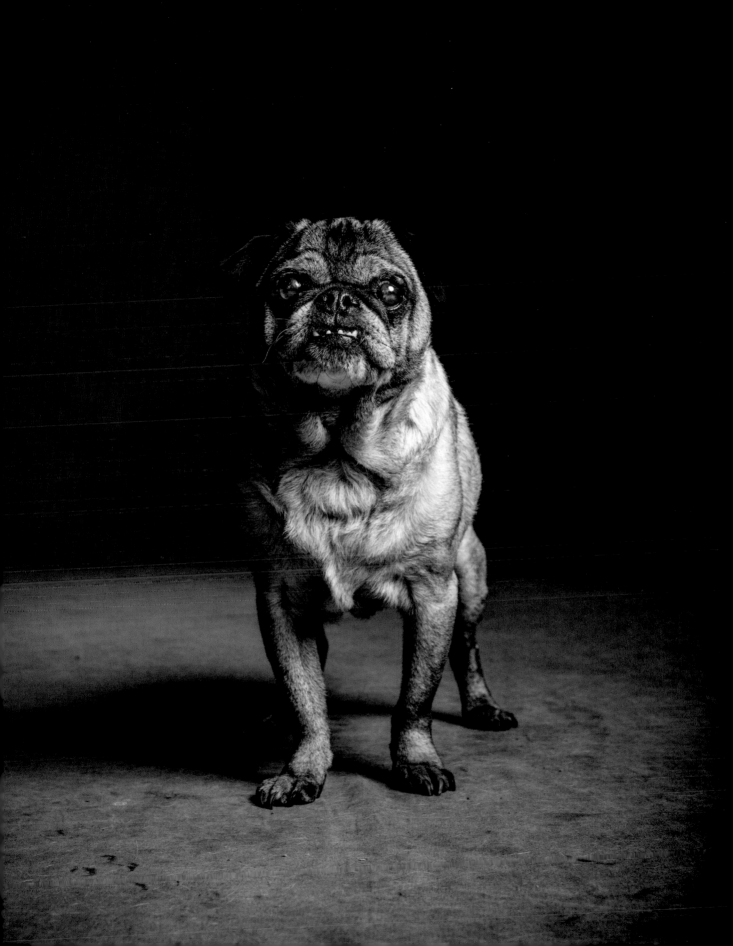

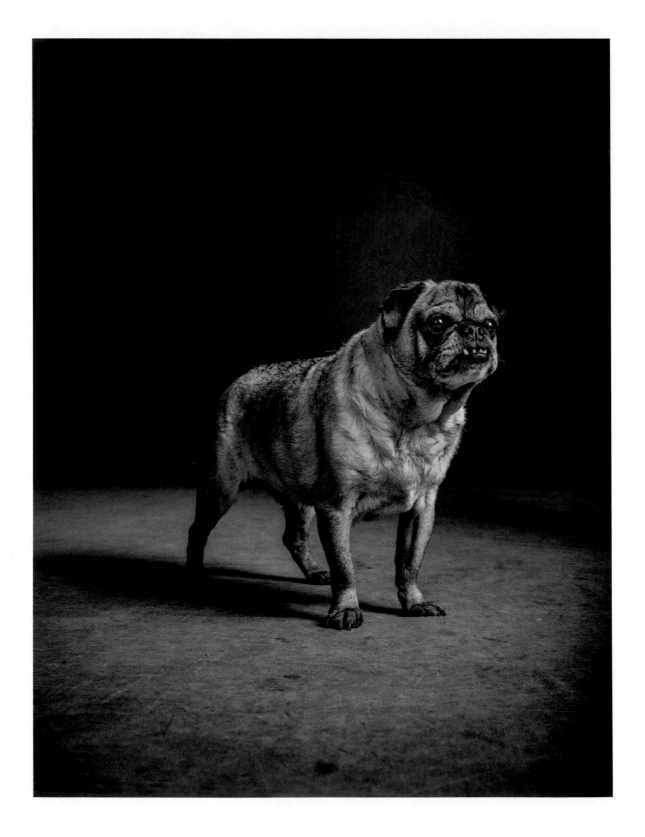

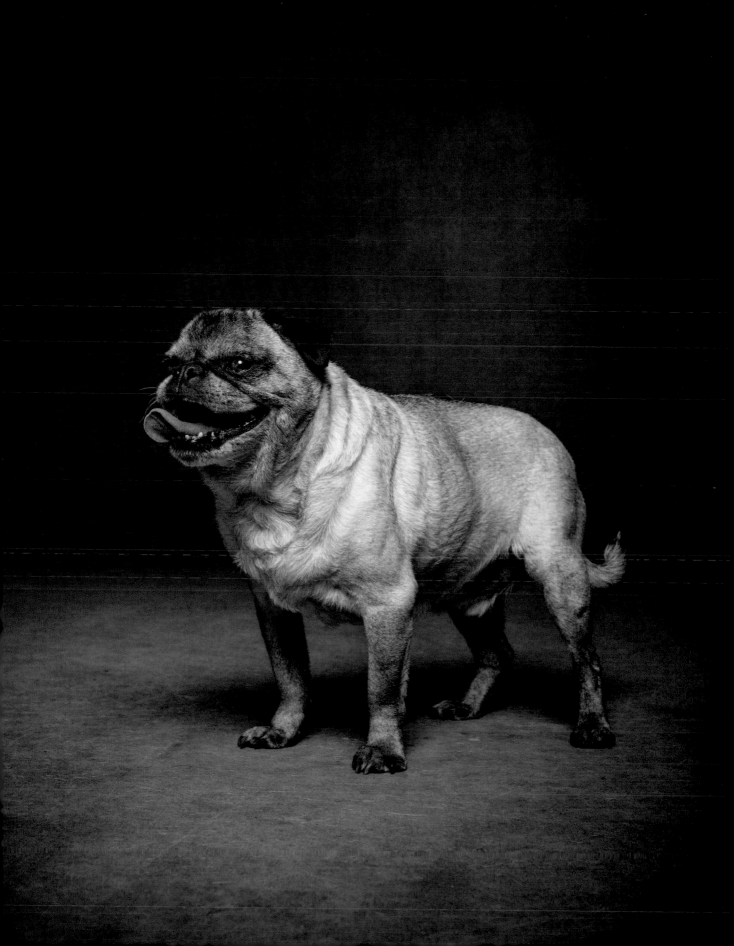

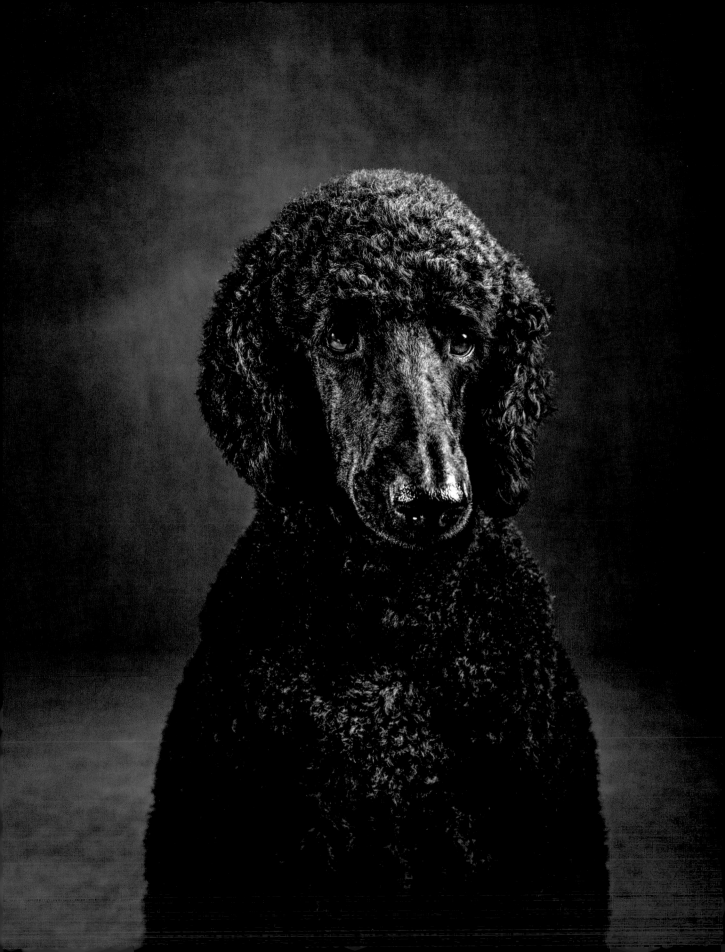

Zorro

Many people envision our work in the studio as a high-energy creative experience, with me shouting, 'beautiful, baby, beautiful,' and the dogs responding with pose after pose like models before the lens of the famous fashion photographer and international spy Austin Powers.

The reality is, I'm somewhat unable to speak when in the process of making photographs. When we work, I have a limited menu of grunting noises with the occasional guttural outburst, which is helpful in getting an animal's attention. It also passes for a kind of barbaric shorthand between Callie and me. That is, until she tires of it and gets mad at me, which she finds helpful in getting my attention.

Zorro is a twelve-year-old standard poodle and was too smart to get in the middle of our bickering. He tried to stay neutral, but eventually he always sided with Callie, the nice lady holding food. I am still learning to live with the rejection.

It's frustrating because Zorro is a very special dog who lights up a room when he enters, and I want a dog like that to like me.

Our connection was fleeting and dramatic. This photograph came together when I was finally able to vocalize a sound that engaged Zorro. I was trying to say his name but the consonants and vowels came out poorly mixed: 'Sha-to-or-oht-za-roo'.

This stopped Zorro, who was deeply engaged with Callie and a snack of some kind. He turned to me, tilted his head, and then he gave me 'the eyes' – the eyes that had comforted, the eyes that had got him out of trouble, the eyes that had earned him more than his fair share of mac and cheese.

And then, Zorro burped. Beautiful, baby, beautiful.

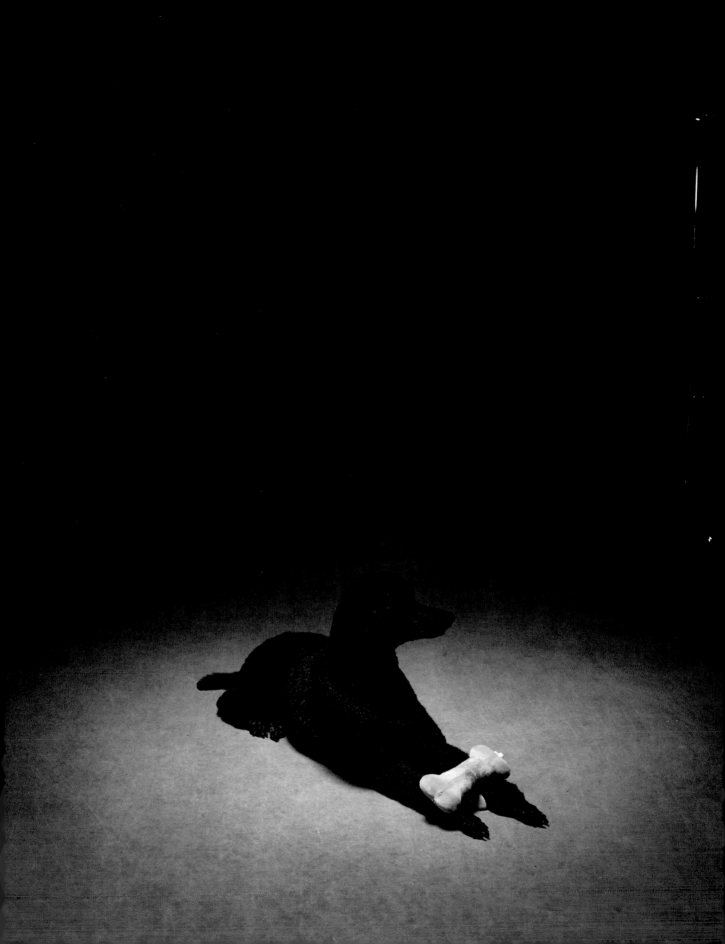

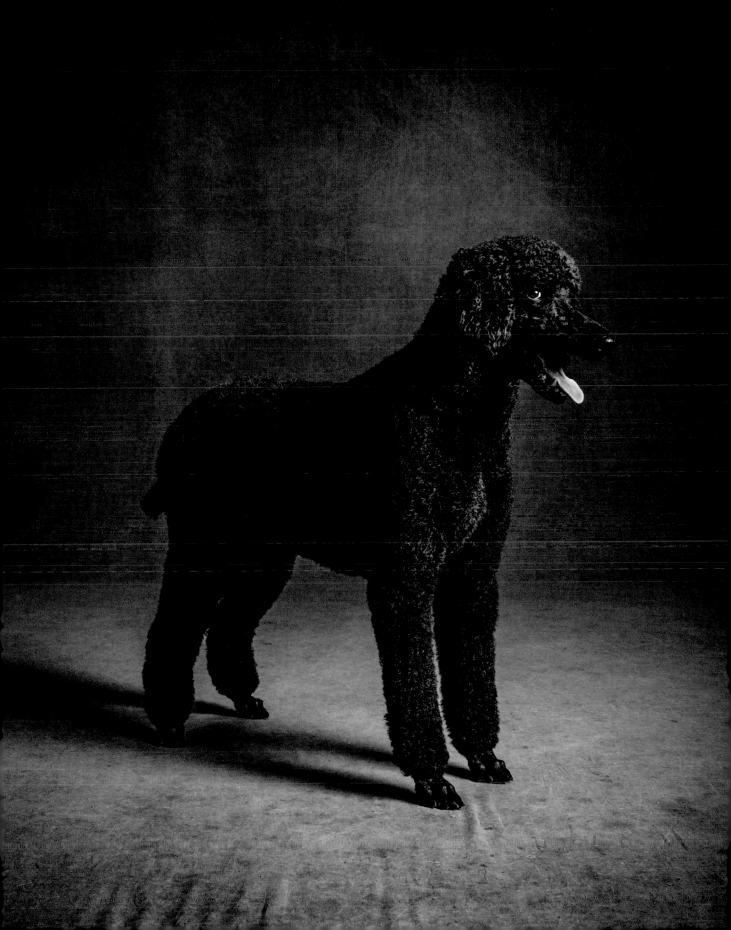

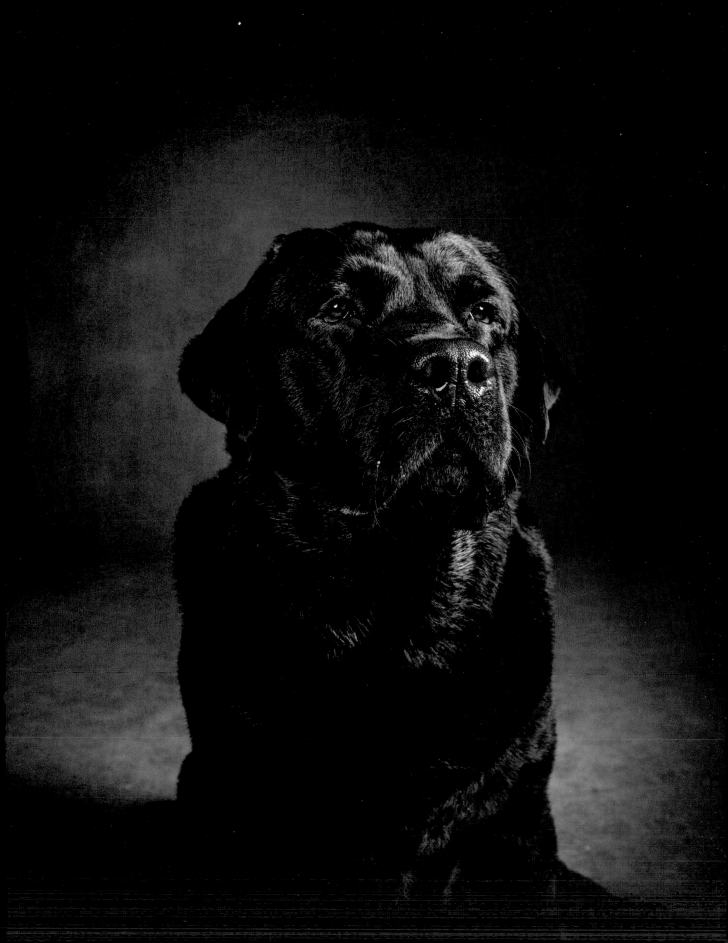

Sherman

Sherman is a New Yorker. A big city dog from the big city, a dog about town whose life reads like a children's story. Think *Eloise* or that oft-forgotten kid from *Home Alone* being chased around Central Park by crazed bandits.

Eloise and the kid were left behind in the city to create mischief and legendary comedy. Sherman is never left behind but, if he were, he would easily do better on his own without resorting to booby traps or superglue. His comedic timing and knowledge of Central Park would challenge even the best of villains. While he may have trouble with the New York City subway system, his Uber rating is a solid four-point-eight stars, both as a passenger and a driver. If you are lucky enough to ride with him, Sherman is well-known as a very generous tipper – if you're into slobber and certified-organic dog treats.

Sherman is also known to be a lens-licker. Between takes in the studio, Sherman liked to lick the front of my lens (a lot). When I wasn't looking, he would lurk around my camera bag and lick the lenses.

This was a first for me, and cleaning fees were considered. My lenses are a little sticky now but my pictures have never been clearer. I can take a licking and keep on clicking.

Brian

Brian is a rescued Labrador whose provenance is never questioned and always respected. At fifteen years old, he holds the position of elder statesman to an ever-expanding quorum of eight other adopted pups.

By the time I was born, both of my grandfathers had passed away, depriving me of the disciplinary regimen that grumpy old relatives bestow upon their descendants. Which is to say, I got away with a lot. Brian has seen his share of the nonsense that can come with a guy who didn't grow up with a grandfather. Which is to say, with Brian, I got away with nothing.

And so our brief time together was punctuated with the kind of give-and-take that arthritic hips and years of good behavior can produce.

They say when the student is ready, the teacher will appear. Thanks, Grandpa.

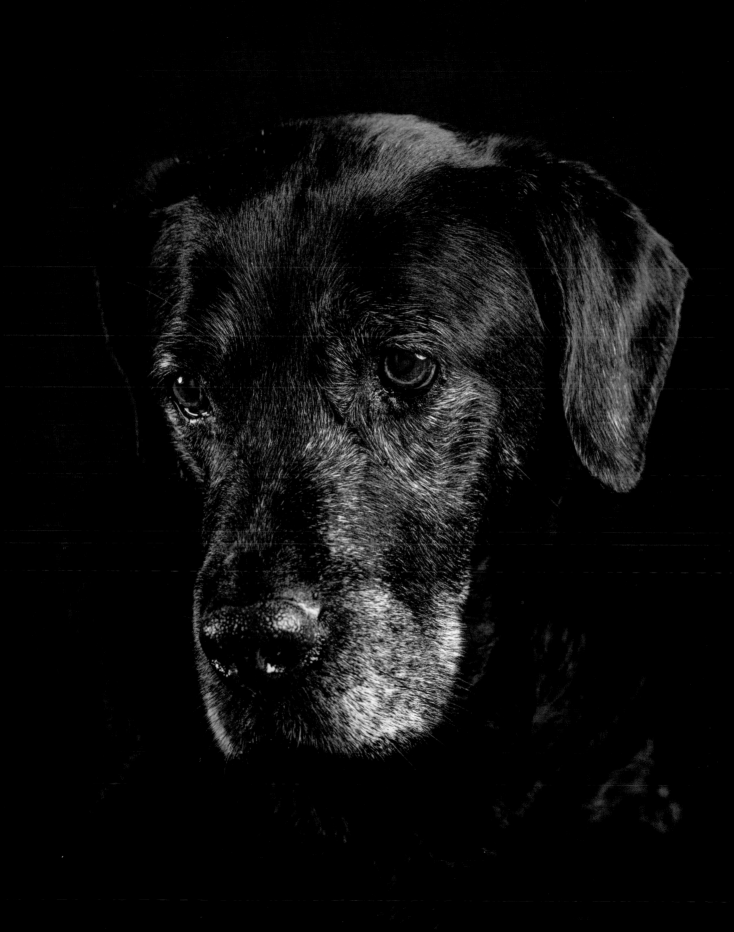

Otis

Otis and I are both originally from around Pittsburgh, close enough to say that we're actually from there but really far enough away to know that it's not true.

Had we grown up together we would have been running mates and got away with stuff. Nothing serious, just lightweight crimes and misdemeanors, the antics and charades of childhood that make grown-ups shake their heads and fists.

When choosing a running mate, you should always choose smarter, faster, and better-looking so as not to draw attention to yourself when running away.

Otis is that guy. He's a two-year-old Doberman pinscher who, when faced with a challenging situation, would charm the pants off you. His real friends are a horse named Piper and rooster named Earl.

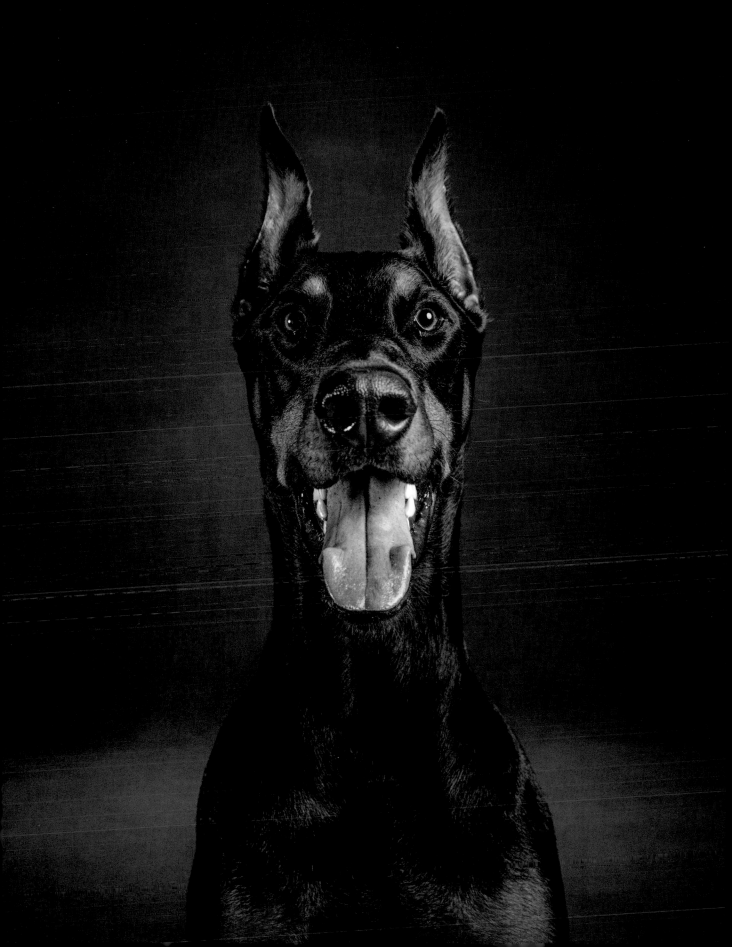

Baby Boo and Luna

I cried when Sonny and Cher broke up. It was the summer of 1975, my first as a teenager, and I was confused about love.

"Love Will Keep Us Together", sang the popular music duo Captain & Tennille. Bad Company always felt like "Makin' Love" and yet Nazareth warned that "Love Hurts". 10cc's lead singer went on and on and on, proclaiming "I'm Not in Love", and everyone knew he really was.

Like all couples Baby Boo and Luna have their ups and downs. I'm told that Baby Boo has something of an ego and has been known to growl. Luna takes it all in stride, confiding that the secret to their long relationship is a short memory. I'm pleased to report that Baby Boo and Luna are still together, and their love is strong.

Both are miniatures; Baby Boo, a Yorkie (left), and Luna, a Maltese (right), aged two and three respectively, have made it work despite their differences in background and age.

Baby Boo and Luna have three grown 'children' who still live at home. As you might imagine or even have experience with, this is a source of occasional friction in their relationship, but both are convinced their love will pay the rent.

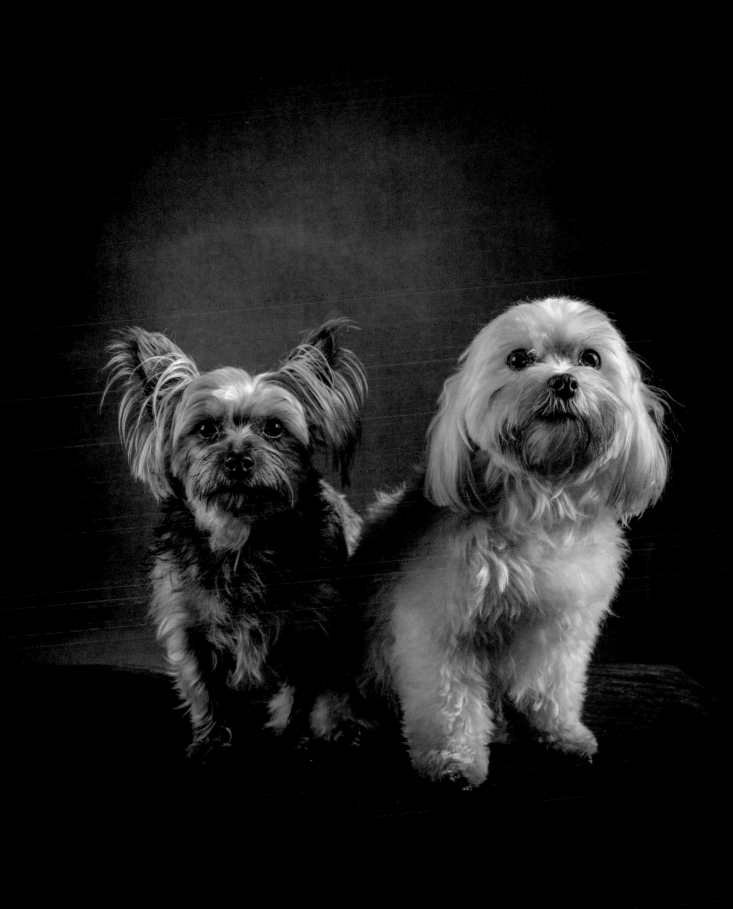

Poppy

A girl I know named Pepper picked out a pound
puppy named Poppy, whose fleece is best pictured as
a poplin – a woven sixty-forty blend of natural fibers,
fine polyester, and hasty breeding. Poppy's marled
and spotted coat has a high thread count and a sateen
feel, yet it does not require dry-cleaning.

In the summer of 1984, I owned a pair of JCPenney
Par Four slacks made of a similar poplin material
that inconveniently and embarrassingly burst at the
seams, exposing my buttocks as I arrived at a photo
assignment for the daily newspaper.

Unlike the Par Fours, Poppy is still fashionable,
strong, and durable. She's a super hard-working
girl with a bucket list that keeps getting smaller, as
this was her first time off the farm, on a leash, on
a plane, and at the beach. She's spent most of her
thirteen years chasing errant cows, donkeys, goats,
and pigs around a farm and keeping deer, squirrels,
and foxes away.

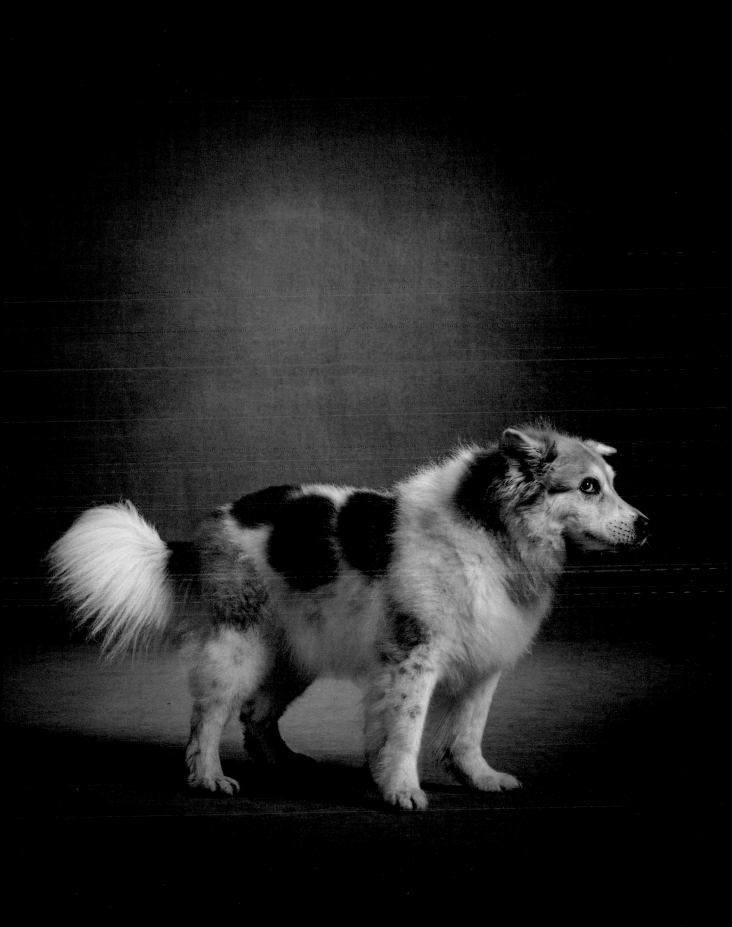

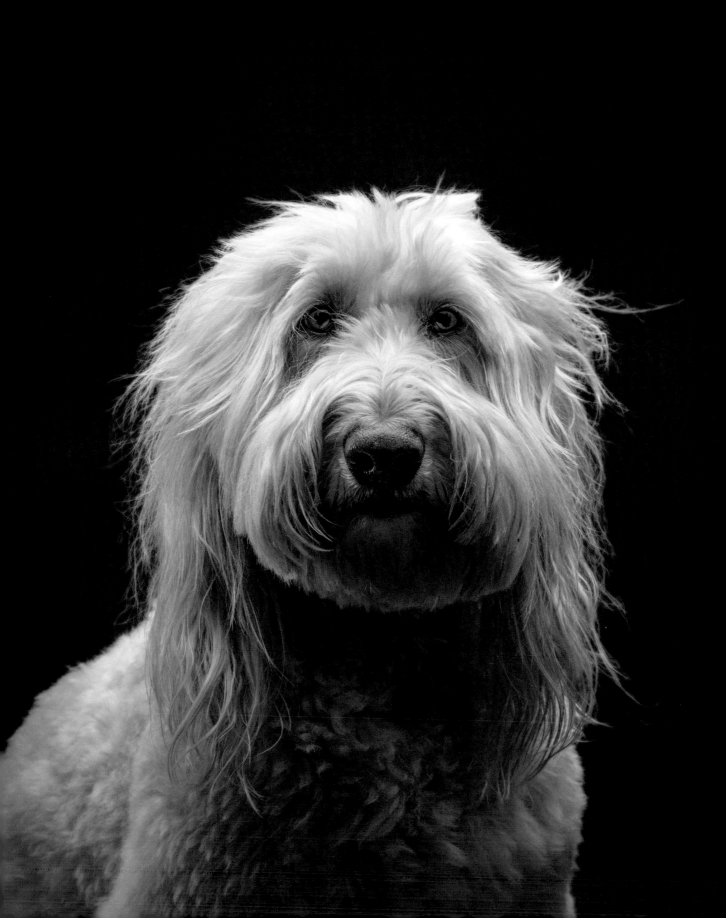

Ralph

Not all doodles are created equal.

An Instagram follower who objected to my possibly defamatory, but wholly truthful, portrayal of doodles is the owner of Monty (page 30). They also happen to own Ralph. I hope both labradoodles and their family will accept this photo as evidence of my contrition.

Ralph would do anything for you. That is a fact. You need that in a dog, because it's the sort of thing that goes a long way when your other dog is a bit of a control freak. I hope I haven't worn out my welcome.

Baby Gus

I recently discovered our dental floss is made in Ireland. Callie flosses more than I do but swears she didn't know. I'm concerned we should be trying to locally source our floss. Maybe find a youth collective hand-waxing the stuff using Sea Island cotton and regionally produced beeswax.

A great smile is so hard to maintain.

Gus will tell you that a great smile can get you a long way. He's a two-year-old Staffordshire terrier with a distinctly French accent and a pleasant tooth-to-gum ratio. Gus has that aspirational smile, the kind you see in those advertisements for invisible braces and DIY teeth-whitening kits. He's playful yet serious, a real 'catch' who is successful both at work and home because of his attention to good dental hygiene and a high-fiber diet.

He's originally from Indiana, where his tactical use of a winning smile got him seen and adopted from across multiple state lines. Gus now spends his time working on his tan at the beach and he usually gets his way just by flashing that cheese.

I do not know where his floss comes from. Keep on smiling.

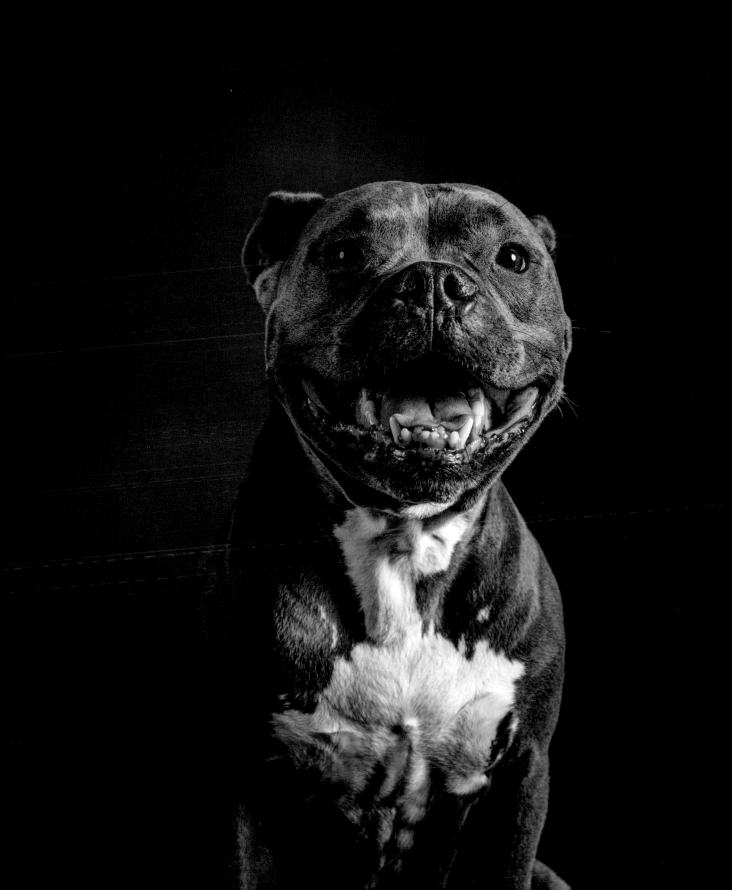

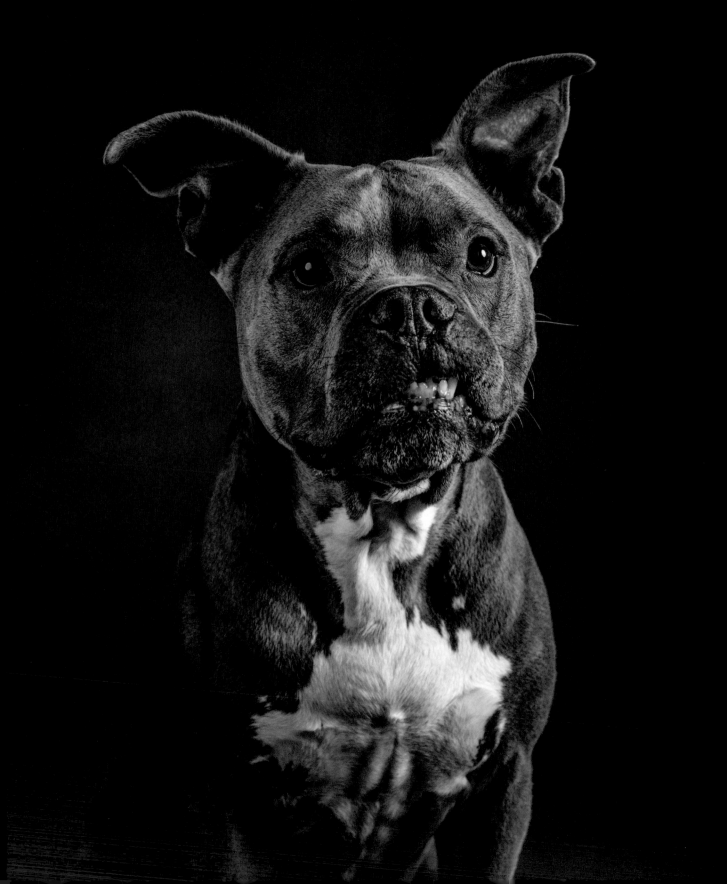

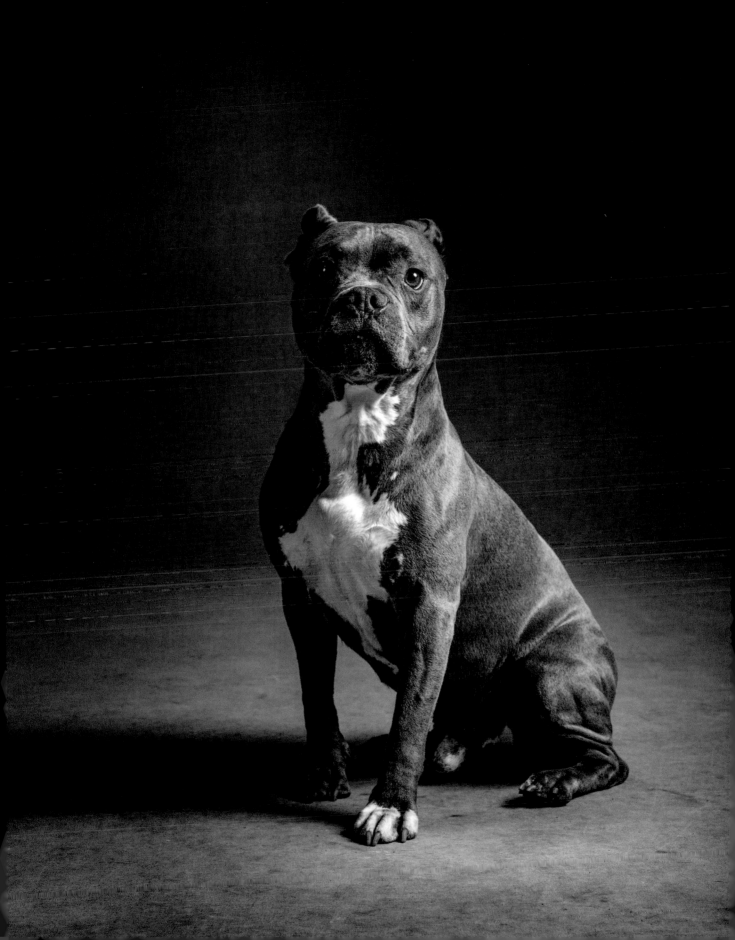

Frankie

Frankie should be a fire dog. He's a five-year-old dachshund mix, blended with a generous touch of law enforcement and public safety. This was likely garnered when he was picked up by the authorities for vagrancy and dumpster diving.

He's naturally equipped on a level that makes me question why fire departments have, for too long, ignored the Swiss Army knife-like versatility of the dachshund breed.

First off, he's fast, focused, and strong, and if meals were provided on a regular basis, he would probably be obedient enough to make it through the rigorous training required.

Second, pay close attention to his unique physical design. Frankie is coordinated and fully operational, like one of those long tiller trucks with two drivers and two steering wheels (one in the back and one in the front).

Third, upon arrival at the scene, Frankie can be deployed as a ladder truck, reaching a neck-and-body to leg ratio that would make a giraffe jealous.

Finally, his ears are powerful beacons used in establishing a mobile command post. He can instruct where to tune in in your area for news and official information, should there be an actual emergency. I submit this proposal to you: Frankie as the ultimate fire dog.

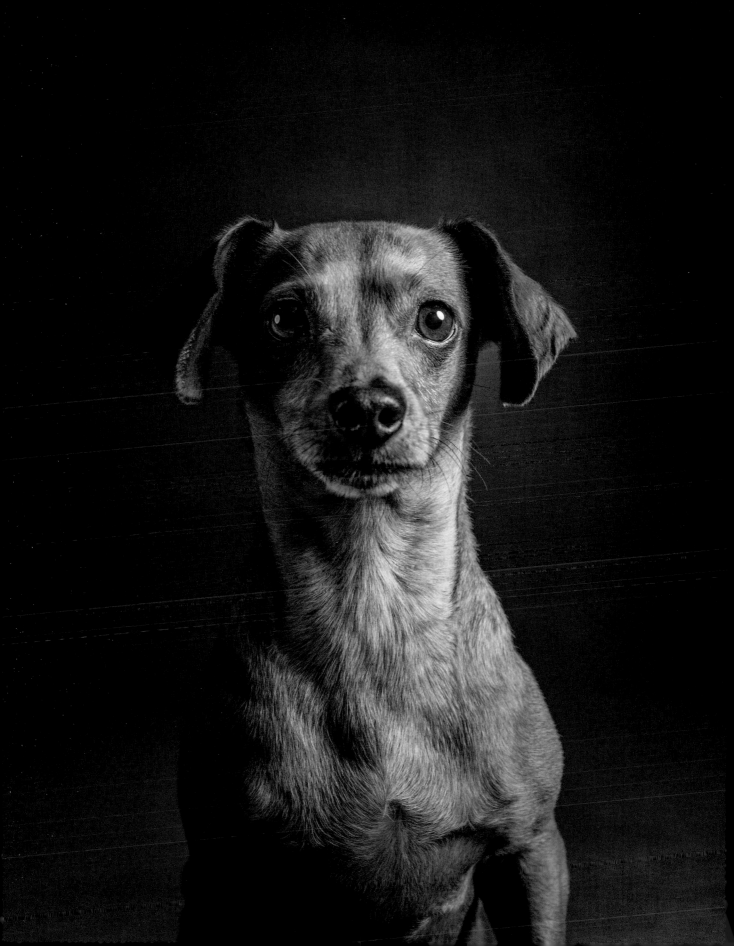

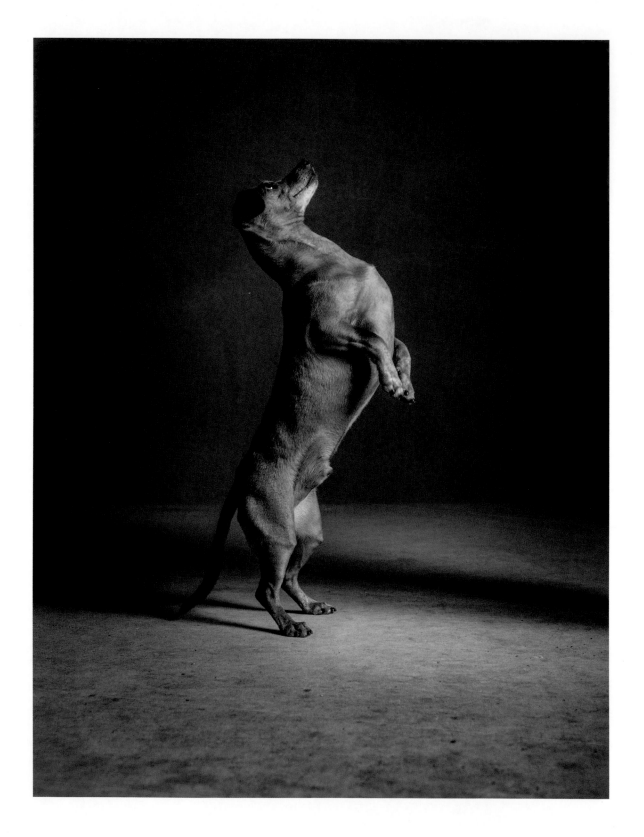

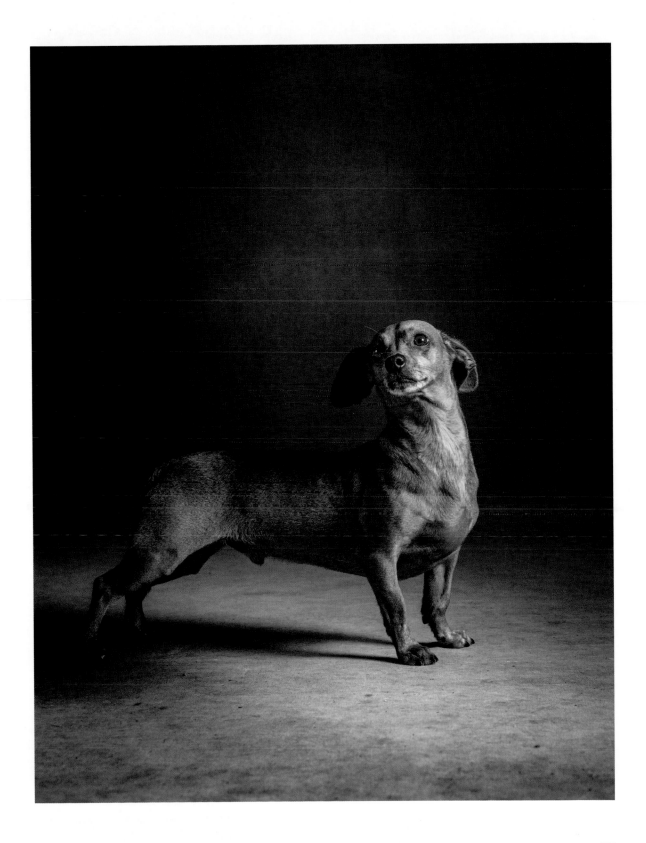

Patsy

Many people write, 'I wish you could photograph my dog.' One person wrote, 'These portraits make me wish I was a dog.' It's the highest compliment I've ever received.

I often wonder what the dogs think about their portraits. Do they think they look old or ridiculous or that I caught their bad side? 'Oh, my fur was a mess,' they might say, or, 'He caught me right when I had to pee.'

Sometimes a dog will present themselves in the most beautiful way, proud almost.

These photographs are never taken but always created through collaboration. Like a dance, each pose and gesture is met with a response. As Callie swirls across the background and a dog follows, I drop to the floor and watch and wait and hope. A flash punctuates the moment and defines it for better or worse. And once in a while, magic happens.

Every dog is different. I have learned to enjoy the uncertainty of it all and am humbled to have it appreciated.

This portrait of Patsy is one my favorites. She's elegant and graceful, powerful and vulnerable.

I wonder what she thinks about her portrait.

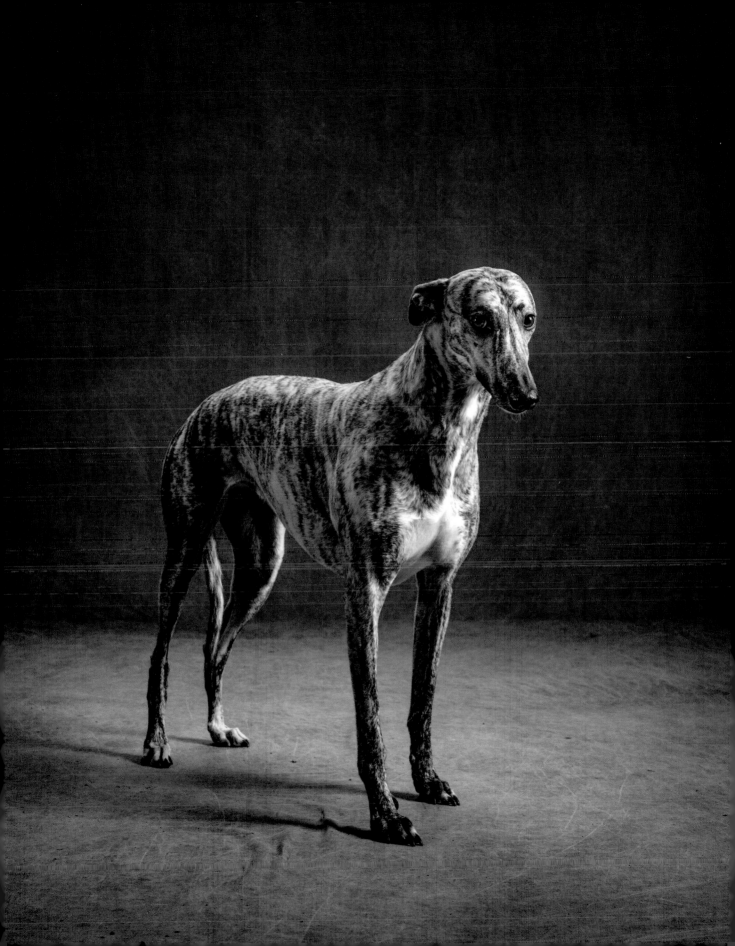

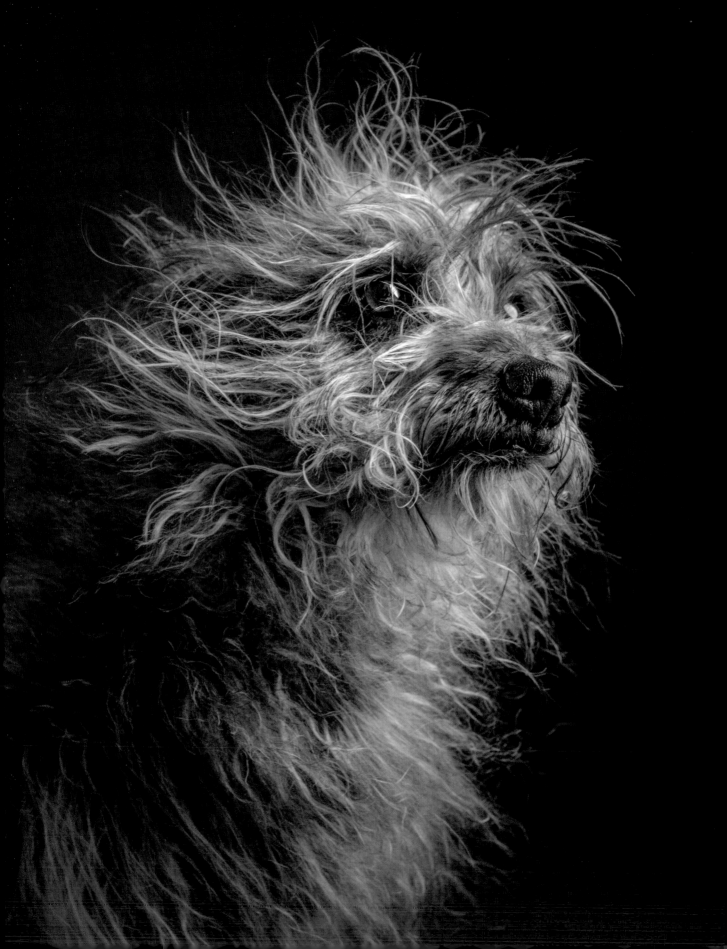

Smokey

Smokey is of unknown age and undetermined breeding. He is estimated to be between seven and 300 years old and he is almost certainly part Wookiee. Like Wookiees, Smokey is loyal, devoted, and courageous, but he does not take quickly to strangers, particularly those who look like him, or other dogs, or other people with gray hair, messy or not.

It's behind him now but Smokey has a record, stemming from an incident with an unnamed gray-haired man. In all fairness, police reports can be misleading. For reasons that are unclear, Smokey strategically left the gray-haired man a message — a deposit of sorts — at the foot of the man's bed and under his covers for maximum impact.

At first, it went unnoticed. Only when the gray-haired man woke did he discover this gift. He had the same reaction as the big-shot movie producer in the film *The Godfather* when he awoke to find a severed horse's head in his bed. Cue the scream.

I could go on beating around the bush, but there's no way to sugar-coat a story about a dog who poops in a guy's bed and tries to hide it just because he doesn't like him. I actually admire the ingenuity, precision, and planning.

For his part, Smokey denies the allegations. Won't even talk about it. Smokey has since offered peace to the gray-haired man, and that peace has been respected over the years. It was an offer he could not refuse.

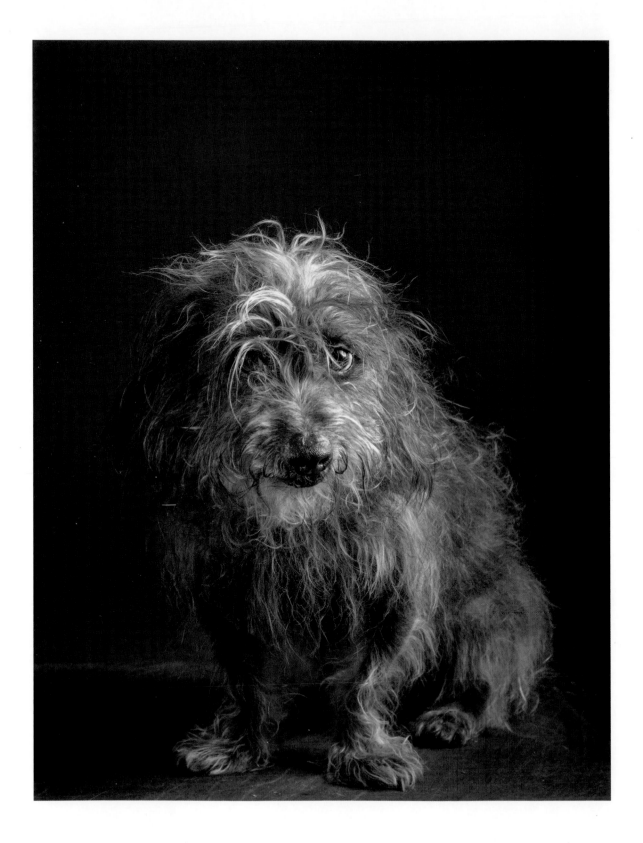

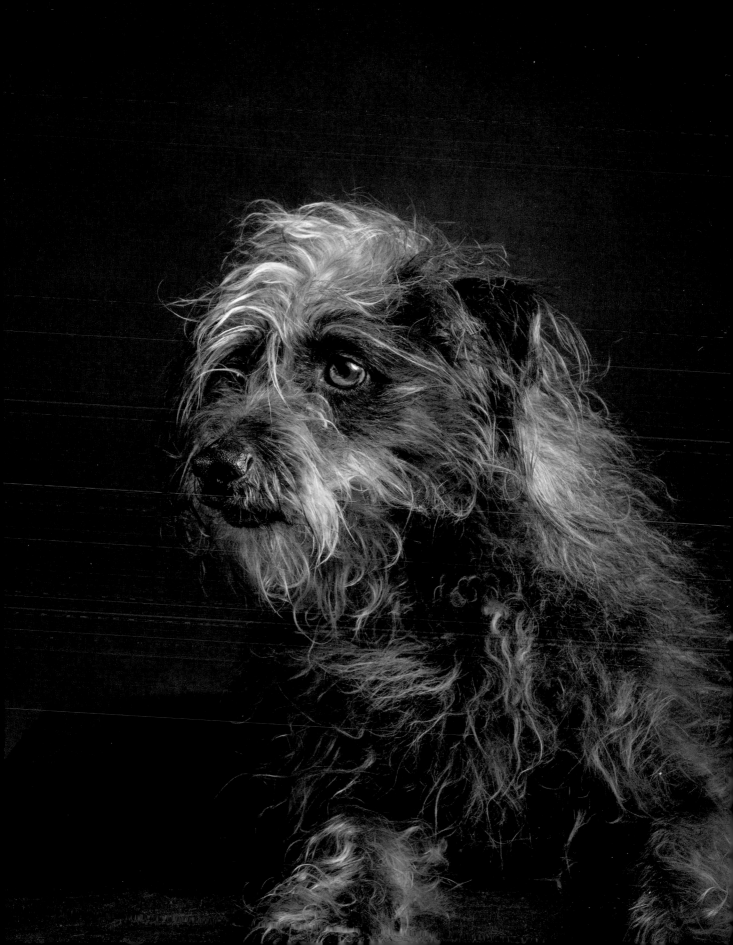

Papaya

I was, for a time, heavily involved in professional sports as a photographer for my hometown newspaper, but I was never an athlete. In elementary school, I was often the last person chosen for dodgeball and the other character-building group activities that made up what we called 'gym class'.

Unlike me, Papaya is a natural-born athlete, always picked first and fought over by the other dogs doing the picking, no matter the sport. You want her on your team. Swimming, surfing, volleyball, chasing, running, retrieving – she is the total package. She remains modest, if not humble, about her gifts.

Papaya does not carry any endorsements, nor does she give interviews to the press. When you are named after a fruit I think you have a huge responsibility to be sweet, unless you happen to be named after one of the sour fruits. Then, anything is possible.

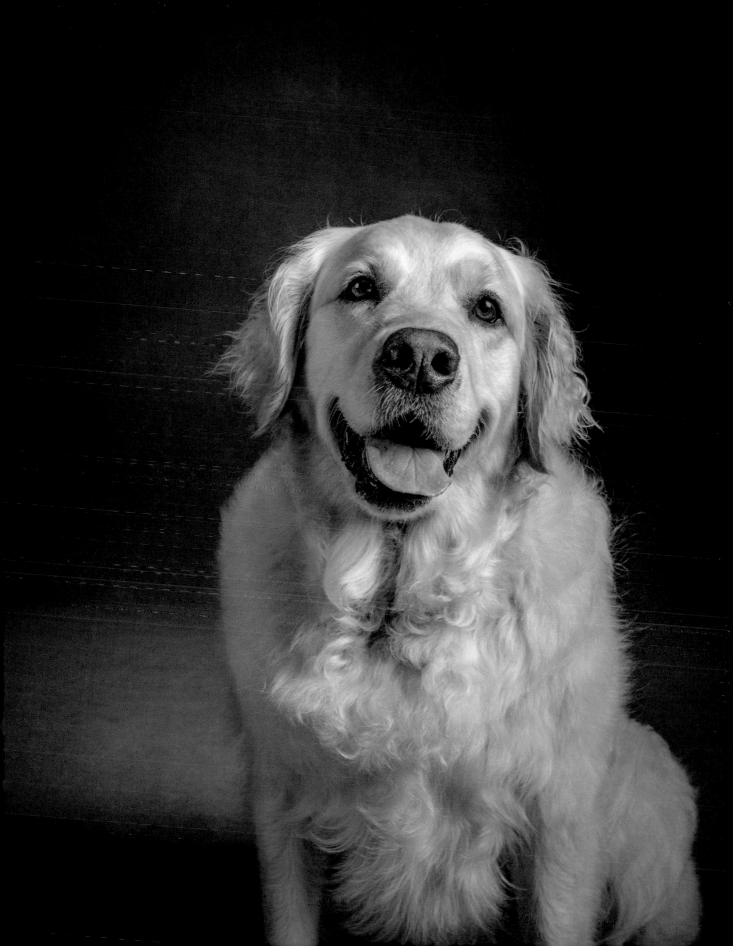

Darcy

Darcy is a fast dog, no matter how many legs she has left. I honestly can't imagine how fast she was when she had four legs, except to say fast enough to survive the speeding car that took one of them.

A hit and a run.

I was once hit by a car while playing Wiffle ball on my street as a boy. It was all my fault and my head wound up closer than one's should ever get to the grille of a 1960 Plymouth Valiant. Because I wasn't hurt badly, the runs still counted.

Darcy is a better athlete and ball player; a statuesque and highly spirited two-year-old. A catchy mixtape of breeds, she's all driven by a bass line of American Staffordshire terrier.

She came from the street, did her time in a shelter, and is happily in a full-time relationship with a college kid on more than a pass/fail basis. They are both exemplary students.

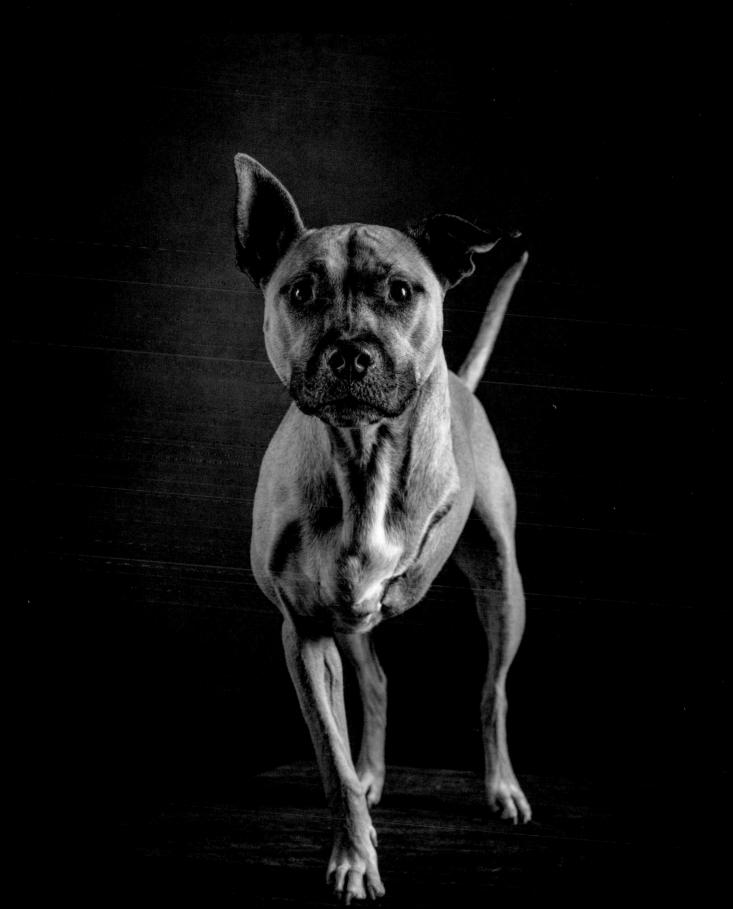

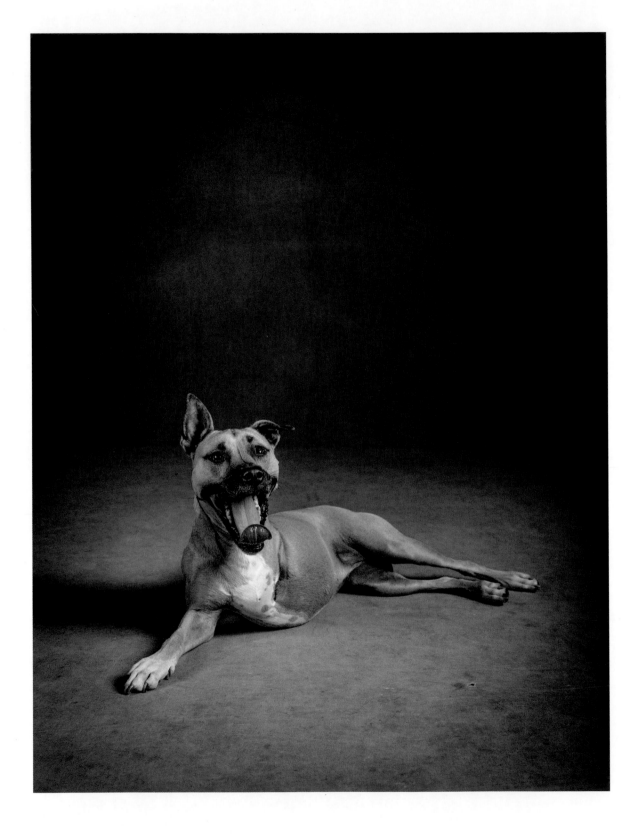

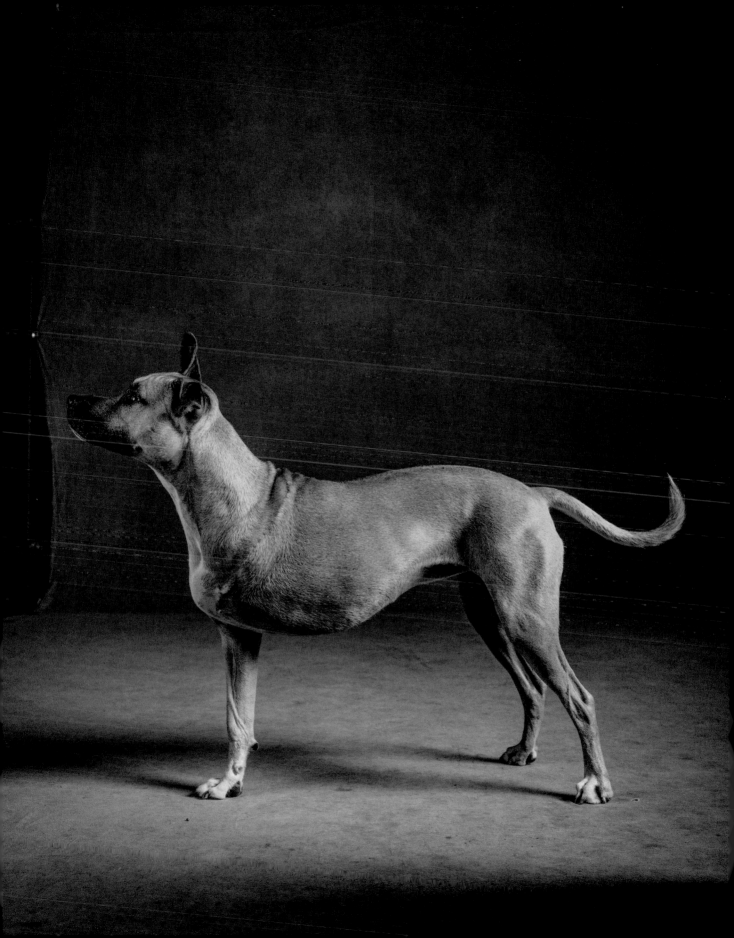

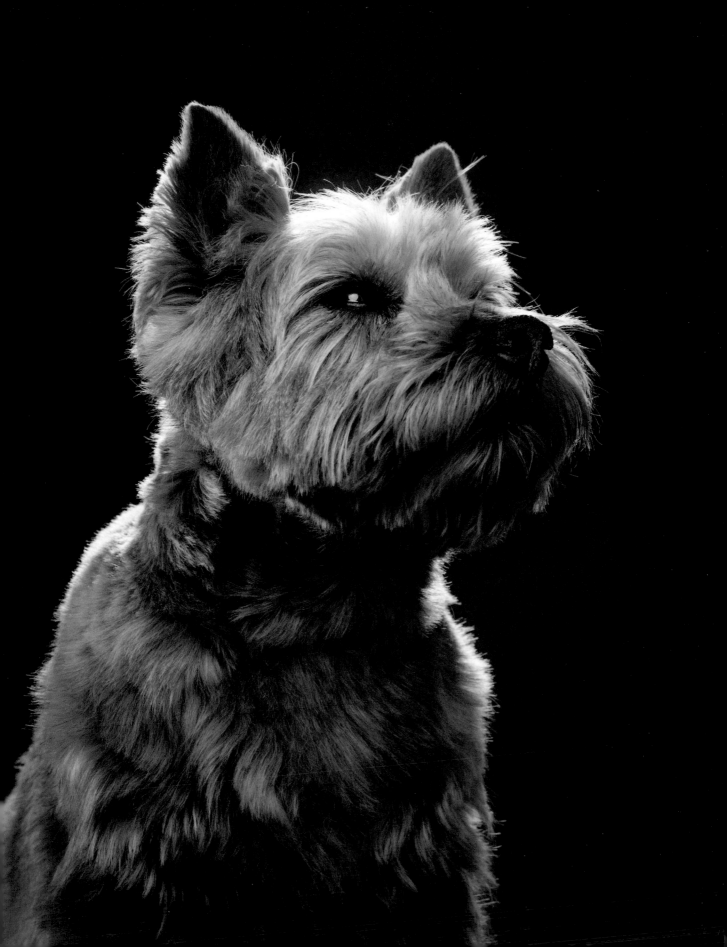

Ed

Ed is a very well-designed dog. If he were a vehicle, he might be a Jeep. Not one of those fancy Jeeps with heated leather seats and an infotainment system, but more like the kind the US Postal Service uses in the swift completion of their appointed rounds.

Ed is twelve years old and just about that many inches high, so he's not the tallest, fastest, or strongest dog you'll ever meet, but he can leap tall steps in a single bound. I agree, the mechanics of this don't really make sense, but Ed can defy gravity when the need arises.

I observed this from up close – and more than once – in his new home, just up the road from my own. Ed followed an entourage of tall people around on a tour, up and down, scaling steps with the best of them, never getting far enough behind to be considered late.

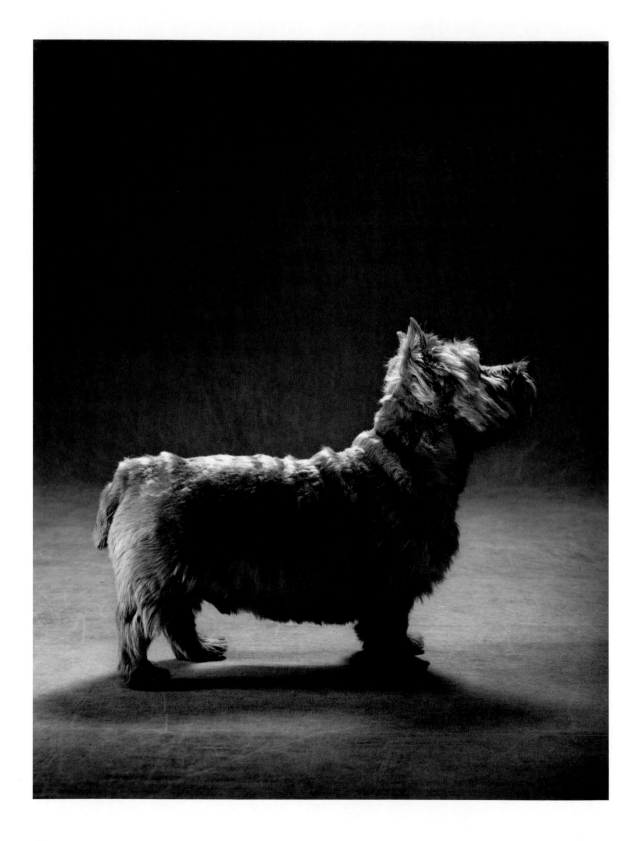

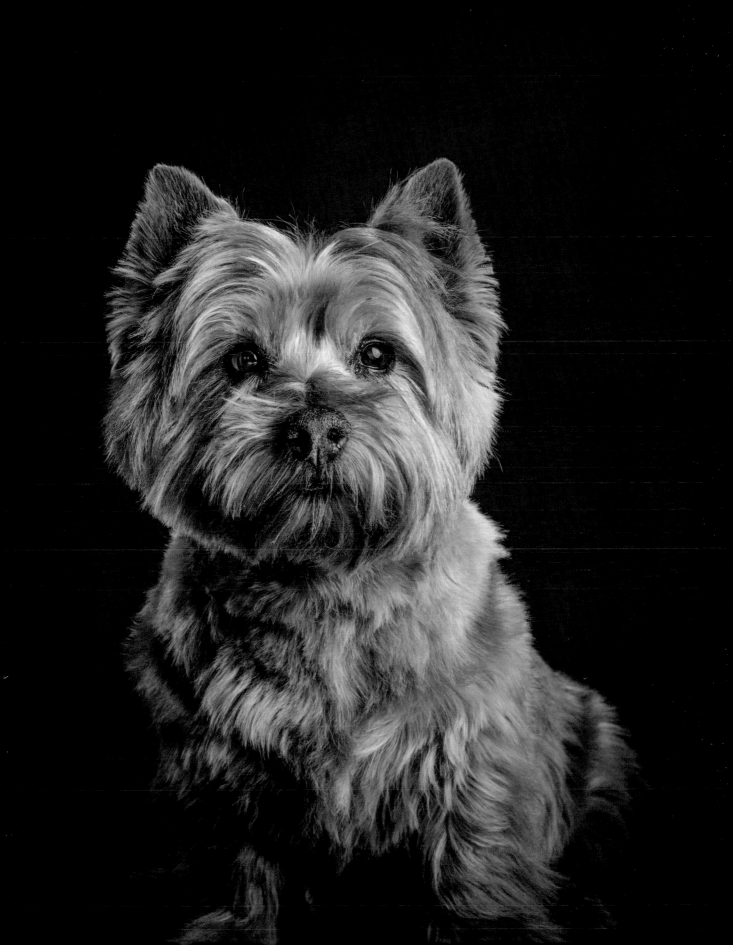

Flynn

Flynn's a tough little dog well versed in matters of
life and death.

He's a twelve-year-old consolidation of various
terriers and life experiences. Flynn survived the
death of his previous owner only to be placed in
a kill shelter.

Rescued, adopted, and relocated, he's now the
family dog of two psychotherapists specializing in
the treatment of PTSD.

It turns out he's an amazing therapy dog, helping
war veterans struggling with their own matters of
life and death.

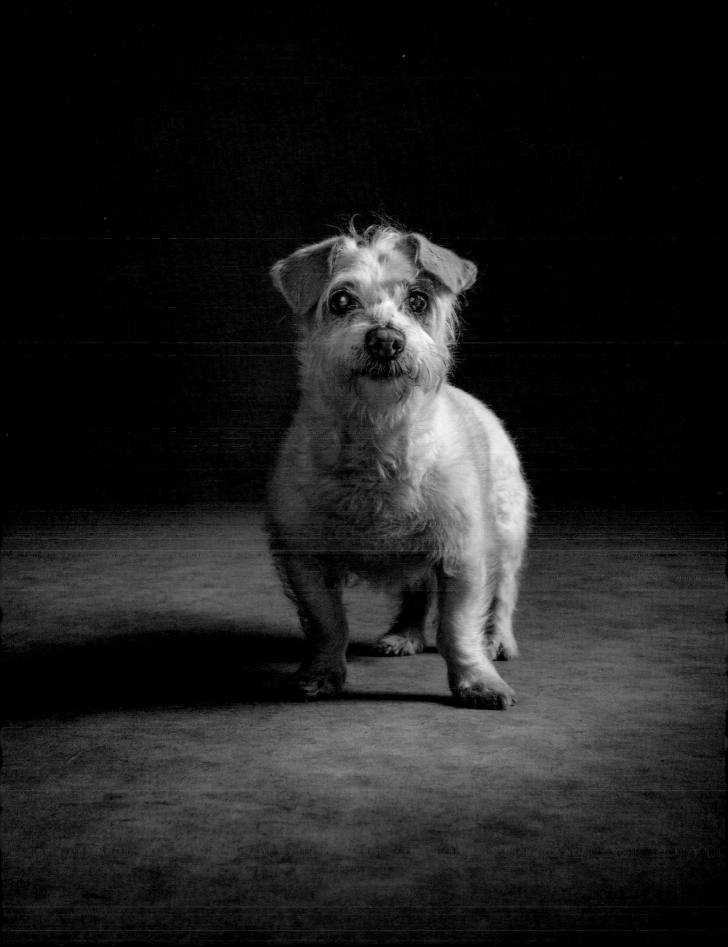

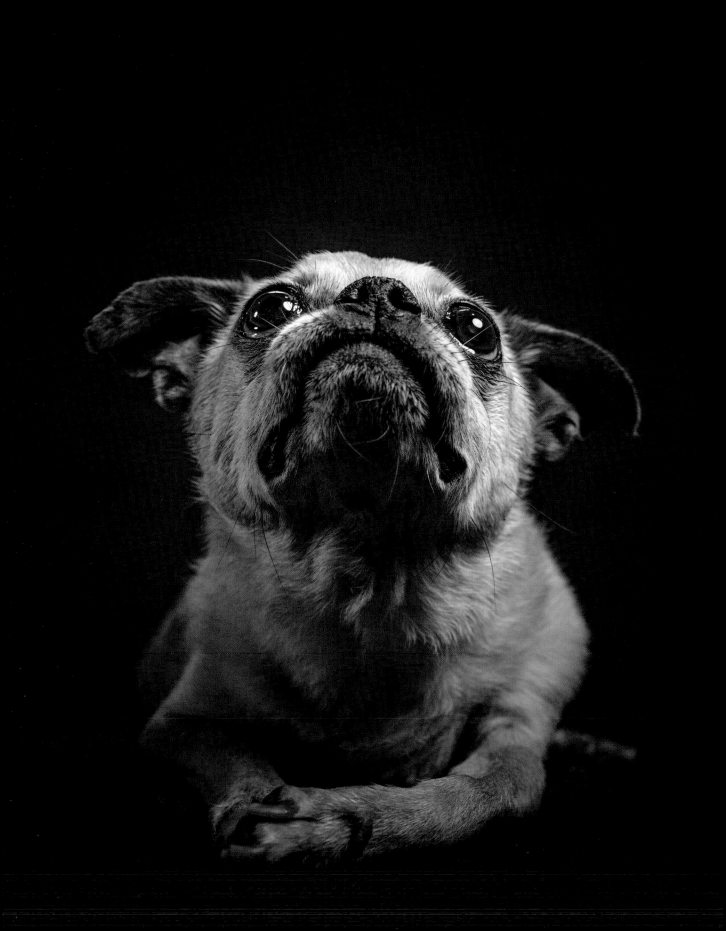

Moose

If Yoda were a breed of dog, a champion Moose would clearly be. At thirteen years old, what Moose lacks in mobility he makes up for in judgment and skill. You could easily see Grand Master Moose sitting on the Jedi High Council sifting through a mountain of applications for new Padawans.

Moose is actually a chug, which is what you get when you add a Chihuahua and a pug together. It's simple mathematics.

Here at the High Council of The Unleashed Studio, Callie spends much of her day sifting through the mountain of applications from prospective dogs. Somewhere in Moose's paperwork was this disclaimer: HIGHLY ANXIOUS. MAY SNAP. FEARS MEN.

Now, just to be clear, this is not the kind of thing we're looking for in our work at the studio, but as self-proclaimed professionals we take into account all mitigating factors. We also have a soft spot for any dog that was once homeless and now isn't.

Moose and his merry band of heartworms were found wandering the streets when he was picked up just in time for a new owner to come along and his parasites to leave.

He doesn't do much wandering these days, but he still enjoys a good walk from the comfort of a stroller. He was pretty chill and he didn't snap or judge me, despite my gender.

May the force always be with you, Moose.

Palatua

Although I'm a Pittsburgher, I will admit that I have many friends from rival Cleveland. Among them is one who says that the difference between us is that, if we both bought the same suit for the same price, I would brag about how much it cost and he would brag about how much he saved.

He, of course, never went shopping with my father who demanded that every garment purchased during my childhood was on closeout and at least two sizes too big, always persuading my mother that I would grow into it.

Still in her first year, the puppy known as Palatua, a cane corso with no connection to either city or my father, is named after a Roman goddess whose main job was to protect ancient Rome from things like the people of Cleveland.

Palatua is a happy-go-lucky dog who enjoys a good rivalry with wild turkeys and squirrels. She brags about it to her friends. She sports a stunning brindle coat that is at least two sizes too large for her, but as she's nearly ninety pounds it's expected that she will grow into it.

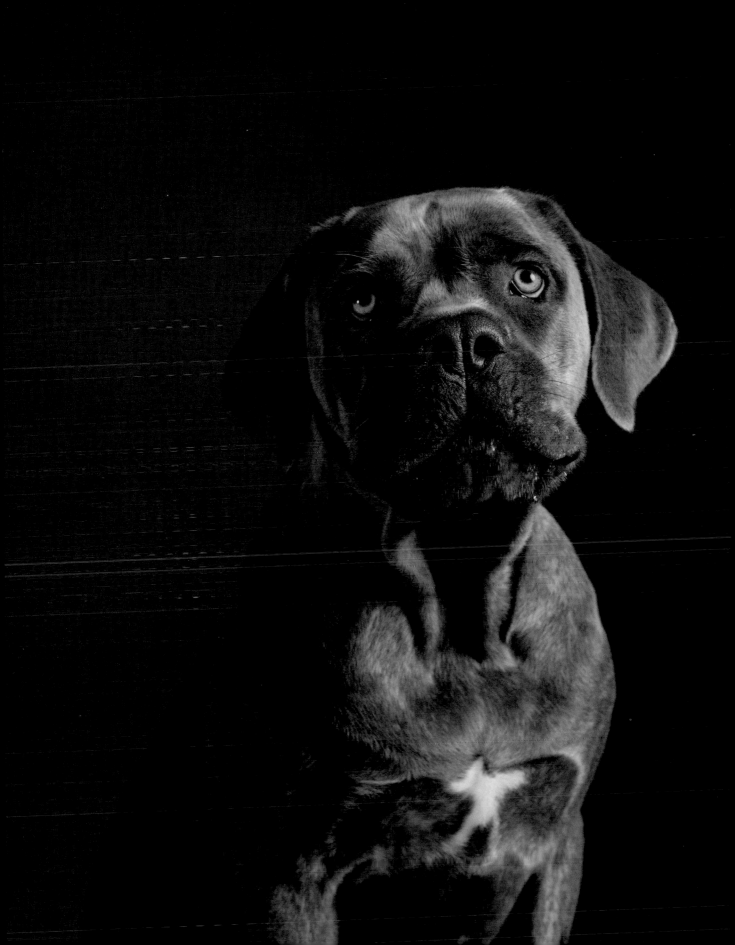

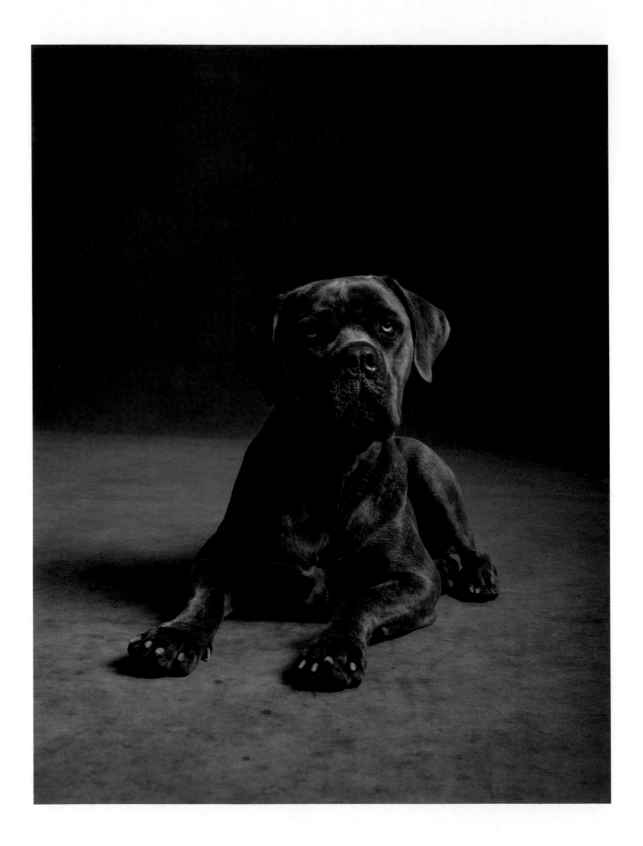

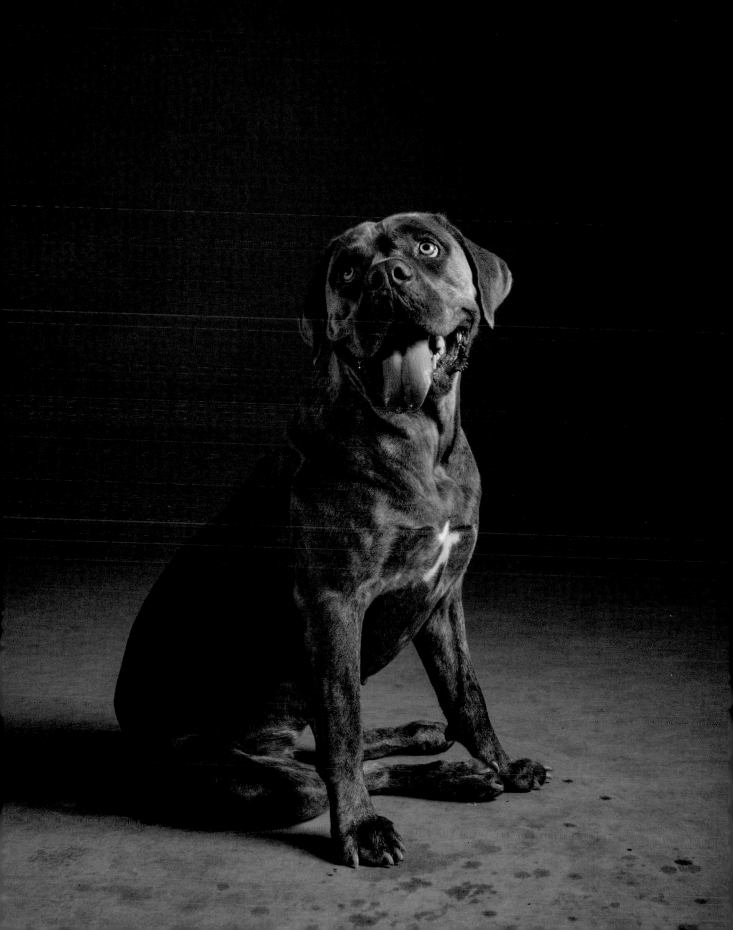

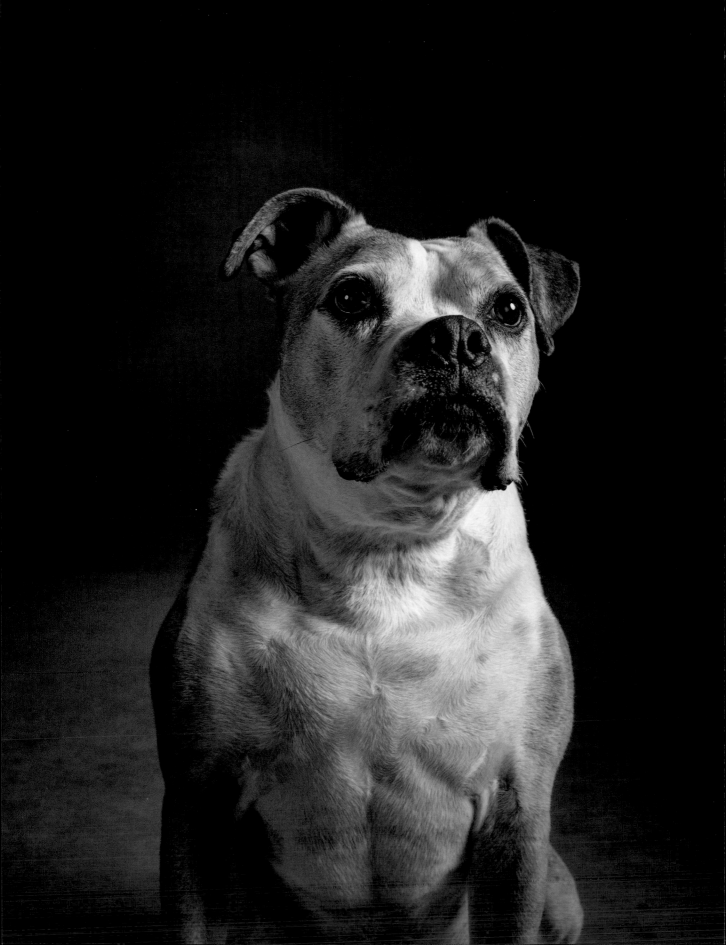

Charlie

Charlie wants out – we all do.

It's a really nice day and we are in a dark warehouse, circling around on an old canvas like a bad fashion show where the models load up on chicken-flavored nuggets between poses.

This business of posing and mugging for the camera gets tired very quickly when you are an old dog with a checkered past. This is true for the both of us, no matter how much chicken we're holding.

Charlie talked his way into a long-term relationship by being persistent. He's a scrappy dog, working-class, and blessed with the gift of the gab. An eleven-year-old boxer-bulldog-pit bull who showed up unannounced nine years ago and tried to sweep a local neighbordoodle named Lola off her paws.

That got him a trip to the snip, a new name, and a second chance to make a go of it. Things never did work out with Lola.

At the time of writing, Charlie has survived many things, including a leap from a moving car, cancer, and a day in our studio.

Nugget

For thousands of years, dogs have been muses to artists, from prehistoric cave art, Bronze Age sculptures, and Renaissance paintings to William Wegman's photos of Weimaraners.

They symbolize loyalty, love, and trust.

The landmark painting *A Friend in Need* from the iconic series *Dogs Playing Poker* was created by Cassius Marcellus Coolidge in 1903. It features a late-night card game with seven dogs making wagers over a substantial pile of chips. The dogs are drinking beer and smoking pipes. Five of them are nearly broke and two of them are cheating.

The bulldogs.

Not all dog breeds are cheaters and you shouldn't think poorly of Nugget, but I wouldn't play cards with him either. He's two years old and apparently looked enough like a chicken nugget in his youth to be partially named after one. This gives him the confidence to bluff and the poker face to pull it off, should he find himself in a position of need.

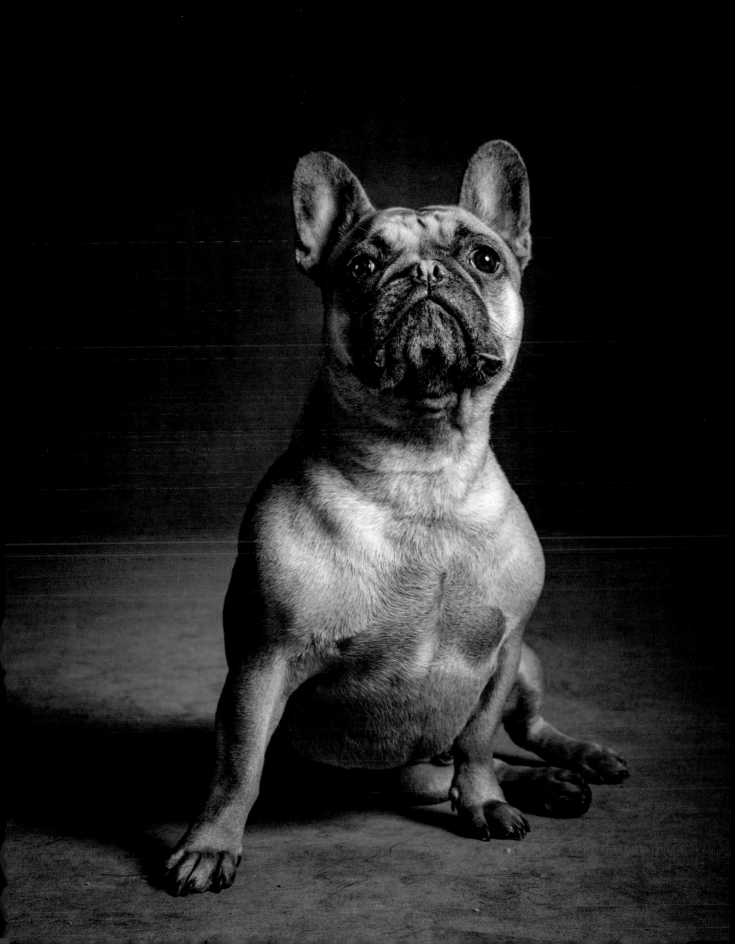

Juice

I can assure you this is a dog.

If you spotted him in the wild, he would be like one of those elusive spirit bears. Children's books would include stories about Juice, and he would be revered for his world view and grooming habits. Double rainbows would follow him wherever he went, and a character loosely based on his appearance would lead an animated television series with bad overdubbing.

Juice is a ten-year-old Japanese spitz (which, again, is a dog) who likes reggae music, and holds dual citizenship and multiple passports. Originally from Australia, he lived in Singapore and Thailand before moving to the US on a work visa.

I'm not in a position to say what Juice does for a living except to say it is legal and you shouldn't be too concerned. That said, if you were to encounter him on the street, he may pretend not to know you.

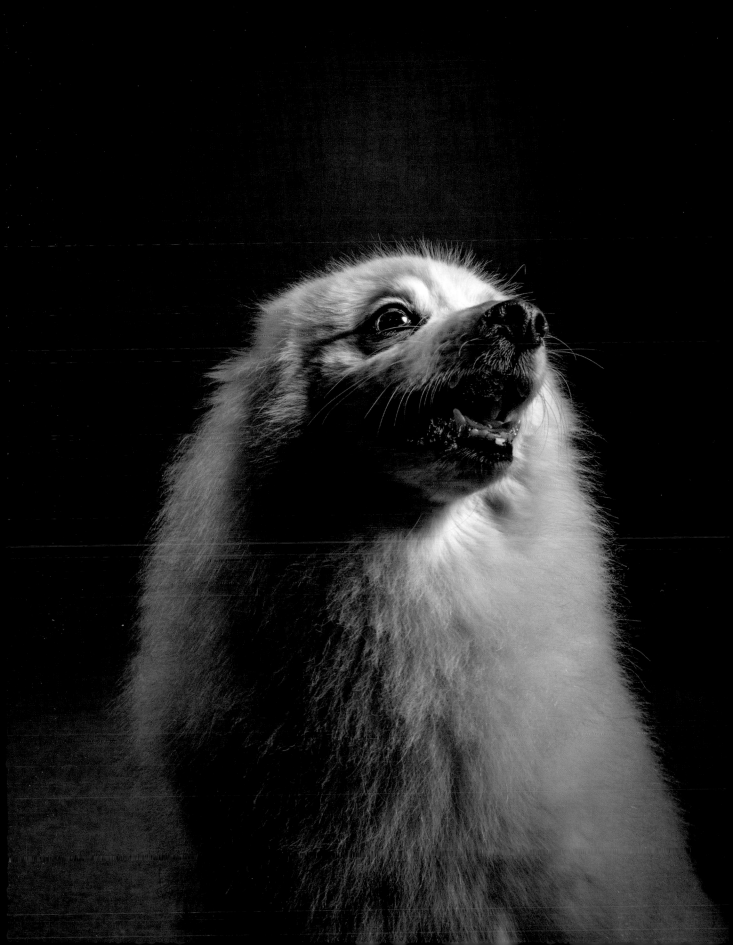

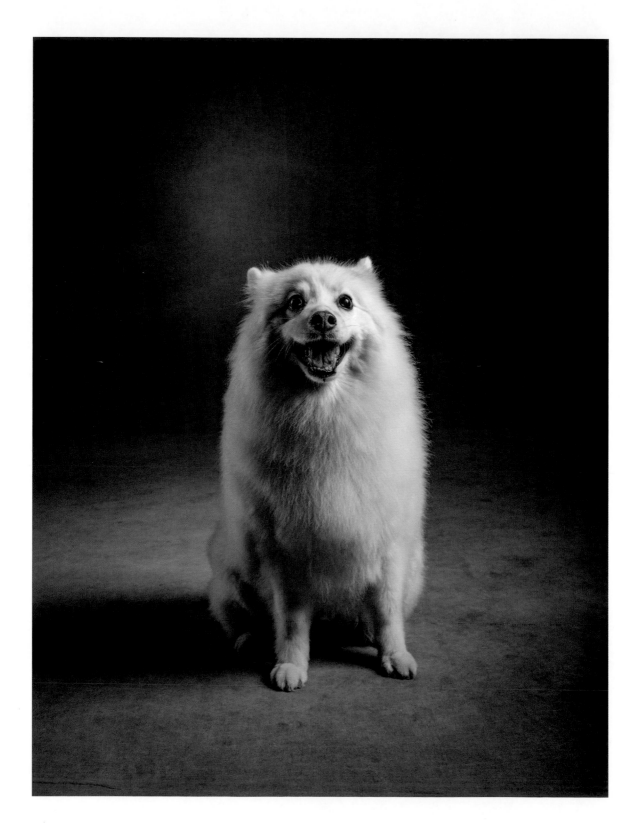

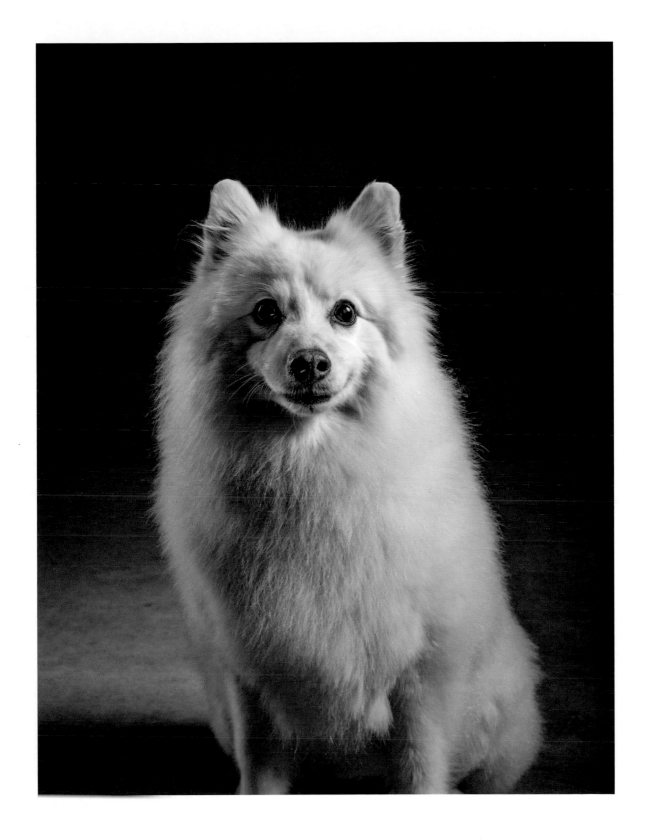

Sully

Sully is a great family dog from a great family. A sweet, playful, dog-next-door kind of dog who you want to live next-door to.

I don't see a lot of 'best in show' dogs in my line of work, but I do meet some great ones – more family than fancy, dogs that bear the responsibility of raising children and providing a lifetime of memories and escapades.

Once, on Thanksgiving Day, the turkey went missing in our home. The usual suspects, my brother and me, were brought in for questioning but quickly released under our own recognizance when it became apparent that our dog, Chris, was mysteriously absent from her usual position in the kitchen. (She was never far from food.)

The living space in our home could be measured in hundreds of square feet and there were only so many places a crafty mutt could drag off and hide a partially frozen eighteen-pound butterball. Even the best thieves get caught and Chris eventually coughed up enough evidence to lead us to the basement, where the now partially eaten and somewhat less frozen bird lay.

All doodles – golden or miniature or otherwise – have the potential for such mischief and it's best to be vigilant at all times. It's always the dog next door who no one suspects.

Sully has not been implicated in any large capers but he's only four years old. Interpol currently has him on a watch list for trafficking in stolen socks.

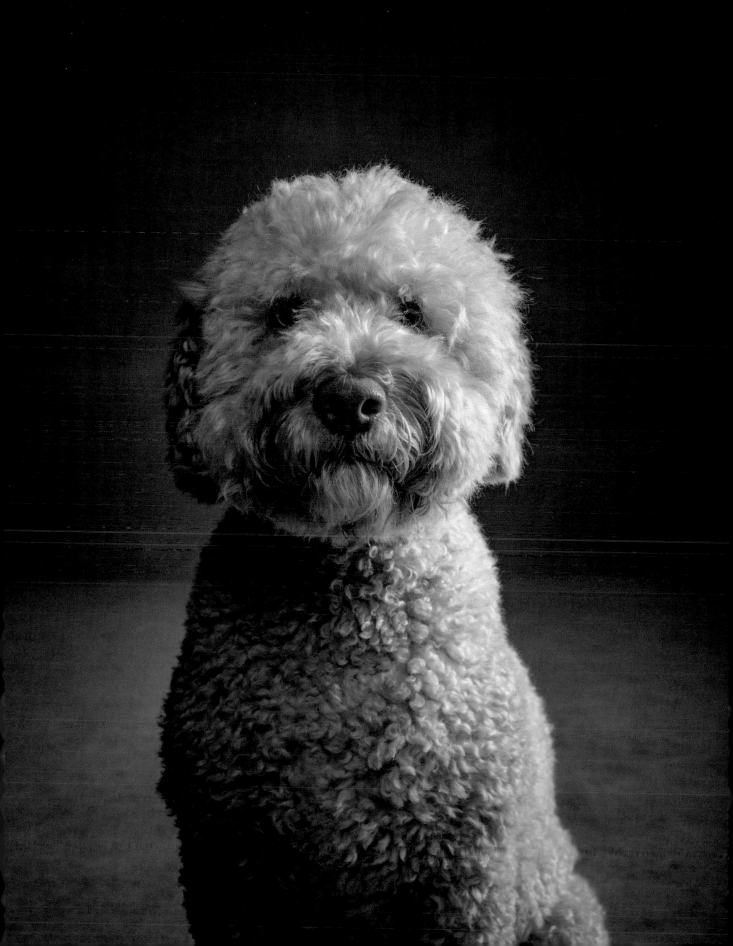

Teal

I wonder who will play Callie and me in the movie adaptation of *The Year of the Dogs*?

It's just never too early to think about these things. Gal Gadot could be considered a frontrunner for Callie. She can talk to animals and has the whole goddess vibe, and a golden lasso. I could see that being worked into the screenplay as a leash of some kind. And as for me, let me just say two words: Idris. Elba.

If you are wondering about Teal, don't. Her modeling portfolio, presented here, shows her range and poise. If she were starring in the movie adaptation of *The Year of the Dogs*, she would play herself and do her own stunts, just like she's been doing her whole life.

With a headshot like this, you could see Teal in any number of roles. A six-year-old Boykin spaniel, she has the good sense to know the difference between good and evil, though she has never acted professionally.

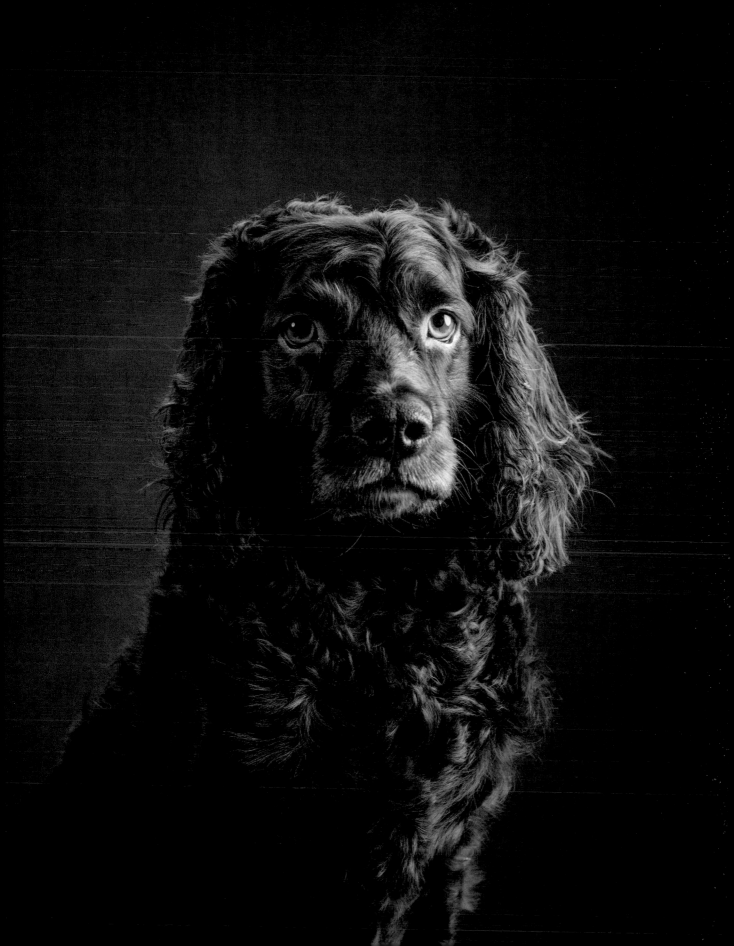

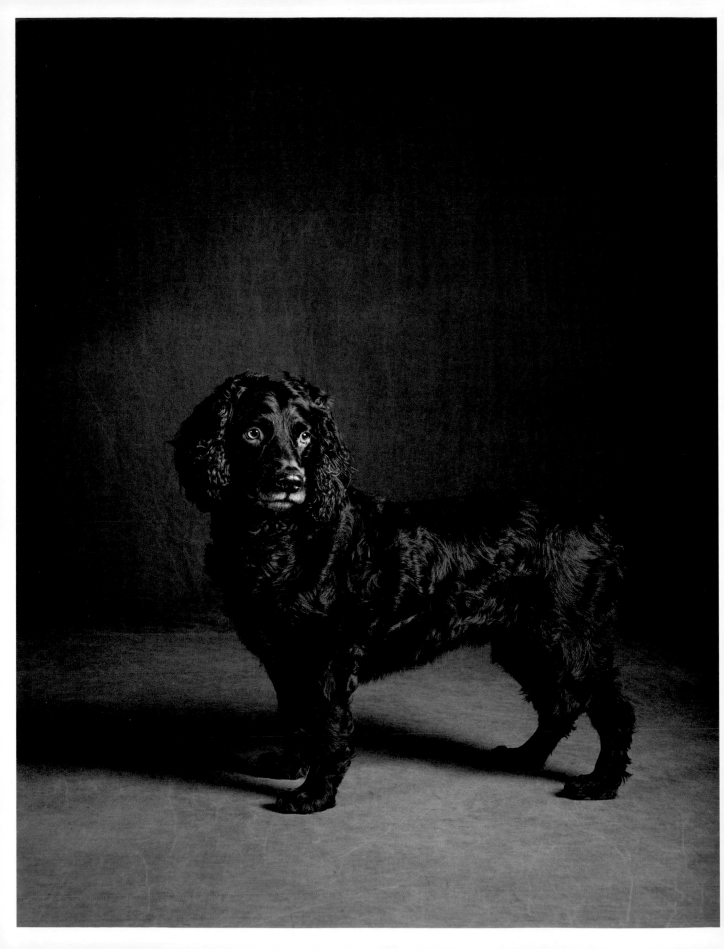

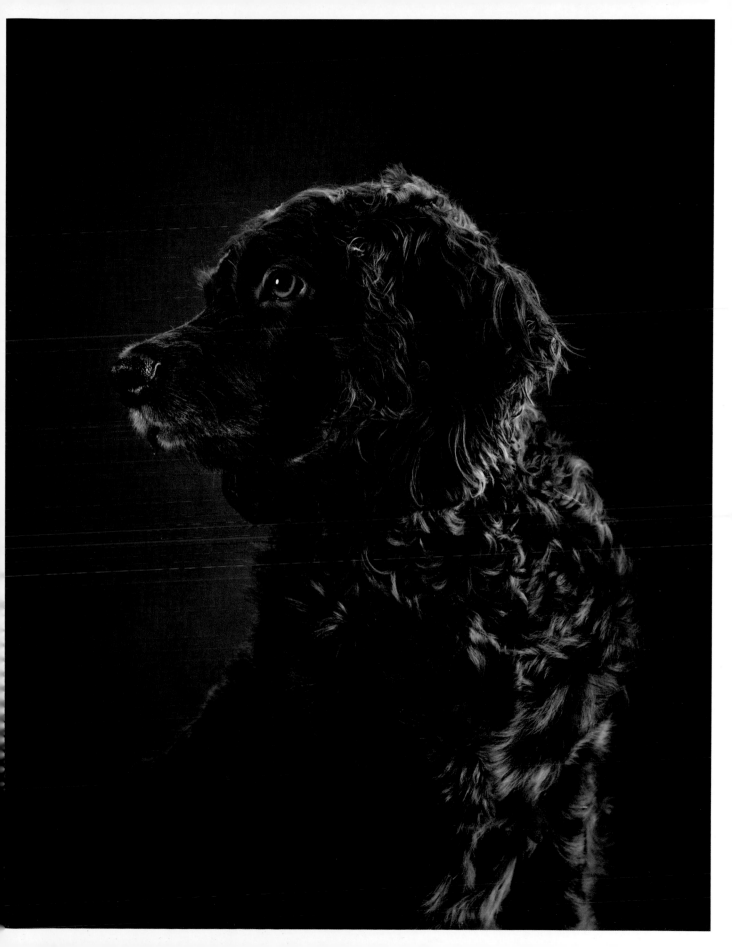

Sammy

I am humbled by Sammy and the humans who heard him.

If memory serves, it was Dr. Seuss's legendary elephant Horton who first heard a Who, way before that sneaky Grinch ever tried to get away with stealing their Christmas.

Horton heard the Whos when no one else did or wanted to or could and it was this generous and kind pachyderm who lived by the moral code that a person is a person, no matter how small.

Sammy is of that scale – small, surprisingly small, and Seussical-looking – an eight-year-old English toy spaniel who might not have mattered or even been noticed had it not been for the generous and kind humans who lived by the code that a dog is a dog, no matter how small or sick or unwanted it might be.

You see, this once-homeless mass of fur was heard when his eyes were filled with glaucoma and his days were numbered in a shelter. Incredibly, he was saved, put back together, rebranded. His voice is heard loudly and clearly and daily by the family that adopted him.

I don't know the folks at the animal rescue, Pawmetto Lifeline, who made this happen for Sammy but just when you think you've seen it all, you haven't seen anything.

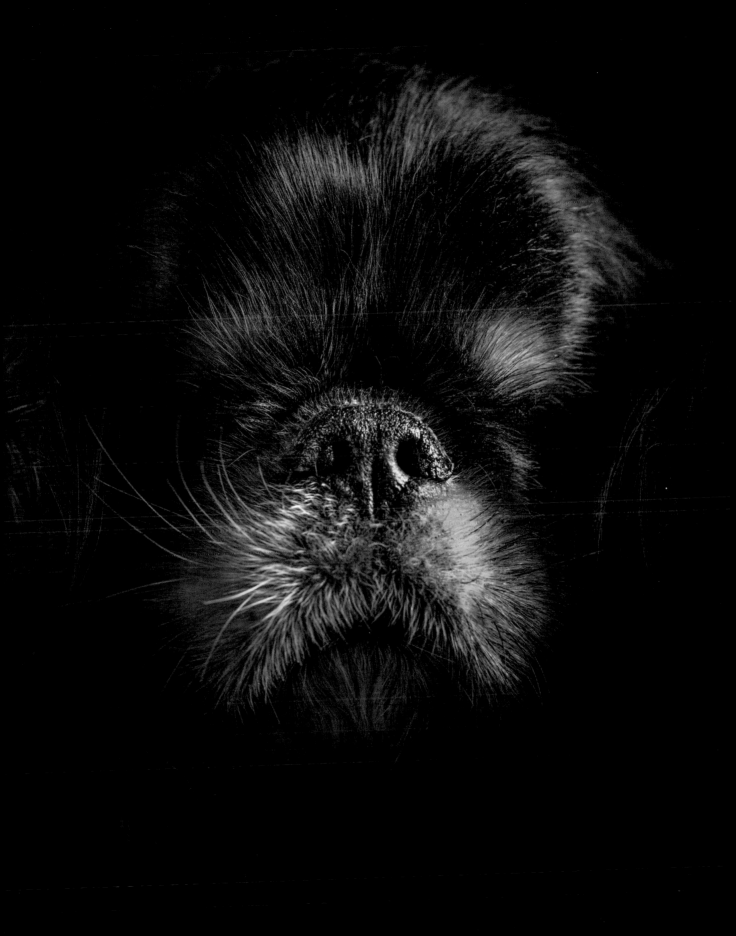

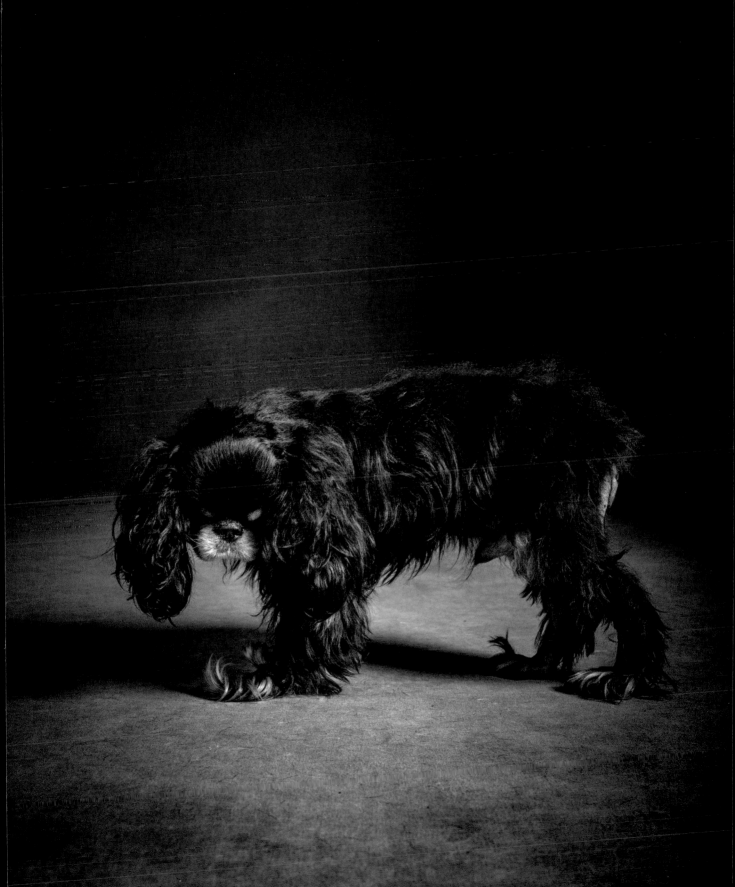

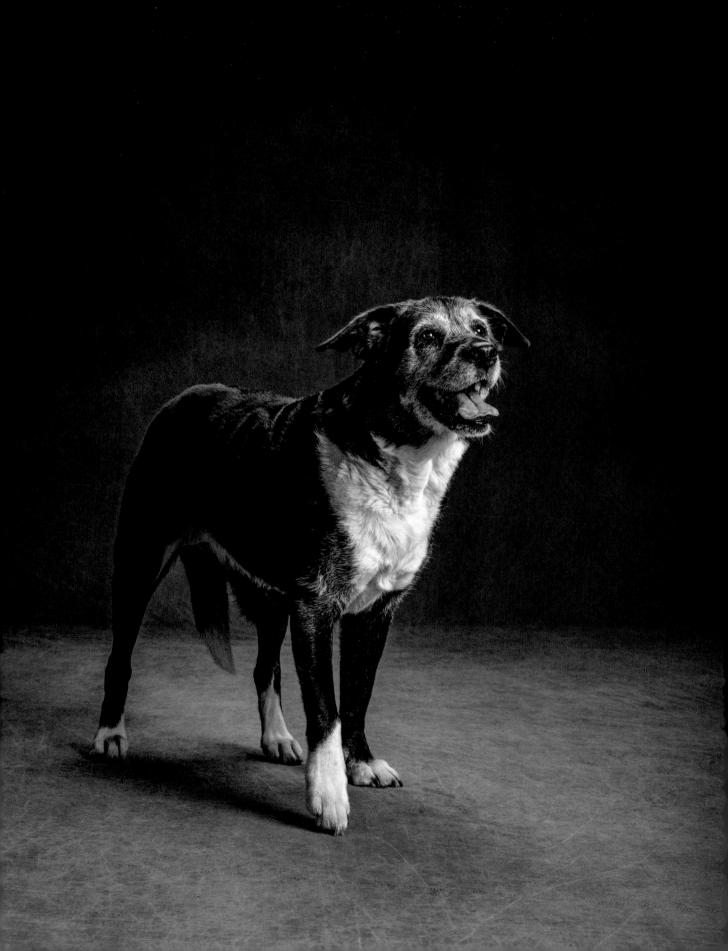

Marlie

In the thirteenth year of Marlie's life, she was pronounced dead – but stubbornly refused to accept the diagnosis.

That's just like Marlie, apparently, who, since her 'passing', gets along just fine without a spleen and still maintains her well-earned reputation as a 'ditch dog diva', according to those closest to her.

Like the shock of white on her belly, Marlie has an obstinate streak that comes from something in her lineage. A checkering of brave and intelligent breeds that, when assembled in close proximity, produce the defiant sort you see here.

One of the absolute minimal requirements for *The Year of the Dogs* is that a dog should remain in front of the camera long enough for me to push the button. Few dogs tested my patience as much as Marlie did.

And while she might say the same about me, we all know you can't argue with a dog – particularly not one who died and lived to tell about it. Long live Marlie.

Winnie

It has long been thought by ardent UFO believers that ancient alien visitors were responsible for anything we didn't understand in the modern world like the construction of the Egyptian pyramids, the symbolism of Stonehenge, or the real meaning of the lyrics of "Stairway to Heaven".

One theory holds that the aliens were actually a group of cosmic canines who traveled to Earth and taught primitive humans about dogs, including how to play fetch and clean up after them. The dogs were revered and treated as gods. Some of them chose to stay on Earth, and all dogs are descendants of these first intergalactic travelers.

New evidence of these mysterious visitors can be seen in the striking resemblance between Winnie, a thirteen-year-old standard poodle living in North Carolina, and the ancient monolithic *moai* of Easter Island.

Five thousand miles of land and sea separate them, and they have never seen each other. Like the *moai*, Winnie is a treasured symbol of power and authority. She is respected for her good nature among her people and followers, many of whom have grown up and left, only to return each year to worship her and play chase.

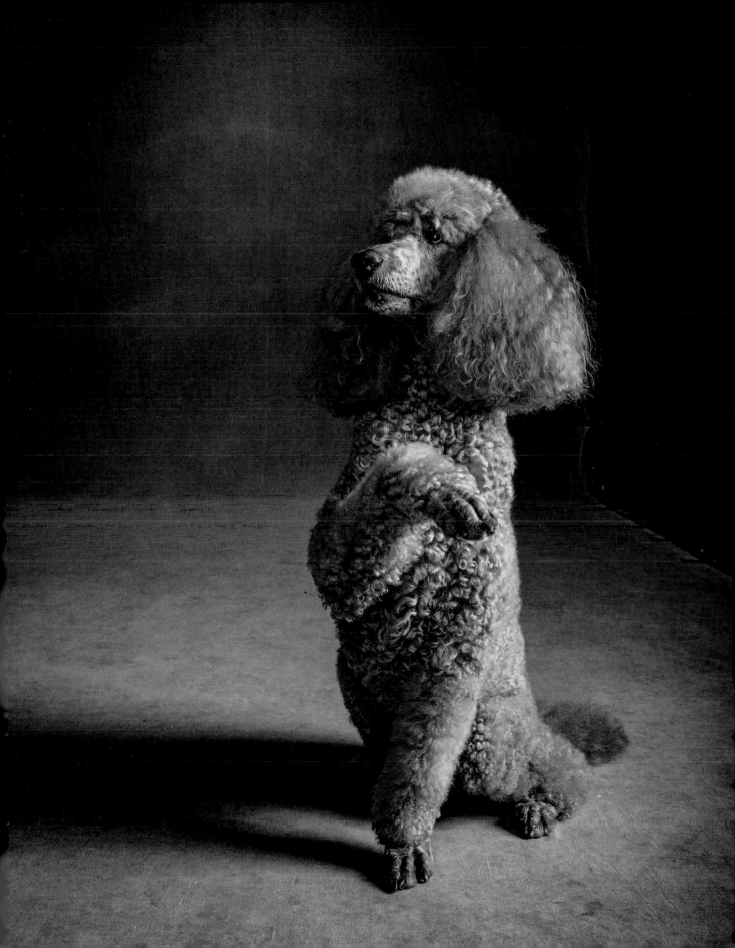

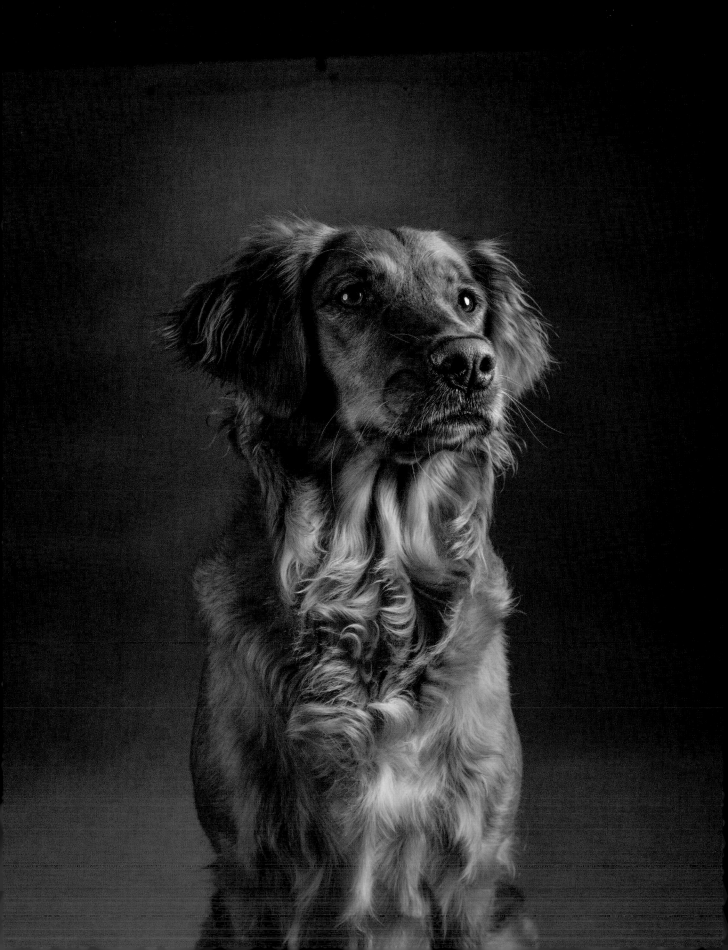

Boston

Boston is from New York, but not originally.

Historically, moving from one city to the other has been good for New York but has not always turned out so well for Boston (the city). Back in 1919, the legendary baseball slugger Babe Ruth left Boston for New York after the Red Sox traded him to the Yankees. With Ruth, the Yankees won the league championship seven times and the World Series four.

The move left the Red Sox cursed. Before the trade, Ruth had helped them win the World Series three times. After Ruth, it would take them eighty-six years to win again.

Boston (the dog) is charming and sophisticated like her namesake.

She's a two-year-old golden retriever with no discernible accent, a penchant for organic poultry, and a fondness for a bikini-clad rubber chicken that does not squeak but at one time did.

Boston has enjoyed great success in New York but leaves no curse behind.

Fox

Fox is young and restless as all puppies should be
he wanted to play, chase balls, and pee.
Despite my pleas for shots,
he ran from me and did all three
and left us with the spots.

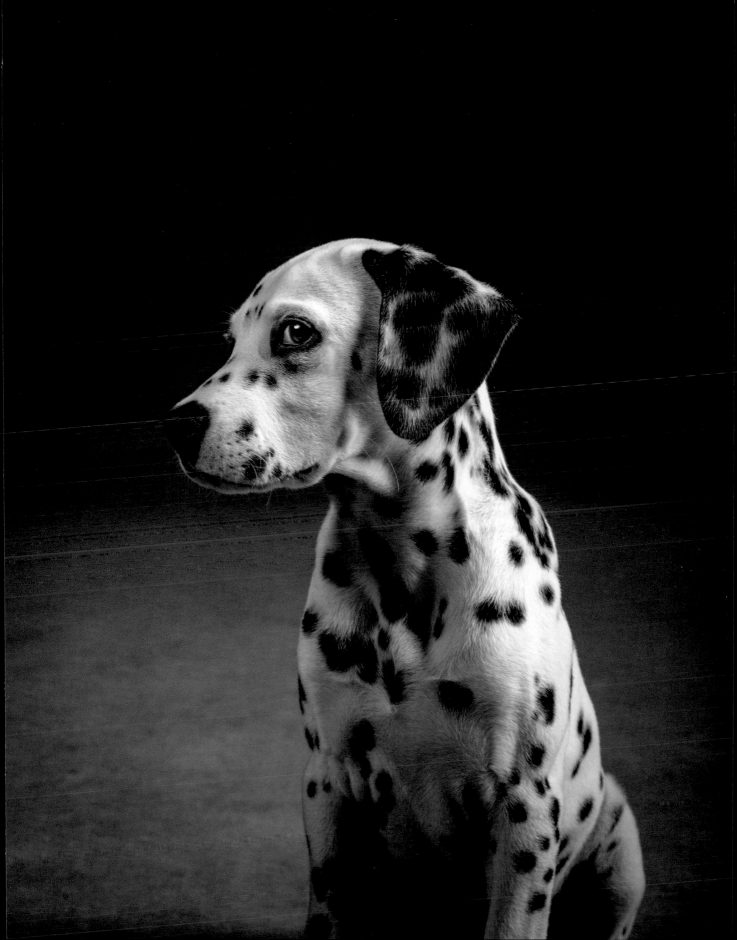

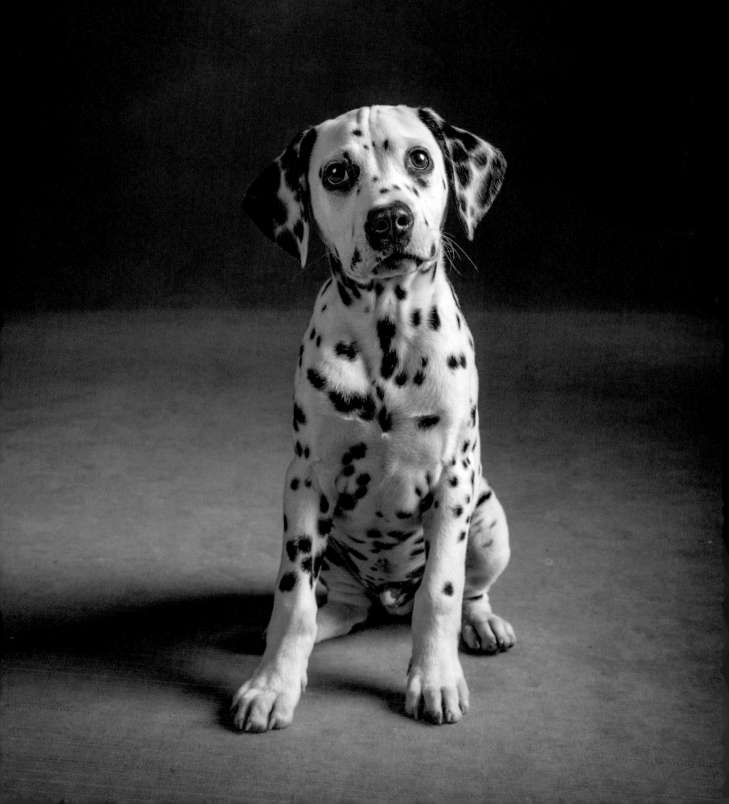

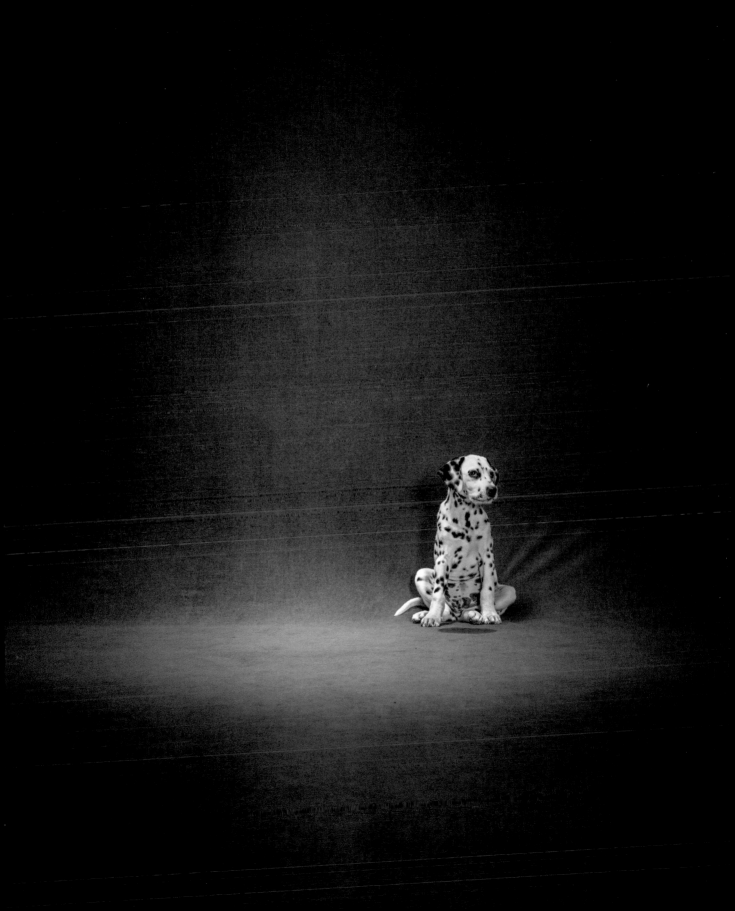

Hector

Hector is a very tiny dog.

He looks much bigger in person, because Hector is made up of personality, hair, and other natural ingredients. If shorn completely, he would float like a balloon. If his tiny ears could flap like Dumbo's, he'd sustain flight.

Hector's small scale makes him very attractive to the neighborhood birds of prey, who enjoy a very tiny toy poodle as much as anyone. For safety purposes, he is never left alone in the yard.

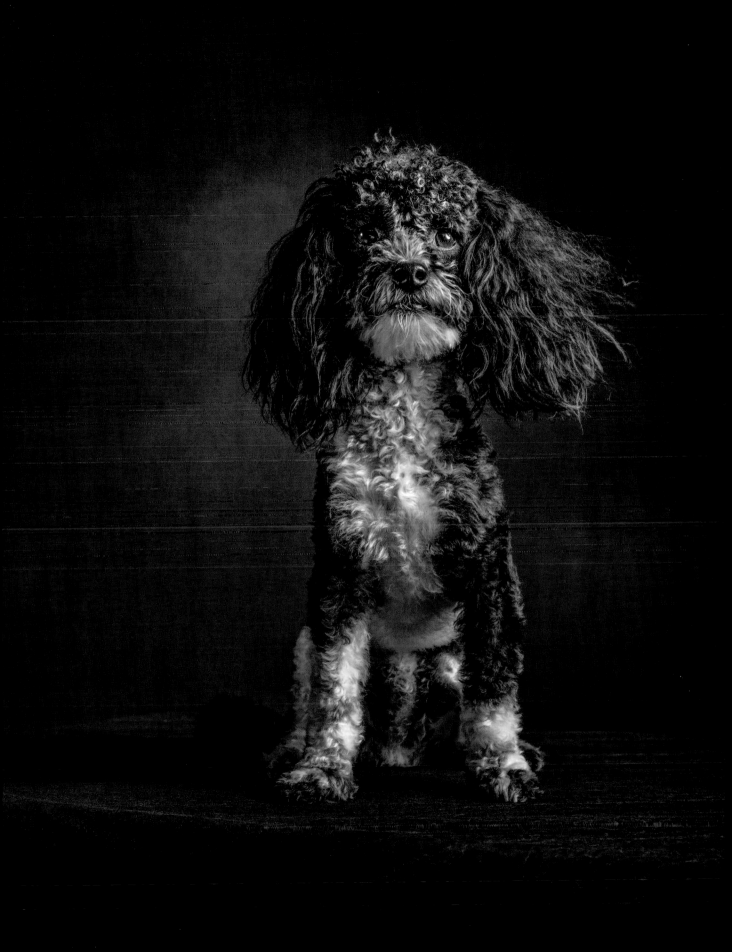

Tellington

Tellington wears the cone of shame so that he can't do something that he shouldn't do. Please don't ask me what it is or why – patient confidentiality laws prevents me from divulging more information.

Fifteen-year-old Tellington doesn't let it get him down, though. He's technically a vet tech and greeter guide in the office of All Creatures vet clinic here in Charleston. However, the cone prevents him from doing any paperwork.

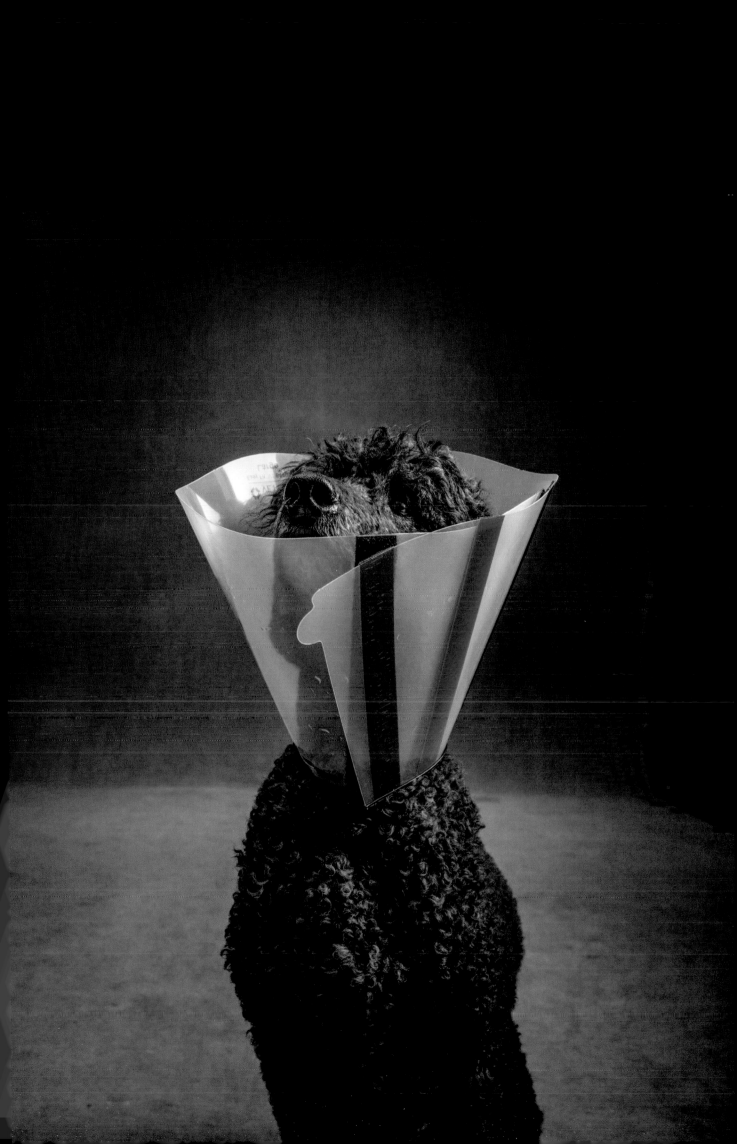

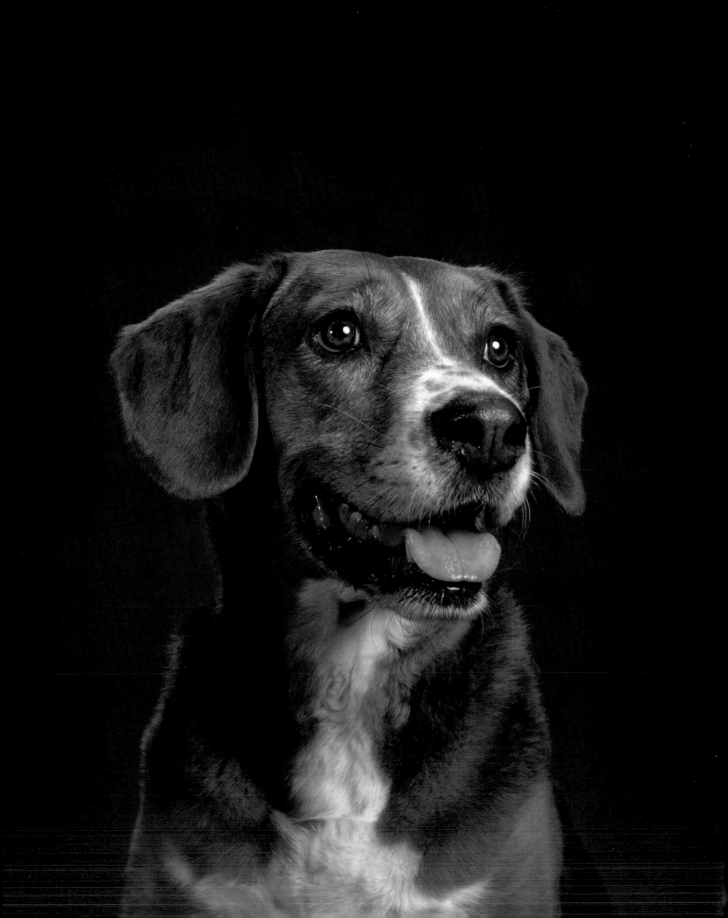

Sadie

I'm not one to brag, but my first extensively published work was when I was a high-school yearbook photographer. It was my first book. In my junior year, I was sent to a workshop taught by the photographers who did all our formal yearbook photos. A cross between long-distance runners and prison guards, these photographers excelled in the art of forcing approximately a thousand children a day into friendly poses and acceptable smiles before moving on to the next school.

I've often thought that if *The Year of the Dogs* were to become a book, it could be a dog's version of a high-school yearbook. Full of inspiring, friendly dogs with ambitious and heartfelt quotes. They could list their altruistic plans for the future alongside humorous ribbing from their dog classmates.

Sadie, Class of 2018
Future Hounds of America, Honor Roll,
Quiz Bowl, Spanish Club

Although she's almost seven, Sadie really showed the freshman dogs a thing or two about how to jump around excitedly at the dog park this year. After missing out on the state championships, everyone is looking for Sadie to get back into varsity ball-chasing after she was sidelined by a mid-season injury.

Sadie founded the Shelter Dog Club and counts beagle, foxhound, and Labrador as her primary influences. She is very well liked by her purebred classmates. Sadie enjoys helping others and was voted most likely to kiss you without being asked.

Scout

Scout is a happy, well-adjusted thirteen-year-old Boykin spaniel who can't see or hear as well as she once could. Food is often on her mind, and her dwindling sense of smell hasn't restricted her ability to raid a trash can in the dark of night.

I often have a lot to say about other people's dogs. This should be worrisome but not unexpected, given my family history. My mother was mostly Greek, had married into a large Italian family, and food was always on her mind. She also had a lot to say about other people's dogs, usually that they looked hungry.

My mother tried to feed every living thing that came within a square mile of our house, whether it was hungry or not. She would feed squirrels, rabbits, lost children, and stray birds. The men who took our trash never left without sandwiches. Escaped convicts on the run could count on a meal at our home before the cops came. 'They look hungry,' she would say.

A gal like Scout would have got along well with my mother. I can hear her now: 'She looks hungry.'

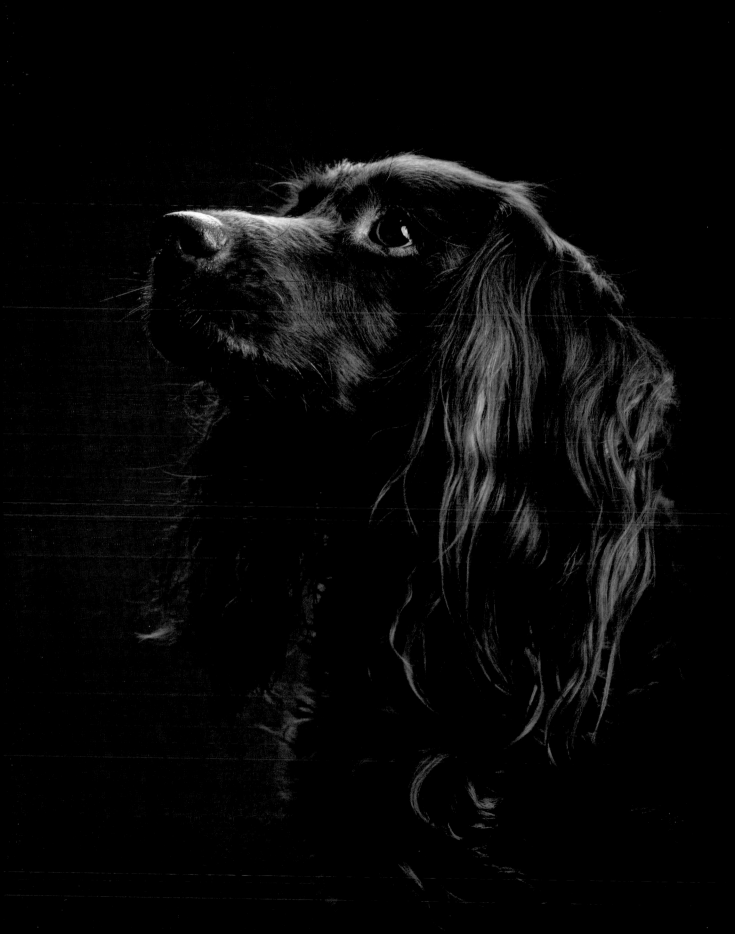

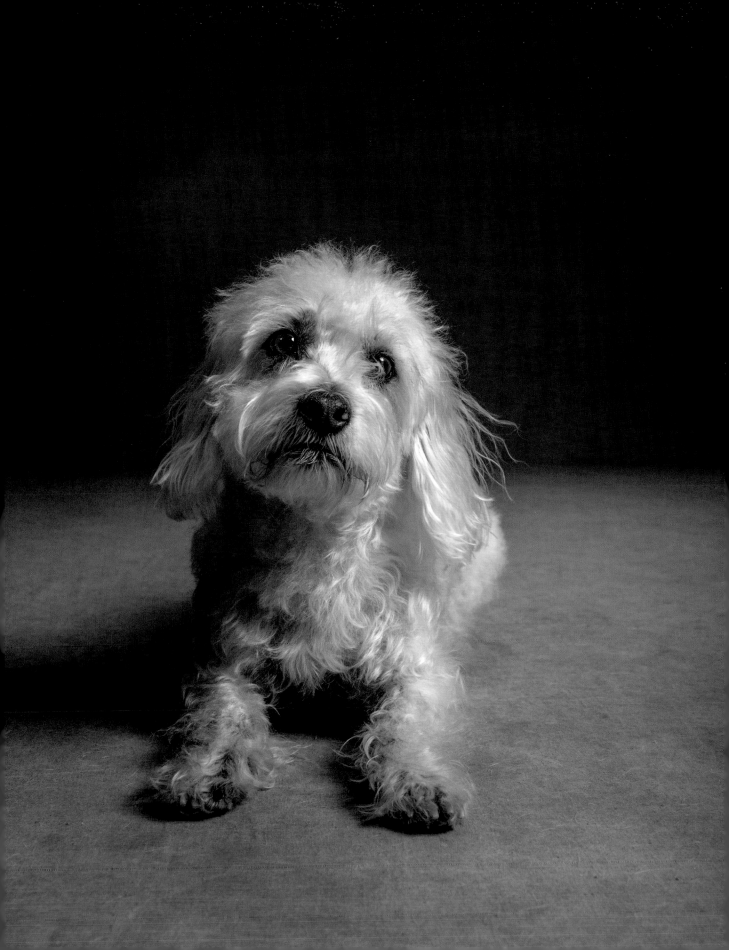

Yogi Benjamin

This little dog means the world to his owner.
When we started photographing dogs, a neighbor
complimented me on my new work and said, 'I wish
I cared enough about my dog to hire you.' I've always
thought it would be a great endorsement for our
next advertising campaign.

My career has mostly been spent making photographs
for a third party – not that there's anything wrong
with that. A photo editor, usually acting on behalf of
another entity like *National Geographic*, would hire
me to travel somewhere to photograph someone
neither of us knew. It meant the world to the editor,
and that's all I needed to know. Now I make a lot of
photographs directly for the people who want them.
And when they say it means the world to them, it
means the world to me to get it right.

Such is the case with Yogi, a seven-year-old former
shelter dog from Los Angeles, an affable merging of
cairn terrier and Maltese. Yogi is transcontinental
and bicoastal, with a fondness for the European
continent as well.

He has a paw in the film industry, but I wouldn't
call him an actor. With more frequent-flier miles
than most dogs we meet, he's in a very important
relationship with a lovely woman who counts on
him as much as he does her.

That said, she thinks he looks like a Muppet.

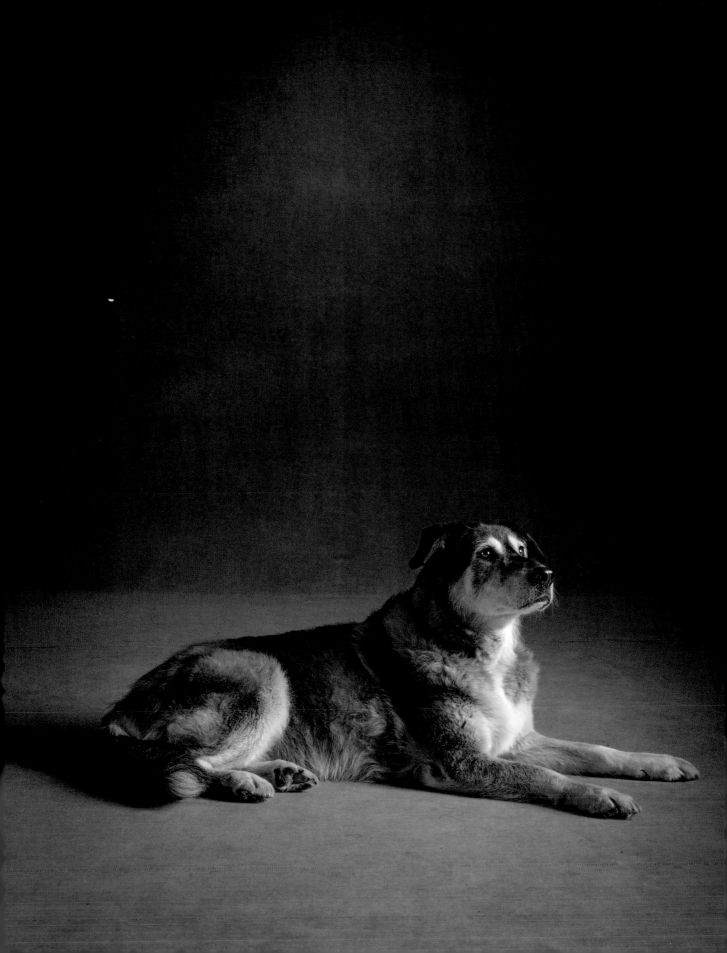

Ruby Ann

For a while, as a teenager, our son pretended to be a lawyer on one of those school mock trial teams. We even bought him a new suit just for court. It was like a school play held in a real courtroom and all the kids pretended to be witnesses or lawyers. Real lawyers were part of this too, but they pretended to be jurors. The judge was actually a real judge.

Callie and I pretended too. Not that our son would become a real lawyer, but that he would become a pretend lawyer like one of those sober-faced attorneys on the many *Law and Order*-type shows. Our son, the pretend lawyer. We were so proud.

Ruby Ann worked for a time in a law office but did not pretend to be a lawyer. Her responsibilities dealt more with client relations and security matters.

If Ruby were to practice law, she would certainly be great at it. She's a listener and would be the sought-out counselor who thought carefully before speaking, returning short answers to long questions carefully shaped by years of patience, understanding, and litigation.

Her portfolio would include Labrador, Australian shepherd, and husky law, and her backstory would be whispered about by those who closely followed her fourteen-year career from street dog to senior partner.

Any objection to these facts would be overruled.

Roy Boy McCall

This is the last time I photographed Roy, a fourteen-year-old English Labrador.

He was the constant companion of a dear friend, and could always be found running navigation from the cockpit of a 1979 Ford F-100 pickup that matched his color from time to time.

I once saw Roy drive a truck. No police reports exist to verify this claim but witnesses are plentiful, should one need to be called to testify. Roy's mind was sharp and his love for hotdogs was insatiable. His hips did not cooperate so much. He loved the beach, the crash of the surf, and took one last run at it before he passed.

He is missed.

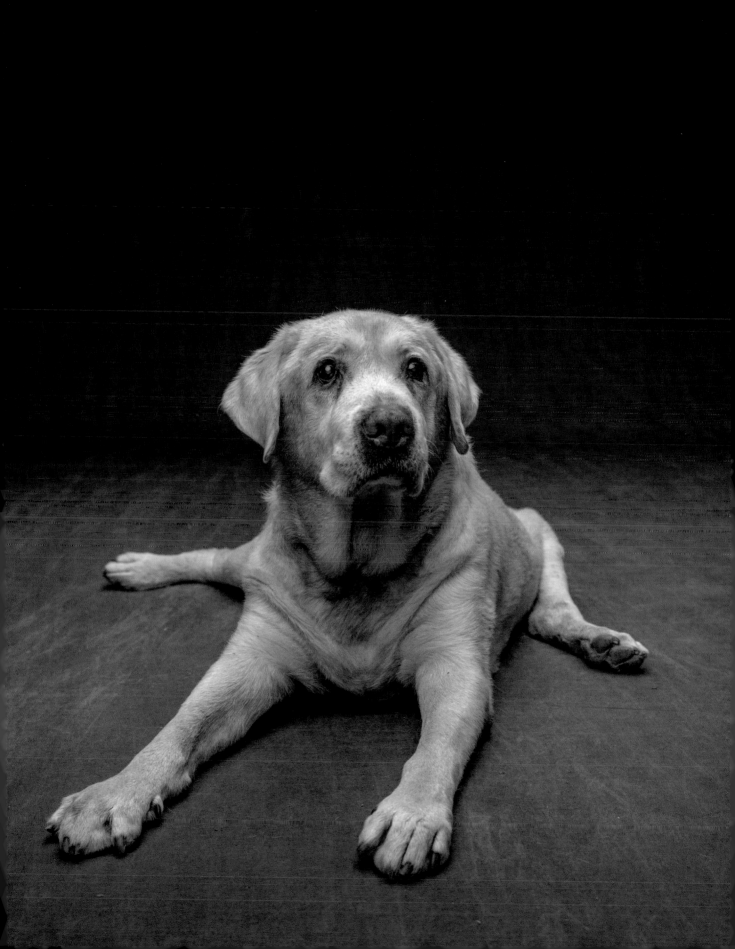

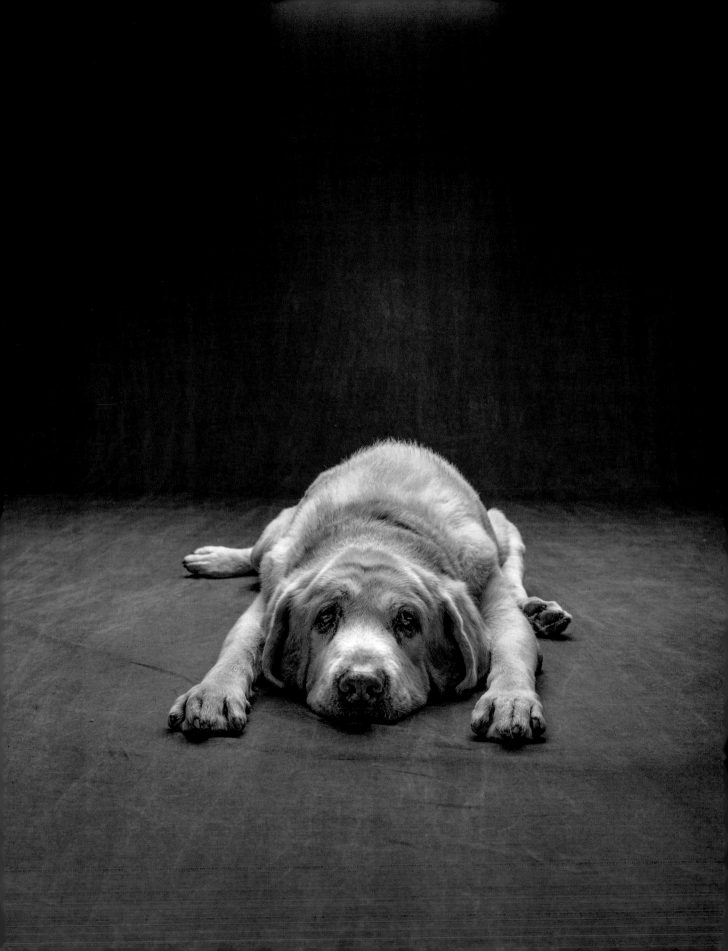

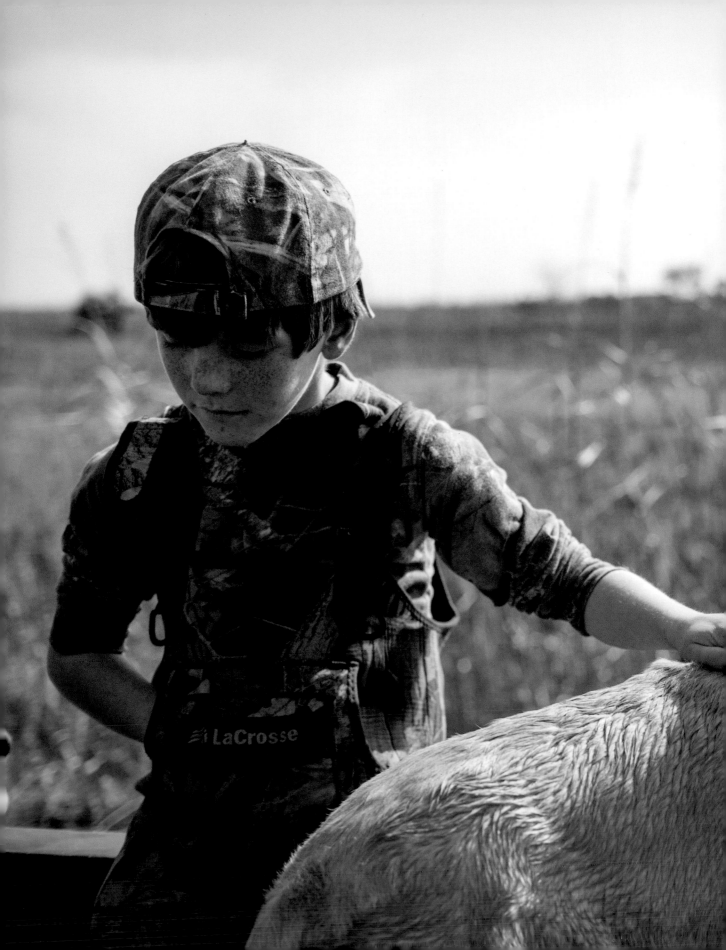

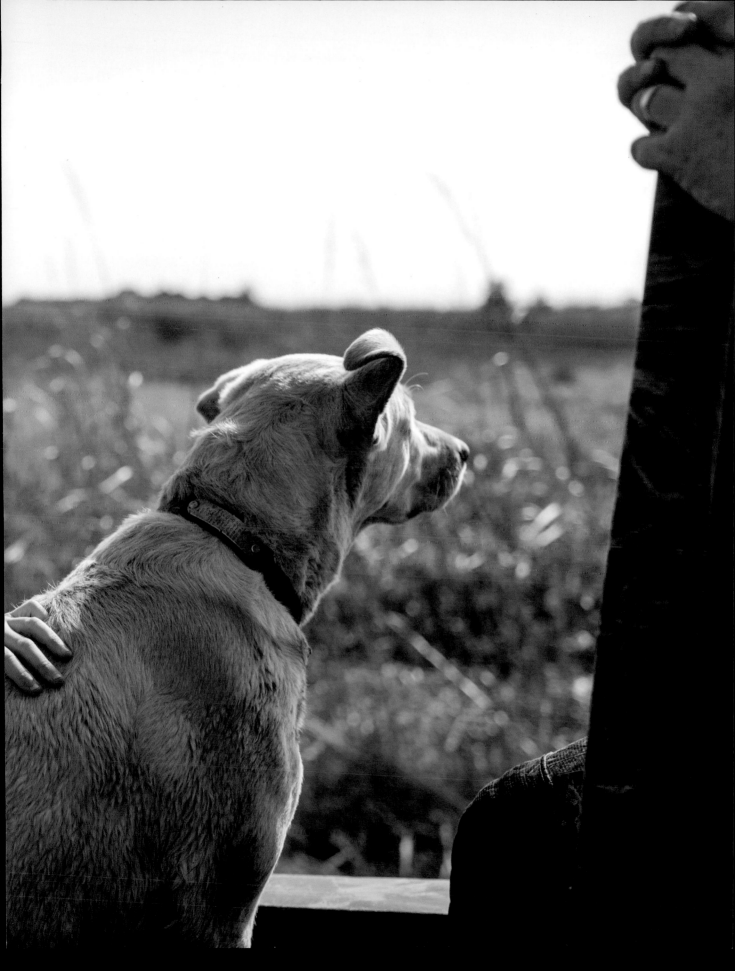

The photograph of nine-year-old J.D. Cate and his dog Henry on the previous spread is one of my favorite images made during the last thirty years of my career.

It is deceptively still. J.D.'s gesture is noble and gentle and quiet. The only clue to movement is Henry's ear curling back from the wind as we barrel along a dirt road in the bed of a pickup truck about an hour's drive from my house.

Neither J.D. nor Henry for that matter paid much attention to me that morning, but I had been looking for them for a long time. Or looking for this picture, or one like it, or one as good as this, and I had been searching in all the wrong places.

Everywhere but home.

I was getting burned out and secretly jealous of my friends with more ordinary jobs, the nine-to-five ones. It was a 'grass is always greener' kind of thing, and after all those years of getting on airplanes, I thought that it looked very lush on the other side.

Sometimes you must slow down and smell the dog poop. The idea of being close to home, spending more time with my family, and making the kind of photographs that I cared about was as thrilling as any assignment I'd ever had.

So we took the leap of faith you now hold in your hands.

Mistakes were made.

They say you can't learn from your mistakes if you don't make any. If this were true, I should be pretty smart by now.

You can't expect an animal of any kind to do what you want just because you want them to. I knew that, but I got carried away with myself. I had photographed lions and tigers, after all.

We started with Luka, the magnificent Great Dane seen here and on page 16. She came in, looked around, took her place on the background and waited patiently for me to make her picture. It was easy.

That never happened again. Ever.

We had runners, biters, barkers, chasers, sleepers, jumpers, chewers, scratchers, nippers, farters, growlers, and lickers – and those were just the owners!

It turns out I didn't know as much about animals, lighting, or even photography as I thought I did.

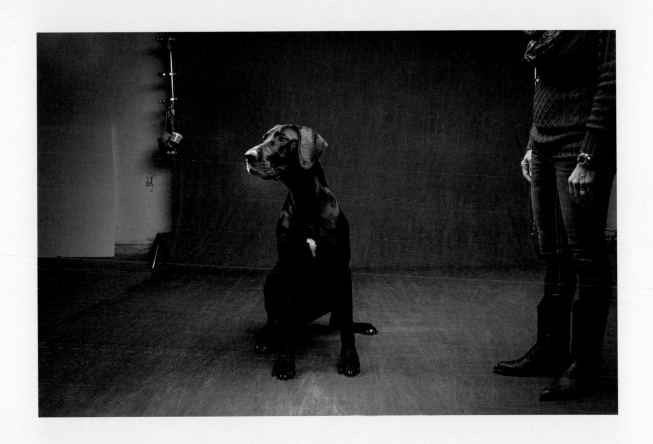

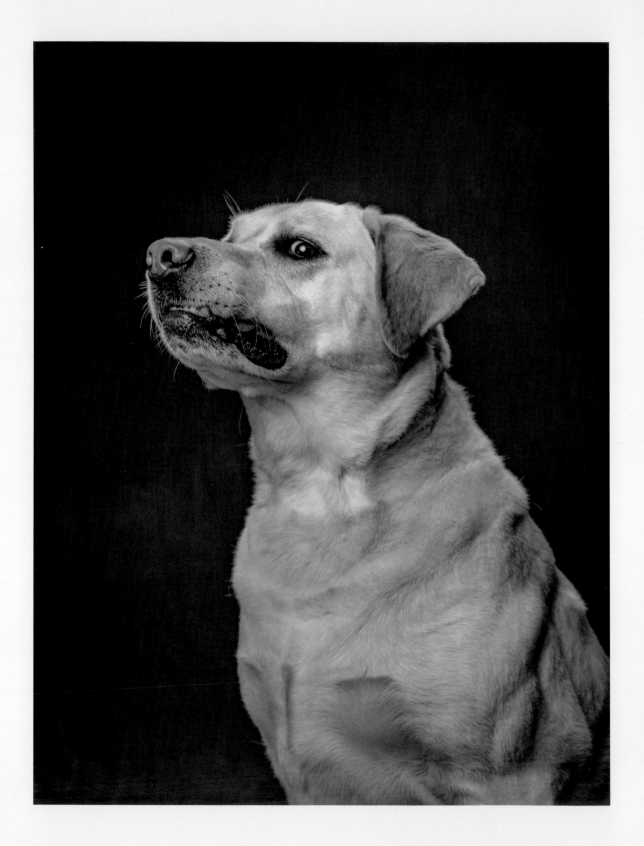

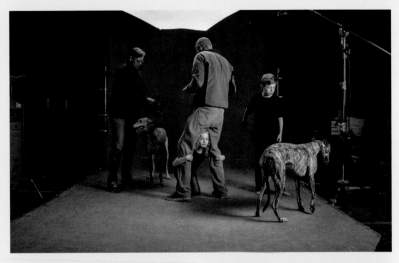
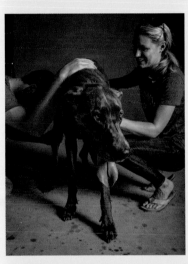
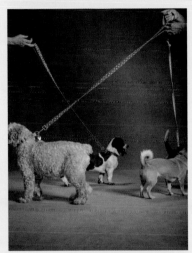
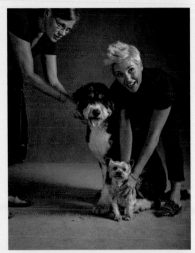
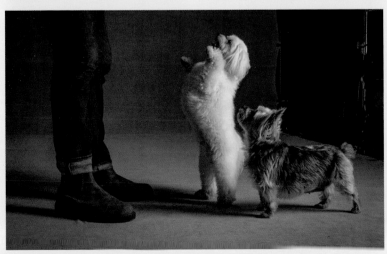
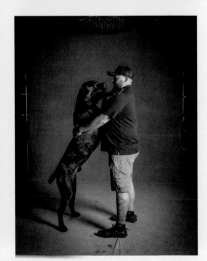

293

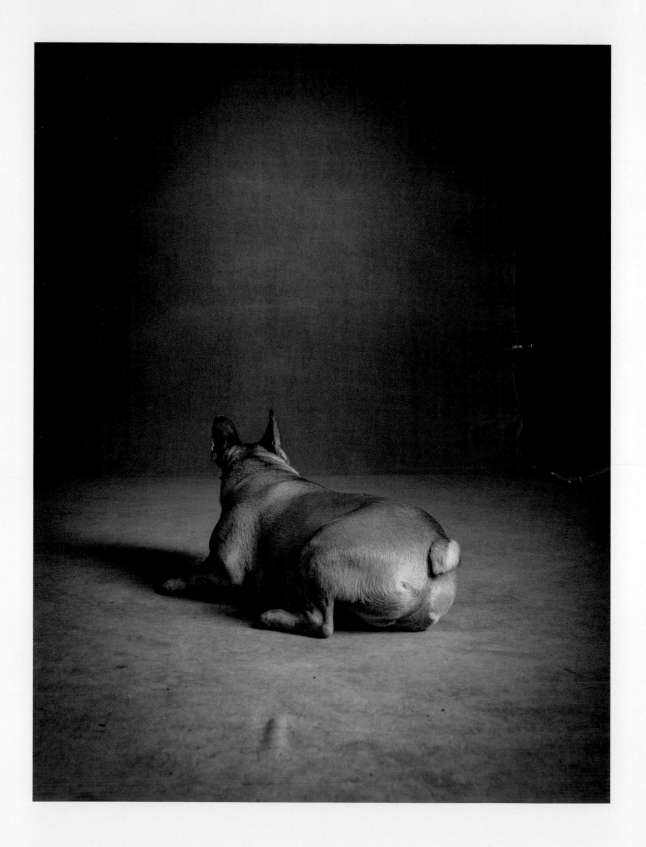

There are no behind-the-scenes videos of me working in the studio because it's too painful to watch a grown man using baby talk to beg a Chihuahua to look at him. Nobody wants to see that sort of thing.

Also, you should never try to work with your wife on a photo project. This book is all Callie's fault. Every time I fell completely apart, which happened daily, she put me back together.

Behind every famous dog photographer is a strong woman who knows we have bills to pay and a kid who wants to go to a nice college. She didn't care which dog peed on me or hurt my feelings. She's really good with the dogs too. You could say whisperer, but I know better. Dogs just like her better than me. It's taken me a while to get over that.

Hunter deserves much of the blame too.

It's really easy to pitch the big ideas when you can go back and work on your math homework. Hunter challenged me to go further with the stories and photographs.

His teenage street smarts make him a perfect editor too. He reviewed every profile and approved most of them. He insisted on the removal of any reference to Nickelback or Grumpy Cat.

There are about a hundred or so contributing photographers to *National Geographic* magazine from around the world. I've never been the first person they call for an assignment. I'm the one they call when that person is busy. I've made a twenty-year career of it. They never play the theme song behind me when I go out the door.

Each year we gather at the magazine's headquarters in Washington, DC, for a week of meetings and events. The finale is a private screening of the work in progress from each photographer. It's a throw down if you will, of the most incredible photography from some of the world's most incredible photographers.

It's competitive, and the subjects are all critical issues like global warming or vanishing cultures. You might learn of the discovery of a new species or see a decade-long project on the life of an endangered beetle. It's an impressive spectacle – both inspirational to observe and terrifying to participate in, particularly if you are a stay-at-home photographer, taking pictures of your neighbors' dogs.

When my name was called, I took the microphone and blurted out sheepishly that I'd been in the doghouse for so long that I'd show everybody what it looks like in there.

The response was humbling.

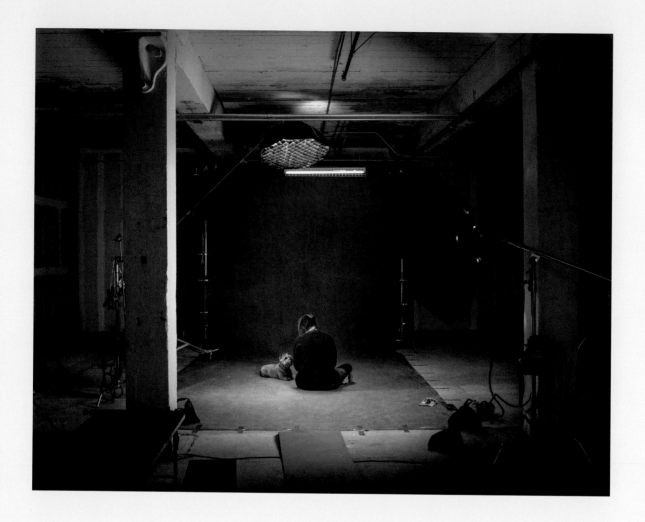

Afterwards, *National Geographic* even did a story about me
photographing my neighbors' dogs.

The Year of the Dogs is undoubtedly about the dogs, but it's also a
metaphor for my life. A tipping point. It's the time when I started over
and learned to love photography again. A time when instinct entirely
took over, and I once again began to live the photographic life.

This book just happened. I didn't plan it carefully with research;
I just let it happen, and unexpectedly found my voice.

The dogs taught me that.

I hope you have enjoyed it.

– VJM

Acknowledgments

Thank you to the many friends I've made on Instagram who shared a kind word of encouragement to create this book. This is a dream made real by friends, family, dogs, strangers, and a couple of cats.

Loren and Mindelle Ziff
Jessica Nagle
Roland Hartley-Urquhart
Owen G. 'Bob' Shell
Thomas Hart Shelby
Andrew J. Schneider
Susan A. Smith
Sloan and Madeline Shell
Kathy Moran
Elizabeth Krist
Sarah Leen
Susan Goldberg
National Geographic magazine
Alexa Keefe
David Griffin
Edwin and Andrea Cooper
Mark and Polly Weiss
Fredda and Keith Culbreth
Indigo Creek Pet Supplies
Kathy Ryan
Greg Lanier
Dan Root
Andrew Cutraro
Bob Croslin
David Alan Harvey

Steve McCurry
William Albert Allard
Michael Nick Nichols
Irving Penn
Richard Avedon
David Sedaris
Kay Luo
Stan Grossfeld
Stacey Kabat
Freddy Paxton
Steve Kaufman
Kathy Best
Edward Diaz
Franco and Ann Taruschio
MaryAnne Golon
Marla Romash
Alan Klaich
Donna Napoleon
Ray Solero
Bunny Pitts
Helen Nawrocki
Butch and June
Mom and Dad
and all the dogs.

Thank you Geoff Blackwell and Ruth Hobday for your friendship, support, and taste in fine wine and photography. Cameron Gibb for making this look good. Nikki Addison for making us sound good. For Callie and Hunter, my reason for being.

First published in the United States of America in 2019 by Chronicle Books LLC.

Produced and originated by
Blackwell and Ruth Limited
Suite 405 IronBank
150 Karangahape Road
Auckland 1010, New Zealand
www.blackwellandruth.com

Publisher: Geoff Blackwell
Editor in Chief: Ruth Hobday
Design Director: Cameron Gibb
Designer & Production Coordinator: Olivia van Velthooven
Publishing Manager: Nikki Addison
Additional editorial: Kimberley Davis, Claire Davis

Library of Congress Cataloging-in-Publication Data available.

ISBN 978-1-4521-8192-9

Chronicle Books LLC
680 Second Street
San Francisco, CA 94107
www.chroniclebooks.com

10 9 8 7 6 5 4 3 2 1

Printed and bound in China by 1010 Printing Ltd.

This book is made with FSC®-certified paper and other controlled material and is printed
with soy vegetable inks. The Forest Stewardship Council® (FSC®) is a global, not-for-profit
organization dedicated to the promotion of responsible forest management worldwide
to meet the social, ecological, and economic rights and needs of the present generation
without compromising those of future generations.